Paris on the Potomac

Perspectives on the Art and
Architectural History of the
United States Capitol

Donald R. Kennon, Series Editor

Donald R. Kennon, ed., *The United States Capitol:
Designing and Decorating a National Icon*

Vivien Green Fryd, *Art and Empire: The Politics of Ethnicity
in the United States Capitol, 1815–1860*

William C. Dickinson, Dean A. Herrin, and Donald R. Kennon, eds.,
Montgomery C. Meigs and the Building of the Nation's Capital

Donald R. Kennon and Thomas P. Somma, eds., *American Pantheon:
Sculptural and Artistic Decoration of the United States Capitol*

Cynthia R. Field, Isabelle Gournay, and Thomas P. Somma, eds., *Paris on the Potomac:
The French Influence on the Architecture and Art of Washington, D.C.*

Paris on the Potomac

The French Influence on the Architecture
and Art of Washington, D.C.

Compiled and edited by
Cynthia R. Field
Isabelle Gournay
and Thomas P. Somma

published for the U.S. Capitol Historical Society by
Ohio University Press ATHENS

www.ohio.edu/oupress
© 2007 by Ohio University Press

Printed in the United States of America
All rights reserved

Ohio University Press books are printed on acid-free paper ∞ ™

14 13 12 11 10 09 08 07 5 4 3 2 1

Library of Congress Cataloging-in-Publication Data

Paris on the Potomac : the French influence on the architecture and art of Washington, D.C. /
compiled and edited by Cynthia R. Field, Isabelle Gournay and Thomas P. Somma.
 p. cm. — (Perspectives on the art and architectural history of the United States Capitol)
 Essays originated in a conference held by the U.S. Capitol Historical Society in 2002.
 Includes bibliographical references and index.
 ISBN-13: 978-0-8214-1759-1 (cloth : alk. paper)
 ISBN-10: 0-8214-1759-2 (cloth : alk. paper)
 ISBN-13: 978-0-8214-1760-7 (pbk. : alk. paper)
 ISBN-10: 0-8214-1760-6 (pbk. : alk. paper)
 1. Architecture—Washington (D.C.)—French influences—Congresses. 2. City planning—
Washington (D.C.)—French influences—Congresses. 3. Public art—Washington (D.C.)—
Congresses. 4. Paris (France)—Civilization—Congresses. 5. Washington (D.C.)—
Civilization—Congresses. 6. Washington (D.C.)—Buildings, structures, etc.—Congresses.
I. Field, Cynthia R. II. Gournay, Isabelle. III. Somma, Thomas P.
 NA735.W3P37 2007
 720.944'09753—dc22
 2007011350

In memory of Thomas P. Somma

1949–2007

Contents

Preface

The essays in this collection, the latest addition to the series on Perspectives on the Art and Architectural History of the United States Capitol, originated in a conference held by the U.S. Capitol Historical Society in 2002 at the French Embassy's La Maison Française.

The five essays in this volume explore aspects of the French influences on the artistic and architectural environment of the nation's capital that continued well after the well-known contributions of Peter Charles L'Enfant, the transplanted French military officer who designed the city's plan. His vision of a majestic capital on a grand European scale remains evident today in the placement of the Capitol, the Mall, and the city's monumental core. As the articles in this volume attest, French influence, however, extends from the city's major federal and public buildings to the city's commercial and residential architecture as well.

The essays in this volume were compiled by Cynthia R. Field, Isabelle Gournay, and Thomas P. Somma, who together originated the concept for the conference. The series editor thanks these three scholars for their diligence and perseverance in seeing this project to publication. He also extends special thanks to two speakers at the 2002 conference: Michael Paul Driskel, who substituted on short notice to present a paper on L'Enfant, and Kenneth R. Bowling, who discussed his book *Peter Charles L'Enfant: Vision, Honor, and Male Friendship in the Early American Republic.*

DONALD R. KENNON

Paris on the Potomac

The French Connection in Washington, D.C.

Context and Issues

ISABELLE GOURNAY

IF AN ACCOUNT OF THE FRENCH ARTISTIC PRESENCE IN THE UNITED STATES IS
of little value without multiple references to the nation's capital, a narrow focus on
"Paris on the Potomac" would be equally sterile. This essay takes us on a journey
through three periods when French ideas about urbanism, architecture, and public art
helped transform many American cities. Each period was triggered by a spurt of artis-
tic activity and creativity in France. The earliest phase spanned from approximately
1790 to 1820, when principles associated with classicism and the Enlightenment helped
shape civic and commemorative designs for the young republic. The second period,
from roughly 1855 to 1875, related to the popularity of the so-called Second Empire
style. The last phase of French influence, which was tied to the popularity of studies at
the Paris Ecole des Beaux-Arts, reached its peak in the first decade of the twentieth
century. In Washington, it began in earnest with the competition for the new Corco-
ran Gallery of Art in 1892 and lingered until World War II. As its protagonists were
more numerous and its imprint most tangible, it is on this third era, and particularly
on its architectural legacy, that this essay will focus.

Aesthetic trends and principles ruling French art and architecture gained relevance
and precedence in the United States when they answered aspirations of political leaders,
members of the financial and intellectual elite, as well as architects and artists them-
selves. However, at their most successful, French-inspired artifacts from L'Enfant's

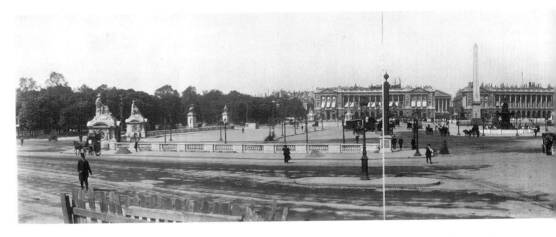

FIG. I. A panoramic photograph of Place de la Concorde, circa 1909. *(Courtesy Library of Congress.)*

plan to the brass *espagnolettes* opening floor-to-ceiling double windows in elegant homes do not simply represent the outcome of abstract historical forces. Instead, in the hands of talented individuals intimately familiar with French art and culture, they were adaptations to specific and unique requirements.

Setting the stage for the Paris on the Potomac story calls for a multifaceted analysis. It requires one to analyze and summarize, for each of the three periods and for both countries, the general climate and particular aspirations presiding over the import of French ideas; to identify institutions, groups, and individuals who were instrumental in bringing these ideas, and to illustrate significant precedents for Washington's French-inspired landmarks, on both sides of the Atlantic Ocean. Last but not least, since other capital cities were also affected by French-inspired neoclassicism, Second Empire style, and Beaux-Arts ideals, it is also worth alluding to the international and cosmopolitan dimensions of these movements.

Studying French connections in Washington carries three additional advantages. First, we can better comprehend this city's complex and ambiguous status in terms of artistic leadership. Expectations that the U.S. capital would set national trends for public design, as happened with its plan, were met on many occasions. However, during the entire course of the nineteenth century, Washington was too small a city to exert cultural and artistic dominance. It did not have the educational and professional institutions, the critical mass of local practitioners and private patrons, which New York, Boston, or Philadelphia could rely on. It is only after 1910 that a Washington-style civic art assumed national and even international prominence, but, again, essentially in the hands of men hailing from other parts of the country. The second peripheral benefit is not insignificant: exploring how French ideas were differently interpreted in

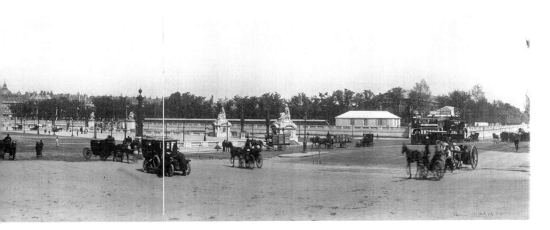

civic and residential commissions helps pinpoint similarities and differences between Washington's public and private spheres. Finally, we can reestablish the significance of artworks and buildings that are no longer extant or are underrated.

Around 1800 three sets of circumstances explain the popularity of French planning, art, and design. First was the military cooperation and intellectual kinship between the United States and its rescuer, France. L'Enfant, the brave soldier, and Thomas Jefferson, the astute diplomat, best exemplify this unusually close connection between the political and artistic lives of two separate countries. Second was the necessity in which the new republic found itself to seek foreign expertise in order to build its institutions and memorialize its revolution, as it had few well-educated artists and even fewer architects who could claim an academic training. Last was a worldwide exodus of Frenchmen, triggered by the Terror and Napoleonic warfare. In fact, this period was unique in that émigrés, as opposed to men born on this side of the Atlantic Ocean, were the primary conduit for influence.

It is fascinating to see how artistic theories established during the ancien régime and ideas related to the Enlightenment had a long-lasting effect on the fine arts in America. Order and hierarchy are key words to understand the artistic movement often referred to as French classicism. Following the lead of Italy, French cities were embellished with public squares centered on freestanding statues. The grandest was the Place de la Concorde originally dedicated to Louis XV (fig. 1). Order was also laid upon hunting forests, urban parks, and private gardens, with tightly controlled effects of close and distant perspective. The work of the consummate master of the French formal garden, André Le Nôtre, was a major inspiration for L'Enfant and, a century later, for members of the McMillan Commission.

Unlike L'Enfant's, Joseph-Jacques Ramée's is not a household name. However, according to his biographer, Paul Turner, his work at Union College in Schenectady (1813), which he designed before Jefferson produced his final scheme for the University of Virginia, introduced "a new type of planning involving many buildings related in complex ways to each other and to the surrounding landscape" and became "a model for collegiate planning."[1] L'Enfant's and Ramée's paradigmatic plans were adapted to New World realities. Laying order upon landscapes of much greater magnitude than was customary in Western Europe, they took into account the preexisting environment, which they fashioned into great swaths of rolling lawns. The clear-cut dialogue they established between natural and man-made landscapes, purposely more abrupt than what was generally produced in France, would become a highly distinctive and successful trait of American urbanism. In other words, the New World suggested a new, more modern dialectic between the formal and the picturesque.[2]

On facades, order and hierarchy were also achieved through mathematical proportions and optical manipulations. Leading principles were symmetry, horizontal massing, unity of materials, the submission of details to the whole, and the proper use of classical orders. Prime exemplars were the east front of the Louvre (fig. 2), commissioned by Louis XIV, and Jacques-Ange Gabriel's twin facades on the Place de la Concorde, which were acknowledged as models for the U.S. Senate and House office buildings (fig. 3) and the Federal Triangle. Visual clarity and superior draftsmanship were not merely signs of artistic virtuosity; they were also tools to implement the above-mentioned principles. Correlation between a sure hand and breadth of vision is perfectly evidenced in Stephen (Etienne) Hallet's proposals for the U.S. Capitol (fig. 4) and demonstrated *a contrario* by the rather awkwardly drawn submissions from American builders and gentlemen architects.[3]

What made the French quest for order particularly significant for the future of American art and architecture was its theoretical and institutional underpinnings. In the seventeenth and eighteenth centuries, France was probably the country where urbanism, architecture, interior decoration, and monumental sculpture had been the objects of the widest ranging and most systematic intellectual explorations. It was certainly the place where they had been most effectively used as tools to express political

[1]Paul Venable Turner, *Joseph Ramée: International Architect of the Revolutionary Era* (Cambridge, Mass., 1996), p. 190.
[2]In addition to easing pedestrian traffic, differences in the appreciation of nature can explain why the McMillan Plan's cross-shaped design for the reflecting pool in front of the Lincoln Memorial, which was similar to that of the Grand Canal in Versailles, was abandoned for a simpler geometry. The grand alleys of trees and large expanses of lawns of the Mall may convey the same visual impression as the gardens at Vaux-le-Vicomte or Versailles. But the strips of generally elevated landscape immediately adjacent to monumental buildings on the Mall or Capitol Hill, as exemplified alongside the Russell Senate Office Building on First Street, NE, are not Parisian-looking. They offer a more dramatic contrast between sharply contoured stone and soft greenery.
[3]See Pamela Scott, "Stephen Hallet's Designs for the National Capitol," *Winterthur Portfolio* 27 (1992):145–70, and *Temples of Liberty: Building the Capitol for a New Nation* (New York, 1995), pp. 27–43.

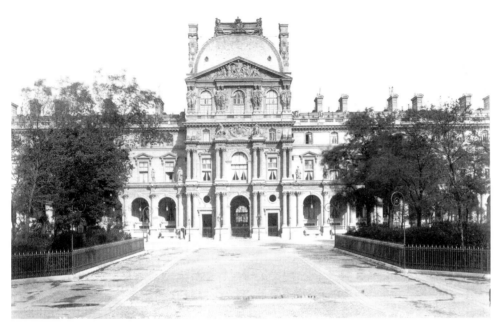

Fɪɢ. 2. The Pavillon Richelieu, Louvre, Paris, France. *(Courtesy Library of Congress.)*

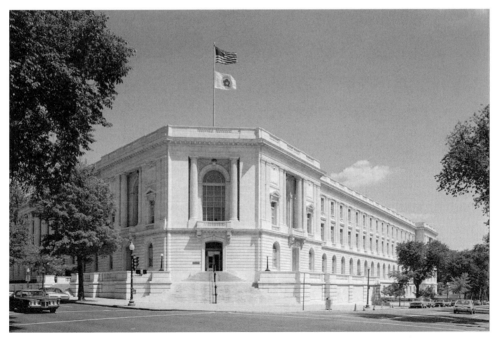

Fɪɢ. 3. House Office Building, now known as the Cannon House Office Building. Historic American Buildings Survey photograph. *(Courtesy Library of Congress.)*

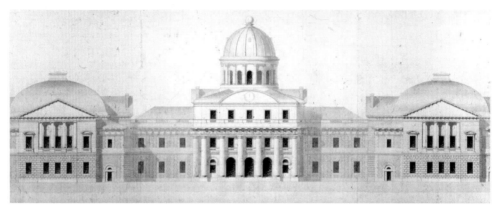

FIG. 4. Elevation of third design for the U.S. Capitol by Etienne Sulpice Hallet, 1792. *(Courtesy Library of Congress.)*

power and social purpose. Indeed, concerns for welfare and hygiene and the didacticism put forward by French philosophers and their famous *Encyclopédie* were brought to America, especially by Jefferson, and impacted upon the built environment.

Although there existed other examples of highly regulated urban design, like the Crescents in Bath or Edinburgh's New Town, it was—and is—a particularly Gallic thing to assume that orderliness and monumentality must be bureaucratically enforced. Beginning with Henri IV, edicts prescribed height limits, alignments, and uniform facades. Along the same lines, artistic and architectural principles were codified and implemented by the state-run académies and their schools. The idea was to train designers and artists capable of expressing the purpose of large and efficient institutions, such as the Royal Mint, whose Hôtel de la Monnaie, built in the 1770s along the Seine River, Jefferson admired greatly. Political regimes changed, but enforcing order and expressing the prerogatives of the state apparatus never stopped ruling France's public sphere.

Respecting the *hiérarchie des genres,* which placed common values over private interest, architects and artists mastered the consummate art of political symbolism. An early example is a project for a semicircular Place de France spearheaded by King Henri IV and his powerful financial advisor Sully, which was intended as the seat of the royal administration and where radial avenues and fan-shaped streets were to be baptized after provinces, in order to strengthen national identity after the religious wars of the sixteenth century and to claim international prominence for France. The same naming principle and related political agenda were exploited by L'Enfant in his plan for Washington.[4]

To serve the monarch and his institutions, French artists and architects used a codified panoply of symbolic forms inherited from antiquity and the Renaissance. Among

[4]Hillary Ballon, *The Paris of Henry IV* (Cambridge, Mass., 1991), pp. 199–207.

them were the equestrian statue and the triumphal arch, which François Blondel re-interpreted to celebrate the Sun King's victories at the Porte Saint-Denis and which Ramée unsuccessfully proposed for Baltimore's monument to George Washington. To translate social purpose and achieve visual excellence, buildings and sculptures were also supposed to express the character suitable to a particular program and use appropriate stylistic precedents. Such logic was followed by Maximilien Godefroy for two buildings still standing in Baltimore, the Neoplatonic First Unitarian Church (1818) and Saint Mary's Seminary Chapel (1808), the first neo-Gothic structure, albeit very classicized, ever built in this country.[5]

Two fundamental and persisting contrasts between the two countries require emphasis. First, relations between public clients and designers differed extensively. In particular, L'Enfant's and Hallet's dismissal and lack of immediate recognition were in great part due to their allegiance to the ancien régime rationale by which the best architects were placed under the direct supervision and protection of officials appointed by the king, or even the monarch himself.[6] Such privileges not only were alien to American democratic ideals but also ran counter to the ever-growing power of private commercial and speculative interests. The second fundamental difference relates to the American unwillingness to adopt a centralized, bureaucratic, and hierarchical system to control the environment and support the fine arts, an unwillingness compounded by the impracticality of enforcing such controls across an area as large as the United States, even in its infancy. At the peak of influence of the Ecole des Beaux-Arts, the idea of a similar national, tuition-free school for the artistic elite to be located in Washington was suggested, but never met much support.[7] A hypothesis worth exploring (and that may be verified in the instance of Washington's Commission of Fine Arts, which was created in 1910) is whether the three periods of greatest French influence discussed in this essay coincided with times when Congress was more intent in controlling the symbolism of the buildings and artworks it commissioned.

One last and equally far-reaching facet of early French influence is the attraction for Parisian townhouses, a taste shared by no less than Thomas Jefferson, whose Parisian residence, the Hôtel de Langeac (now demolished) by Jean-François Chalgrin, was a consummate example of how symmetry and harmony, grandeur and privacy could be achieved in a small, irregular lot of the sort one finds in the District of Columbia.[8]

[5]Robert L. Alexander, *The Architecture of Maximilien Godefroy* (Baltimore, 1974).

[6]See C. M. Harris, "Etienne Hallet's Predicament: Politics, Architecture and the U.S. Capitol," presented at "The French Connection in Washington," symposium organized by the Latrobe Chapter of the Society of Architectural Historians, National Building Museum, 1999.

[7]For instance, the idea was suggested in H.W.F. "Free Architectural Schools," *Architectural Record* 19 (1906):475–76.

[8]Susan Stein, *The Worlds of Thomas Jefferson in Monticello* (New York, 1993), p. 23, illustrates this hotel. Chalgrin also designed the Senate Chamber at the Luxembourg Palace, a precedent for Benjamin Latrobe's House Chamber in Washington. Yvon Bizardel, "French Estates, American Landlords," *Apollo,* n.s. 101 (1975):108–15, studies how, as early as 1893, American citizens bought aristocratic residences in and around Paris.

The third president's attraction for the Hôtel de Salm (presently Musée de la Légion d'Honneur; see fig. 1 in the essay by William Allen in this volume), which encapsulates much of the French architectural thinking for the age of Louis XVI and a major exemplar for late-nineteenth-century architects is well known. To Jefferson and John Quincy Adams, and even to their countrymen who had not traveled to France, the lifestyle of Parisian aristocrats and *grands bourgeois* was synonymous with refined luxury and comfortable elegance. For affluent households, including those who lived in the White House, emulating French *art de vivre* meant importing paintings and furniture, fabric and wallpaper, silverware and objets d'art, porcelains, clocks and statuettes, even wine and delicacies.[9] But around 1800, the scale and decor of Paris's grand townhouses remained more of a match for public buildings, like New York's City Hall, than for private residences.[10]

In the 1820s, the French stamp on American cities became more diffuse as Neoclassicism evolved into an international idiom. German architects and Italian sculptors emigrated in much larger numbers than their French counterparts, leaving a strong mark on Washington. By 1850, the picturesque vogue, which favored Gothic and Italianate Revivals, also prompted an interest in France's eclectic offerings. The transfer and adaptation of the so-called Second Empire style to America has not been the object of a comprehensive survey. In addition to the fact that everything French, from furniture to dresses, carried an aura of sophistication and opulence, mixed with a slightly risqué (and all the more exciting) dimension, its rationale is not entirely clear. This new phase of Francophilia benefited from a unique set of circumstances, coming at the right time and in the right place. It most certainly had more significant political and socioeconomic underpinnings than currently assumed. In fact, Louis-Napoléon and Eugénie, whose splendid court life captivated Americans, had adopted the taste of the *grands bourgeois,* the Pereires and Rothschilds, whose voracious ways of making money, building, and collecting paralleled those of American entrepreneurs such as Washington banker William Corcoran. For this reason, it would be useful to examine economic and financial ties between the two countries (especially those transiting through the nation's capital), as they certainly had cultural and artistic ramifications.

The Second Empire vogue embodied two rather distinct architectural forms—that most familiar to us derived from additions made by Napoleon III to the Louvre. Work on expanding and modernizing the palace of French kings began in 1852. A direct connection was established by Richard Morris Hunt, the first American citizen to be officially registered in the architecture section of the Paris Ecole des Beaux-Arts, as he

[9]Betty C. Monkman, *The White House: Its Historic Furnishings and Its First Families* (Washington, D.C., 2000), is replete with illustrations of French artifacts. It is also amusing to see how presidential households can be divided into pro- and anti-French party lines, with regards to the chef they hired for the White House kitchen.

[10]Damie Stillman, "New York City Hall: Competition and Execution," *Journal of the Society of Architectural Historians* 23 (1964):129–42.

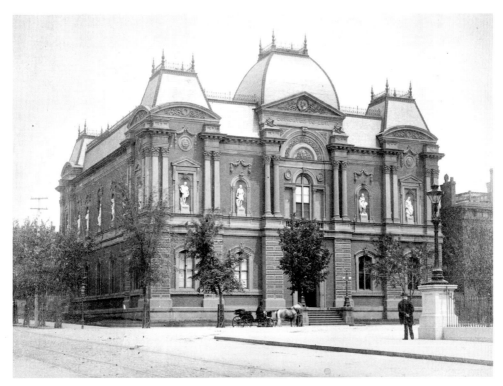

FIG. 5. The Renwick Gallery, the original Corcoran Gallery. *(Courtesy Library of Congress.)*

supervised the construction of the Pavillon de la Bibliothèque on the rue de Rivoli and, upon his return to the United States, briefly worked for Thomas U. Walter on the Capitol dome.

Architects for the new Louvre took their cues from the oldest portions of the palace. They also freely interpreted major landmarks of French classicism such as the Château of Maisons by François Mansart and the Dôme des Invalides by his great-nephew Jules Hardouin-Mansart. Compared with the east front of the Louvre, the new parts achieved monumentality in a much "noisier" manner. Striking differences related to the rejection of the colossal order encompassing several stories, and the introduction of highly three-dimensional wall treatments and conspicuous rooftops. The new Louvre fashion caught England by storm and soon embodied a cosmopolitan as much as a specifically French aura. As the story goes, this new aesthetic was a revelation for Corcoran and his architect, James Renwick, during their travels to Europe. Begun in 1859, Corcoran's mini-Louvre (fig. 5), located a stone's throw from the White House, was completed a decade later.[11] A much more sober interpretation was Boston's city hall, completed in 1865, the first in a line of so-called Second Empire public structures.

[11]Rosalie T. C. McKenna, "James Renwick, Jr. and the Second Empire Style in the United States," *Magazine of Art,* Mar. 1951, pp. 97–101.

Undoubtedly, the new Louvre, which sumptuously housed several French ministries, came to symbolize political power. As impressive but less intimidating than classical exemplars, it superimposed decorative variety to an overall symmetrical order and provided new and exciting ways to combine necessary monumentality with fashionable picturesqueness.

Alfred B. Mullett, the supervising architect of the Treasury, adapted the new Louvre idiom to a series of post–Civil War federal buildings, examples of which survive in Washington, next to the White House and in St. Louis, Missouri.[12] At the State, War and Navy Department (fig. 6, now known as the Old Executive Building), the silhouette of detached pavilions and high, separate roofs, the wedding cake emphasis on horizontal divisions between stories, are akin to their French prototype. But the smoother stonework and simplified decor betray the use of more mechanized construction techniques and of larger wall and column units than in France. This important distinction would manifest itself when steel framing and marble or limestone veneer would become prevalent. For budgetary reasons, but also to express a good government ethic, the Second Empire style acquired in the United States a far more mechanical and far less sensual character. Its lack of compositional flexibility as much as its great cost and association with political scandals precipitated the Second Empire style's demise and triggered a long-lasting hatred on the part of the political class and artistic elite.[13]

In Washington as in other parts of the country, an alternate translation of the Second Empire fashion was the residential and commercial vernacular mode, which might be dubbed as "mansardic" because of its primary identification with rooftops. In fact, it started before the reign of Napoleon III and was more pervasive than the Louvre-inspired building campaign, reaching much greater popularity than in France itself, but it has mostly almost vanished from view. As it was first popularized in elegant homes built in Boston by the French decorative artist Jean Lemoulnier and in New York City by the German-born, but Paris-trained, architect Detlef Lienau, its adoption in Washington is indicative of the northernization of this city.[14]

Built for men prominent on the Hill, the grandest of Washington's mansardic homes are long gone. One of them was designed by Montgomery Meigs for himself: in addition to the roofline, it was essentially inspired by Italian villas. Another was by the German-

[12]Lawrence Wodehouse, "Alfred B. Mullett and His French Style Government Buildings," *Journal of the Society of Architectural Historians* 31 (1972):22–37; Andrew Dolkart, *The Old Executive Office Building: A Victorian Masterpiece* (Washington, D.C., 1984). On Mullett's impressions during his visit to France in 1860, see Daisy Mullett Smith, ed., *Alfred B. Mullett Diaries &c: Annotated Documents, Research and Reminiscence Regarding a Federal Architect Engineer, 1834–1890* (Washington, D.C., 1985), pp. 37–49.

[13]Sue Kohler in *The Commission of Fine Arts: A Brief History, 1910–1995* (Washington, D.C., 1996), pp. 43–44, mentions that in 1917 Paris-trained architect John Russell Pope proposed to camouflage the Old Executive Building by adding pedimented temple fronts as well as colossal pilasters.

[14]David Van Zanten, "Jean Lemoulnier in Boston, 1846–1851," *Journal of the Society of Architectural Historians* 31 (1972):204–20; Helen Kramer, "Detlef Lienau, An Architect of the Brown Decade," *Journal of the Society of Architectural Historians* 14 (1955):18–25.

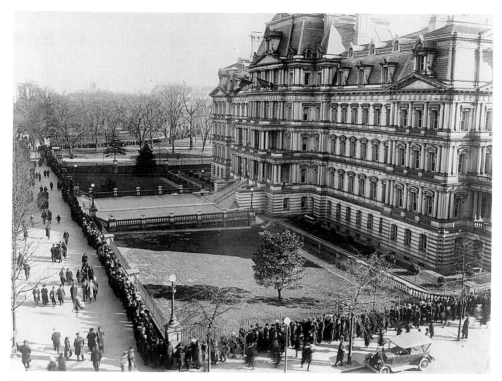

FIG. 6. Old Executive Office Building, 1922. Photographed by Herbert E. French, National Photo Company Collection. *(Courtesy Library of Congress.)*

born architect Adolf Cluss for Sen. William Stewart on Dupont Circle: the cupola, pilasters, and porte cochere had a vertical (and Victorian) élan that distinguished them from their French prototypes.[15] Capitol Hill was by no means immune to the mansardic mode: examples include the Congressional Hotel, located where the Cannon House Office Building stands today, and the Fire Engine Company No. 3 on C Street and Delaware Avenue.[16] Crowned by their distinctive tall roofs, such buildings could be sparsely or profusely decorated, depending on whether they housed thrifty charitable and educational organizations or served as advertisement for commercial establishments.[17] Today, the District of Columbia, including Georgetown, preserves scattered examples of nineteenth-century mansard roofs, indeed a practical solution for habitable attic space.

[15]These houses are illustrated in James M. Goode, *Capital Losses* (Washington, D.C., 1979), pp. 72, 77. Cluss also designed mansard roofs for the red-brick Department of Agriculture on the mall, completed in 1868 (illustrated in *Capital Losses,* p. 316).

[16]Illustrated in Robert Reed, *Old Washington, D.C., in Early Photographs, 1846–1932* (New York, 1980), pp. 14, 17.

[17]Examples of the first category are the Providence Hospital, 1866 (Goode, *Capital Losses,* p. 20), Howard University Medical School (Reed, *Old Washington,* p. 116), and the Louise Home (Goode, *Capital Losses,* p. 20), which was established by William Corcoran. See also Kann's Department Store illustrated in F. M Miller and Howard Gillette, *Washington Seen: A Photographic History, 1875–1965* (Baltimore, 1995), p. 86.

The Beaux-Arts era coalesced the search for order and classical monumentality of L'Enfant's time and the eclectic state of mind of the Second Empire period. Its historical roots are compelling and intricate. France maintained the high level of artistic activity and creativity it had witnessed since 1850. In the hands of extremely capable and powerful administrators, Baron Haussmann pursued the beautification of Paris.[18] The author of a popular book on French traits marveled: "With the architectonic spirit informing all activities, the trifling as well as the serious, it is no wonder that Paris is the world's art-clearing house."[19] Public commissions, such as the rebuilding of the Sorbonne and Hôtel de Ville and the erection of town halls in Paris's twenty arrondissements, involved ambitious decorative programs. Townhouses were erected in greener, more spacious surroundings, along the avenues Montaigne and du Bois (currently avenue Foch), facing the Parc Monceau and Champ de Mars. Built for the 1900 World's Fair, the Petit and Grand Palais and Pont Alexandre III produced an extraordinary tableau and challenged Americans' desire to embellish their own capital.[20] With the Gare d'Orsay, also opened in 1900, Paris had "brought a railroad to the center of the city" and built "one of the important monuments of the year."[21] Erected opposite the Tuileries Gardens, its dignified facade empowered partisans of building a new terminal at the foot of the U.S. Capitol. A chronicle called "Chat of Gay Paris" kept readers of the *Washington Post* informed of the brilliant social life surrounding the magnificent fair.

Sensing that their country was losing some of its industrial clout to Great Britain, Germany, and the United States, the French stressed their nation's self-fashioned civilizing mission. Exporting Gallic taste helped both their ego and their wallets. Officials fed America's fascination for royalty and aristocracy by building reproductions of the Grand Trianon at Versailles and the Hôtel de Salm at the 1904 St. Louis World's Fair and the 1915 San Francisco International Exhibition, respectively.[22] Businessmen were as eager to export their luxury goods, including those pertaining to art and architecture, as well-to-do Americans were to purchase artifacts from a country endowed with "universal taste."[23]

American public opinion showed little sympathy for Frenchmen after their defeat by the Prussians in 1870, but relations between the two countries improved a decade

[18]"Making Paris Beautiful, Municipal Art in the French Capital We Could Well Imitate," *Washington Post,* June 23, 1901, p. 26 (reprinted from *Harper's Magazine*).

[19]William Crary Brownell, *French Traits: An Essay in Comparative Criticism* (1889; reprint ed., New York, 1902), p. 277.

[20]Ibid.

[21]Joseph C. Hornblower, "The Grouping of Government Buildings, Landscape and Statuary in Washington City," in *Papers Relating to the Improvement of the City of Washington, District of Columbia*, ed. Glenn Brown (Washington, D.C., 1901), p. 15.

[22]John Callan O'Laughlin, "France at St. Louis, Grand Trianon Will Be Reproduced at the Fair," *Washington Post,* Nov. 8, 1903, p. ES4.

[23]Brownell, *French Traits,* p. 275.

later when republicanism had firmly established itself in France. In 1882, the French legation in Washington was raised to the level of an ambassadorial post, a gesture reciprocated by Americans eleven years later. A ballet of diplomatic gifts between the two nations ensued, most more impressive by their size or craftsmanship than their intrinsic artistry (the French were partial to vases from the Manufacture Nationale de Sèvres).

Two early-twentieth-century ambassadors, Jean Jules Jusserand (fig. 7)—whose tenure lasted from 1902 to 1924, by far the longest for a Frenchman—and the noted playwright Paul Claudel (1926–33), had truly exceptional intellects. Coming from an affluent family, Jusserand attended law school and earned a *doctorat ès lettres.* He received a Pulitzer Prize for the best book in history and was elected president of the American Historical Society. He and his wife, who was born in France to American parents, were the darlings of Washington society. His love of the outdoors considerably eased a great friendship with Theodore Roosevelt, whose presidency marked a high point in Franco-American relations. Their long hikes and tennis games are the stuff of legend, and Rock Creek Park hosts a memorial bench dedicated to the "biggest little man in Washington," the first monument to a foreign ambassador ever built on federal land.[24] Although they never approached the subject in great detail, both Jusserand and Claudel voiced positive (and seemingly sincere) opinions on current American art and architecture. A popular speaker, Jusserand astutely played the card of cultural diplomacy. He was courted by, and enjoyed the company of, artists and architects in the Beaux-Arts orbit.[25] Jusserand also gave L'Enfant's rehabilitation its final push by devoting to the major—whom he characterized as "haughty, proud, intractable, but sincere, loyal, full of ideas and remarkably gifted"—a chapter of *With Americans of Past and Present Days,* which Scribner's published in 1917.[26]

As the Spanish-American War (which ended in a peace treaty signed in Paris) projected the United States into the mainstream of world affairs, the new prominence of Washington encouraged leading European countries to send as emissaries "statesmen of exceptional prominence and ability" and to build flagship embassies, instead of just renting existing homes.[27] In 1900, the Chambre des Députés introduced a substantial

[24]Vylla Poe Wilson, "Jusserand Memorial Recalls Many Stories of His Distinguished Service Here; Biggest Little Man in Capital Won Deep Respect of Citizens," *Washington Post,* Oct. 24, 1936, p. B2.

[25]See in particular Jules Jusserand, "The Place of Art in Civilization," in *The Promise of American Architecture: Addresses at the Annual Dinner of the American Institute of Architects,* ed. Charles Moore (Washington, 1905), pp. 25–30.

[26]Jules Jusserand, *With Americans of Past and Present Days* (New York, 1917), pp. 137–83 (*En Amérique jadis et maintenant,* Paris, 1918). In 1911, Jusserand founded the Institut Français des Etats-Unis, which published Elizabeth Kite's *L'Enfant and Washington, 1791–1792* in 1929. The journal *American Architect and Building News* (*AABN*) played a major role in reinstating L'Enfant's place in American history; see "Pierre Charles L'Enfant," *AABN* 10 (Oct. 22, 1881), pp. 192–94; De Frieze, "Washington, the City Beautiful," *AABN* 69 (July 7, 1900), pp. 5–6; "A Letter of Major L'Enfant's" *AABN* 75 (Feb. 8, 1902), pp. 46–47; "A Monument to Major L'Enfant," *AABN* 95 (Apr. 28, 1909), p. 144, 2 pl. See also "A la mémoire de l'Enfant," *La Construction Moderne* 24 (1908):375, 411.

[27]Waldon Fawcett, "Washington: An American Versailles," *World To-Day,* Jan. 1910, p. 363.

FIG. 7. Jean Jules Jusserand.
(Courtesy Library of Congress.)

credit to purchase land and erect a diplomatic outpost in the District of Columbia. A large tract was acquired the following year on Kalorama Heights, "on a high knoll a short distance west of Connecticut Avenue, with frontages on S and Twenty-second and Decatur place."[28] The project was soon entrusted to Louis Bernier, best known for his Opéra Comique, and a professor at the Ecole des Beaux-Arts from 1905 to 1919. Former Sen. John B. Henderson and his colorful wife, Mary, took advantage of Bernier's slow progress to commission from George Oakley Totten, an embassy chancery at the intersection of Sixteenth Street and Kalorama Road, which they leased to the French on a long-term basis. For Mrs. Henderson, erecting a "Modern French" mansion "specially designed for entertaining" was part of a more ambitious plan to transform upper Sixteenth Street, where she lived in an extravagant medieval manor, into the Champs-Elysées of Washington.[29] Completed in 1907, the French Embassy (fig. 8) had an unmistakable, albeit caricatured and bashful, Parisian look. But it was tame in comparison to Bernier's proposal (fig. 9): reminiscent of contemporary *hôtels*

[28]"Bought for French Embassy, Large Plot in Northwest Section to Have a Handsome Building," *Washington Post,* Apr. 17, 1901, p. 7.
[29]"Embassy for France," *Washington Post,* June 9, 1907, p. R2, and "Embassy Near Completion, Home of French Ambassador to Be Elegant Structure," *Washington Post,* Oct. 20, 1907, p. R6.

Fig. 8. French Embassy. *(Courtesy the author.)*

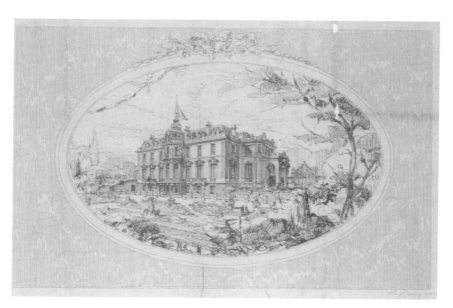

Fig. 9. Proposed design by Louis Bernier for the French Embassy, 1908. Paul P. Cret Collection, Athenaeum of Philadelphia. *(Courtesy Athenaeum of Philadelphia.)*

de ville in large French cities, Jusserand judged it totally unsuited to Washington's climate.[30] After another failed attempt, in the 1920s, to build a flagship residence adjoining Meridian Hill Park, the French purchased an Elizabethan house in Kalorama in 1936, the interiors of which were Frenchified by successive ambassadorial wives. They erected a monumental chancery on Reservoir Road in the 1980s.[31]

Political rapprochement was enacted by monumental public sculpture. In 1878 Frédéric-Auguste Bartholdi's fountain (fig. 10), which Congress purchased after it had been exhibited at the Centennial Exposition in Philadelphia, was installed on the grounds of the Botanic Garden.[32] In 1890, a congressional competition for a new monument to Lafayette was won by Jean-Alexandre-Joseph Falguière and Marius-Jean-Antonin Mercié.[33] In 1902, the monument to Rochambeau, commissioned by Congress to Fernand Hamar, was unveiled, also on Lafayette Square, with invited descendants of this great man in attendance.[34] Twenty years later, a reproduction of Paul Dubois's *Equestrian Statue of Joan of Arc* in Reims (which Augustus Saint-Gaudens regarded as "one of the greatest statues of the world") was placed on the Great Terrace of Meridian Hill Park (see fig. 22 in the essay by Thomas Somma in this volume), where it would have established a visual dialogue with the planned French embassy.[35] Donated by the Société des Femmes de France, this exquisite work is in dire need of tender loving care.

Uninhibited wealth was a major contributing factor. For America's newly rich, adopting French styles for their homes as well as the museums and libraries they patronized, was a stepping stone for their social and cultural ambitions. New York City, with its high concentration of tycoons, ambitious women, and Paris-trained architects, artists, and decorators, led the way, filtering French ideas and redistributing them. During the (relatively) mild winter season, Washington, "a clean, restful, pleasure-loving, non-commercial city," where "the private residence is still the dominant unit" and where real estate was considerably cheaper than in Manhattan, harbored a rather fluid and very cosmopolitan milieu of retired industrialists, independently wealthy diplomats, and recent millionaires turned Congressmen, attracted by "the opportunity to witness the machinery of Congress in motion, to participate in social functions at the presidential mansion, and to view at close range the cosmopolitan life of the diplo-

[30]For an account of subsequent embassy projects by Paul Cret, see Marc Vincent, "Thirty Years of Frustration: Paul Cret and the French Embassy Designs," presented at "The French Connection in Washington," symposium organized by the Latrobe Chapter of the Society of Architectural Historians, National Building Museum, 1999.

[31]Mary V. R. Thayer, "Embassy Decor Is Now Franc-ly Chic," *Washington Post,* May 11, 1957; Dorothy McCardle, "Chatelaine and Chantuese [*sic*], Decorates Embassy for Just 'A Song,'" *Washington Post,* Feb. 10, 1957, p. F2.

[32]Bartholdi also sculpted the *Monument de l'Indépendance Américaine* in Paris, representing Lafayette and Washington.

[33]Mercié was also the sculptor for the Robert E. Lee monument in Richmond (1890).

[34]Douglas Lewis, "The French Civic Sculpture of Lafayette Park," presented at "The French Connection in Washington," symposium organized by the Latrobe Chapter of the Society of Architectural Historians, National Building Museum, 1999.

[35]Charles Moore, *Washington Past and Present* (New York, 1929), p. 240. In Saint-Gauden's estimation, only Donatello's Gattamelata in Padua and Verrochio's Colleoni in Venice placed higher.

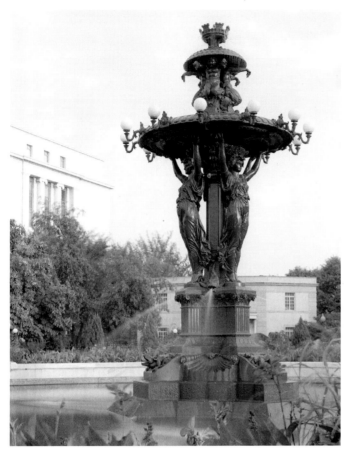

FIG. 10. Bartholdi Fountain, 1985. Photograph by Louise Taft, Historic American Buildings Survey. *(Courtesy Library of Congress.)*

matic corps."[36] Journalist and statesman André Tardieu dubbed these precursors of the jet set *oiseaux de passage* and deemed their mansions better suited for *apparat* and socializing than for family life.[37] One such migratory bird was the widow of Clarence Moore, who died on the *Titanic,* and the daughter of meat-packer Edwin Carlton Swift; she had remarried a Danish-born diplomat and maintained residences in New York, Massachusetts, and Paris, in addition to the French-looking townhouse on Massachusetts Avenue. This was a time when, in the nation's capital, diplomats conversed in the language of Molière and Racine, prominent members of the French mission were aristocrats (and had independent wealth), women with money and personality would be called madame, the Palais Royal was a fashionable department store, and French emigrants were sought after as fencing masters, hairdressers, dressmakers, cooks, or personal maids.[38]

[36]Fawcett, "Washington: An American Versailles," p. 365. On p. 370 the author mentions that another advantage of Washington was "an almost inexhaustible supply of comparatively low-priced Colored labor for domestic services."

[37]André Tardieu, *Notes sur les Etats-Unis: La Société—La Politique—La Diplomatie* (Paris, 1908).

[38]For instance, the French naval attaché and his wife, Viscountess Benoit d'Amy, organized a splendid French costume ball, which was described at length in the *Washington Post,* Apr. 2, 1910, p. 7.

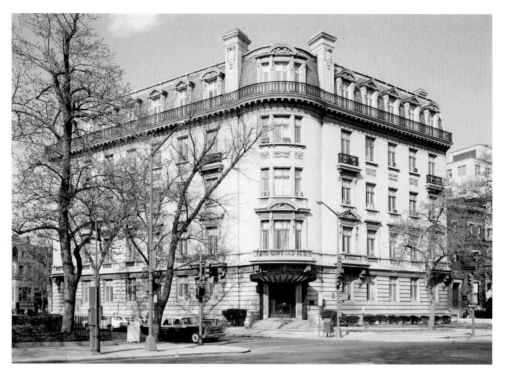

FIG. 11. The McCormick Apartments, 1785 Massachusetts Ave., NW, designed by Jules-Henri de Sibour. Initial construction 1917. Photograph by Jack E. Boucher, Historic American Buildings Survey, 1970. *(Courtesy Library of Congress.)*

Many physical attributes of a Parisian-looking townhouse—the marquise at the entrance, the colonnaded vestibule and the sweeping staircase with a wrought-iron railing, or the gilded ballroom—served as social ritual and as signs of class distinction, just as valets in livery. French, one among several stylistic options, came with a high price tag and was essentially adopted by the richest of the rich. Not surprisingly, the grandest of all Washington's apartment buildings (fig. 11), now the headquarters of the National Trust for Historic Preservation, was also the most Parisian-looking.[39] For Washington's old-timers, especially Georgetown's "cave dwellers," French-style houses, with their stone facing, copper roof ornaments, and entrance halls as big as those of an ocean liner, symbolized new money indiscriminately spent by ostentatious outsiders. As they have been recycled for diplomatic or nonprofit uses, these palatial residences have survived in much greater number than in other American cities.

[39]See James M. Goode, *Best Addresses: A Century of Washington's Distinguished Apartment Houses* (Washington, D.C., 1988), pp. 134–38. The maids' rooms were located at the back of each unit, while they would have been all at the rooftop in Paris.

Moneyed clients found their match in a pool of highly talented and creative archi-
tects, artists, and decorators who had received a direct or indirect French training. Many
American-born painters and a few sculptors studied in private schools, but the magnets
for architects were the ateliers of the government-run Ecole des Beaux-Arts, which
had inherited and enriched the curriculum of the pre-Revolutionary académies. By the
late 1860s, when architect Charles McKim and sculptor Augustus Saint-Gaudens were
in attendance, this school had become an unrivaled art center. From Hunt's tenure
to World War I, more than four hundred Americans were officially registered in its
architecture section. They complied with a strenuous curriculum, some staying long
enough (a minimum of four years) to complete a *diplôme,* the equivalent of a master of
architecture thesis. Benefits of an Ecole training were immense: architects were taught
how to conceptualize programs quickly and clearly (a major asset to win design com-
petitions), learned superior draftsmanship, and, through school exercises and travels,
gained an intimate knowledge of French historical styles.

Some Washington buildings are textbook illustrations of methods taught at the
Ecole des Beaux-Arts. For instance, facades for the Carnegie Library (fig. 12) and the
headquarters of the National Geographic Society on Sixteenth Street resemble those
prepared by applicants to the Ecole in their *esquisse d'admission.*[40] Paul Cret's design for
the building of the Pan American Union (fig. 13), now the Organization of American
States, epitomizes the Beaux-Arts rule of thumb that first-time visitors must find their
way without verbal orientation.[41] It is also an exemplar of urbanity and impeccable
craftsmanship as compelling as anything found in Cret's country of origin. The eleva-
tion on Seventeenth Street features what a well-known French critic described as the
typically American "trick of presenting to the eye great bare surfaces in order to en-
hance some charming, exceptional motif," resulting in an art "'pruned down,' brought
back to its primal simplicity and capable of appearing modern."[42]

Ecole methods and French source books helped solve planning and compositional
challenges raised by Washington's irregularly shaped lots. They also proved useful re-
gardless of the style adopted for the building. The Supreme Court may not look French,

[40]Alison K. Hoagland, "The Carnegie Library: The City Beautiful Comes to Mt. Vernon Square," *Washing-
ton History* (1990–91):88, mentions that architect Albert Randolph Ross studied at the Ecole des Beaux-Arts.
There is, however, no archival evidence that he passed the entrance examination.

[41]Elizabeth Greenwell Grossman, *The Civic Architecture of Paul Cret* (New York, 1996), pp. 26–64, argues
that the competition opposed two visions of classicism, one championed by McKim, for whom Roman imperial
grandeur equated efficient government and the character given to elevations mattered most, and the other ex-
pounded by Cret, whose major concerns were to excel in planning and to translate the democratic and domestic
character of a house for the American republic. Grossman convincingly argues that the Assembly Hall (Hall of
the Americas) was conceived as a magnified version of a *salle des fêtes* or ballroom in a private mansion or in a
hotel.

[42]Léandre Vaillat, "The Exhibit of American Architects at the Salon of French Artists," *Journal of the Ameri-
can Institute of Architects,* Sept. 1921, p. 292 (reproduced from *Le Temps*).

Fig. 12. Carnegie Library. National Photo Company Collection. *(Courtesy Library of Congress.)*

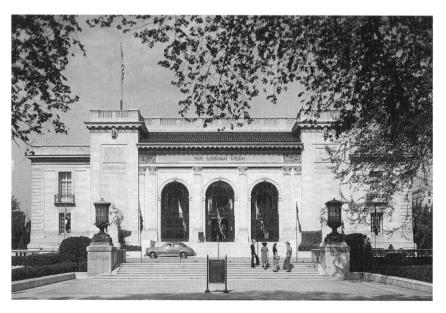

Fig. 13. Pan American Union Building, 1943. Photograph by John Collier. *(Courtesy Library of Congress.)*

but its plan owes a great deal to Henri Labrouste's Rome Prize–winning entry for a Cour de Cassation, itself a tribunal of last recourse.[43] For the National Archives, John Russell Pope relied heavily on D'Espouy's *Fragments d'architecture antique*.[44]

The biographical sketches in the appendix to this volume help us grasp the magnitude of Washington's indebtedness to Ecole-trained architects between the early 1890s and World War II. Separate lists are for *diplômés,* students officially registered in an atelier, those who studied in Paris without any official registration, and graduates of American schools—in particular MIT and the University of Pennsylvania—where the curriculum was dominated by French principles and design critics. Inequality between Ecole backgrounds had a strong bearing on architecture in Washington. Around 1900, two types of Paris-trained architects produced work there. A first group was composed of local practitioners who had attended an atelier at the Ecole for a year or two without passing the entrance examination. Joseph C. Hornblower (who was one of the pioneers of a French education, as he studied there in 1875–76), was the designer of the National Geographic building and received many commissions from the Smithsonian Institution.[45] George Oakley Totten, who designed Jusserand's abode, was essentially known for his firm's townhouse designs. Jules-Henri de Sibour, the architect of the above-mentioned McCormick Apartments, had an authentic French aristocratic pedigree, married a well-bred local girl, Margaret Claggett, and combined Gallic charm with a love for golf, a favorite pastime for Washington's society. Both Totten and de Sibour studied under Honoré Daumet and inherited some of the panache their professor had demonstrated in his addition to the Château de Chantilly.[46]

A second group consisted of out-of-town architects, generally hailing from New York City, who had been officially registered at the Ecole.[47] Among them were McKim, without whom the McMillan Plan may never have been implemented, and his former employees John Merven Carrère and Thomas Hastings, who gained enough international prestige to have their portraits included in the French directory of Ecole alumni.[48] Carrère's Senate Office Building and Hastings's House Office Building (fig. 14) are

[43]Allan Greenberg and Stephen Kieran, "The United States Supreme Court Building," *Antiques* 128 (1985):760–69.

[44]Steven Bedford, *John Russell Pope: Architect of Empire* (New York, 1998), p. 152. Cynthia R. Field, "A Rich Repast of Classicism: Meigs and Classical Sources," in *Montgomery C. Meigs and the Building of the Nation's Capital,* ed. William C. Dickinson, Dean A. Herrin, and Donald R. Kennon (Athens, Ohio, 2001), p. 82, mentions Meigs's indebtedness to Letarouilly's *Les édifices de la Rome moderne* for his take on Rome's Palazzo Farnese at the Pension Building.

[45]See Anne E. Peterson, *Hornblower & Marshall, Architects* (Washington, D.C., 1978).

[46]Jules-Henri's older brother Jean Théodule François Louis de Sibour (Charleston, 1865) was officially registered in the atelier of Daumet et Girault in 1889. He remained in France and never practiced architecture.

[47]A subgroup were young draftsmen for the supervising architect of the Treasury, who under James Knox Taylor designed French-inspired public structures erected elsewhere in the country.

[48]Edmond Delaire, *Les architectes élèves de l'Ecole des Beaux-Arts, 1793–1907* (Paris, 1907). Carrère's annotated copy of this directory is now preserved at the Prints and Photograph Division of the Library of Congress.

equally compelling examples of Beaux-Arts empowerment and superior design ability, when one compares their plans and elevations with those first proposed by the Capitol's superintendent, Elliott Woods, who had no formal training.[49] Woods was keenly aware of his limitations. Anxious to secure "a consulting architect of the highest possible attainments," he saw in Boston's Robert Swain Peabody, who attended the Ecole des Beaux-Arts at the end of the Second Empire and designed the Grecian Delta Bureau in Georgetown, "a man of mature years and one who had not reached the Frenchy stage" who could achieve the "old fashioned, but correct architecture" he thought the project needed.[50] Since Peabody's financial demands were not accepted, Carrère and Hastings, "the first prominent American architectural firm to stand consistently and intelligently for the results of French training and the forms of French architecture," were hired as salaried consultants.[51] Their correspondence with Woods bears witness to a harmonious and successful cooperation.

Before Carrère and Hastings, another Beaux-Arts man played a key role on the Hill. Edward Pierce Casey, who coordinated the interior decoration of the Library of Congress, was not only the son of the Army Corps of Engineers general who had taken over the project from its local designers but also a former student of Victor Laloux, the architect of the Gare d'Orsay and city hall in Tours. Ecole students learned how to devise interior decoration and to work jointly with painters and sculptors, and Casey's ability to conduct such a major project is undoubtedly related to his training.

Disparity in tenure at the Ecole is of limited significance with regard to residential work but greatly affects projects at a larger scale. For instance, Hornblower's plan for the new Corcoran Gallery of Art achieves none of the spatial fluidity and supple adaptation to the irregular site that helped Ernest Flagg secure this important commission.[52] In terms of graphic ability and composition, Totten's "Suggestion for Grouping Government Building upon the Mall" is a far cry from the McMillan Plan, which was devised at the same time.[53]

Washington also hosted two tiers of institutions with significant French and Beaux-Arts connections. In 1892, a small architecture program at George Washington University (which was phased out in the 1930s) was established by Hornblower, and the

[49]See William C. Allen, *History of the Capitol of the United States: A Chronicle of Design, Construction, and Politics* (Washington, D.C., 2001), pp. 378–86, and F. W. Fitzpatrick, "Les édifices du gouvernement à Washington," *La Construction Moderne* 24 (1909):268–72, pl. 56–58.

[50]Elliott Woods to Charles Moore, June 22, 1903 (copy preserved in the archives, Office of the Architect of the Capitol).

[51]"The Works of Carrère and Hastings," *Architectural Record* 27 (1910):112.

[52]The two plans are illustrated in Ingrid Steffensen-Bruce, *Marble Palaces, Temples of Art: Art Museums, Architecture, and American Culture, 1890–1930* (Lewisburg, Pa., 1998), pp. 154–55.

[53]George Oakley Totten, "Exposition Architecture in Its Relation to the Grouping of Government Buildings," in *Papers Relating to the Improvement of the City of Washington, District of Columbia,* ed. Glenn Brown, (Washington, D.C., 1901), pp. 83–86.

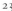

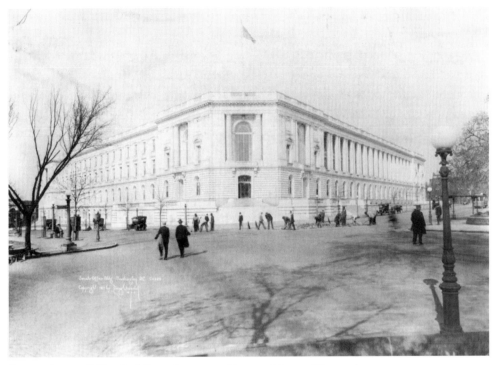

FIG. 14. Senate Office Building, circa 1917. *(Courtesy Library of Congress.)*

Washington Architectural Club was founded. Beginning in 1901, this club, taking its cue from the Paris Salons and from sister organizations established in cities with a larger Beaux-Arts contingent, organized annual juried exhibitions at the Corcoran Gallery of Art. Accompanied by an illustrated catalogue, the exhibits highlighted local work but also presented projects by Ecole students and by major East Coast designers. They were eye-openers for the local press and the educated public. In 1902, the Washington Atelier was founded by Theodore W. Pietsch, a *diplômé* employed in the office of the supervising architect of the Treasury and a firm believer in the "superiority of the French-Trained architect."[54] For a low fee, draftsmen in local offices could learn French methods; their projects were sent to New York City and judged by prominent members of the Society of Beaux-Arts architects. At the national level, the American Institute of Architects (AIA) relocated its headquarters from New York City to New York Avenue, NW, in order to lobby the government more efficiently. At the time of AIA's move, its most influential members were generally French trained. As they saw

[54]Theodore Wells Pietsch, "The Superiority of the French-Trained Architect," *Architectural Record* 25 (1909):110–14. Pietsch's *diplôme* is reproduced in the 1902 exhibition catalogue of the Washington Architectural Club.

themselves as L'Enfant's logical heirs, they made the preservation and extension of his plan a priority.

Disparity in status between local and national firms headed by Paris-trained architects continued until the end of the Beaux-Arts era. Two high achievers at the Ecole established a practice in Washington. Nathan Wyeth, who came to work for Carrère and Hastings on the House and Senate office buildings, was the city's first *diplômé*. A fine designer, but a rather retiring personality, he was the District of Columbia's municipal architect from 1934 to 1946. Frederick Vernon Murphy worked essentially for Catholic orders and parishes, leading him to adopt design solutions with a strong Old World, if not purely Gallic, flair. He also founded an architecture program at Catholic University in 1911, which became a separate school in 1924.[55] Students were trained along Beaux-Arts lines to win competitions, including the prestigious Paris Prize.[56] Ecole-trained out-of-towners judged competitions for major projects, were appointed to the Commission of Fine Arts, and kept receiving the most prestigious commissions. In particular, the Federal Triangle is in great part the work of a quartet of turn-of-the-century *diplômés:* Edward Bennett; Arthur Brown Jr.; William Adams Delano; and Chester Holmes Aldrich.

Speaking at a banquet organized by the AIA, Ambassador Jusserand quoted an Ecole official: "Of all foreigners who come to France to practice the arts of design, the American is the one who penetrates most easily and most deeply the genius of our nation."[57] As far as the city of Washington is concerned, this compliment did not ring empty. Although there is no such thing as a dedicated Beaux-Arts style, five major interpretations of French architecture affected Washington between 1890 and 1940. Distinct although sometimes related, they will be examined in the order in which they appeared in this city.

A relatively minor domestic movement, which essentially affected facades, continued the picturesque mind-set and appealed to clients receptive to the romance of Loire Valley castles. Popularized by Richard Morris Hunt in the mansion he built for William K. Vanderbilt on Manhattan's Fifth Avenue, the so-called chateauesque style made its way to Massachusetts Avenue in the early 1880s with a house built by Library of Congress architect Paul Pelz. Other, charming, surviving examples were designed by Totten. A related, but rather unusual, idiom is the post–World War I French provin-

[55]Norma Evenson, "Echoes of the Ecole: Architectural School in Washington," unpublished paper, "The French Connection in Washington," symposium organized by the Latrobe Chapter of the Society of Architectural Historians, National Building Museum, 1999. James Philip Noffsinger, "The Influence of the Ecole des Beaux-Arts on the Architects of the United States," Ph.D. diss., Catholic University of America, 1955, is the earliest reconsideration of the Beaux-Arts phenomenon.

[56]"T. H. Locraft Wins Architectural Prize: Brilliant Student Is Going to Paris for Two Years' Study at Beaux-Arts," *Washington Post,* June 24, 1928, p. 2. Catholic University produced another Paris Prize winner, T. Socrates Stathes.

[57]"Some Speeches at the Annual Banquet, AIA," *American Architect* 87 (Jan. 26, 1905), p. 28.

FIG. 15. Corcoran Gallery of Art. Photograph by Theodor Horydczak. *(Courtesy Library of Congress.)*

cial, or Normandy, style. In the early years of the Beaux-Arts era, the opposite end of the French design spectrum drew its inspiration from néo-Grec and constructive rationalism. Cerebral and crisp, expressing social purpose, it was adopted for many civic structures in Paris. In Washington, an isolated but remarkable example is the Seventeenth Street elevation of the Corcoran Gallery of Art (fig. 15), which the famous critic Montgomery Schuler deemed "astylar" and "without any classical member."[58]

The trend referred to as Modern French or Beaux-Arts baroque (and dubbed "Frenchite pastry" by Frank Lloyd Wright) shared some of the characteristics of the Second Empire style: high relief, detached columns, and prominent rooftops.[59] Its opulence was better channeled, however, as it relied on colossal orders and contrasts between unadorned, smooth wall surfaces and overscaled, decorative details that

[58]Montgomery Schuyler, "The New Washington," *Scribner's Magazine,* Feb. 1912, reprinted in Frank Oppel and Tony Meisel, *Washington, D.C.: A Turn-of-the-Century Treasury* (Secaucus, N.J., 1987). Mardges Bacon, *Ernest Flagg: Beaux-Arts Architect and Urban Reformer* (New York, 1986), p. 85, convincingly argues that this facade was inspired by that of the library of the Paris Faculté de Médecine.

[59]Frank Lloyd Wright, "In the Cause of Architecture," *Architectural Record* 23 (1908):163.

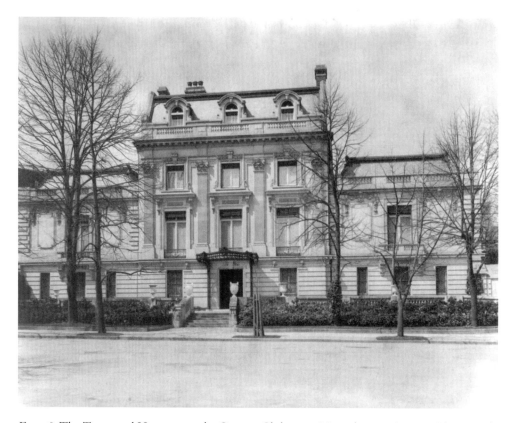

FIG. 16. The Townsend House, now the Cosmos Club, 2121 Massachusetts Avenue. Photograph by Frances Benjamin Johnston. *(Courtesy Library of Congress.)*

characterize baroque more than classical architecture. Slavish imitation was rejected, extra-wide openings were used as centering elements, and interiors were exceptionally fluid. The palatial mansion (now a museum), which Nellie Jacquemart and Edouard André built in the Plaine Monceau in the 1870s, illustrates this trend; its courtyard facade anticipates the exterior of Carrère and Hastings's Townsend House (fig. 16), which is now the Cosmos Club.

Fittingly festive, Modern French was adopted at the Buffalo Pan-American Exposition and St. Louis World's Fair. In permanent structures, it was at its most striking and uninhibited in New York City. The Salon Doré, now at the Corcoran, was one of 130 rooms in Montana Senator William A. Clark's Fifth Avenue manse, for which Henri Deglane, one of the architects of the Grand Palais, had been commissioned for decorative accents. As Ecole students formed a powerful artistic diaspora, Modern French was the in style in many capital cities, mostly in Bucharest and Buenos Aires, but also in London and Brussels. In Washington, its most striking commercial incarnation was de Sibour's Folger Building (fig. 17), still standing on Fifteenth Street, a

stone's throw north of the Treasury Building. Residential variations encompassed the house, infused with Belle Epoque fantasy and now occupied by the Indonesian Embassy (fig. 18), which Thomas F. Walsh built after he came back from a extended stay in Paris as one of the U.S. commissioners to the 1900 World's Fair. Its windows, with curved, almost art nouveau mullions, were all the rage in France. As far as public and institutional buildings were concerned, Modern French was an absolute no-no in Washington. When Hornblower and Marshall submitted a proposal for the Smithsonian's National Museum (Natural History Museum) with a central motif imitating that of the Petit Palais, Charles McKim and construction supervisor Bernard Green were up in arms.[60]

Most present and enduring to this day is the fashion for the Louis styles—particularly XIV, XV, and XVI. In France, nostalgia for the refined (and rarefied) taste and lifestyle of the ancien régime encouraged members of the *haute noblesse* and *grande bourgeoisie,* as well as wealthy American expatriates, to commission homes displaying archaeologically correct montages of seventeenth-century landmarks—not only châteaux and *hôtels particuliers,* but also smaller *pavillons de chasse* and *folies.* In Washington, just as in Paris, the Louis (and Marie-Antoinette) mania extended to furnishings and women's clothing and hairdos.[61] In architecture and interior decoration, the trend was fed by many sourcebooks, including some published locally.[62] Consummate masters of the Louis revivals were Parisian architects Paul-Ernest Eugène Sanson and his former employee René Sergent.[63] Both had an international clientele (Sergent designed the Bosch Palace in Buenos Aires, which is currently the residence of the U.S. ambassador). But only the likes of Perry Belmont, who asked the Sanson firm to draw plans "in the style of Louis XIV" for a triangular site on New Hampshire Avenue (fig. 19), could afford architects with such exacting demands for fine craftsmanship and authentic details.[64] Sanson's Parisian patrons included counts, dukes, and marquis with impeccable lineage (Vogüe, Sabran, la Trémoille, Breteuil), some of them holding elected offices as *sénateur* or *député.* His best-known, and unfortunately demolished, work is the Palais Rose for Boni de Catellane, who had the good fortune to marry American heiress Anna Gould. Built on the avenue Foch, the structure's Grand Trianon exterior sheltered

[60]According to Cynthia R. Field and Jeffrey T. Tilman, "Creating a Model for the National Mall: The Design of the National Museum of Natural History," *Journal of the Society of Architectural Historians,* Mar. 2004, pp. 52–73, McKim confided to Saint-Gaudens: "There is no doubt that Hornblower & Marshall should never have had charge of this important work. They have neither the experience or the initiative, and have depended wholly on the experience of a French draughtsman just out school for their facade." McKim was referring to Edouard Frère Champney, who was actually American.

[61]"Washington Woman to Try the Louis Quinze Costume," *Washington Post,* May 9, 1909, p. M7.

[62]Andrew and Graham, Co., Photo-Lithographers, Washington, D.C., published Eugène Rouyer's *L'art architectural en France/Ornamental Iron, Louis XV* and Jean François de Neufforge's *Louis VI.*

[63]Gérard Rousset-Charny, *Les Palais parisiens de la Belle Epoque* (Paris, 1990), and "Ernest et Maurice Sanson: Une résurgence du classicisme: 1863–1914," *Bulletin de la Société d'Histoire de Paris et de l'Ile-de-France* 115 (1988):125–61.

[64]"Permit for Belmont Home," *Washington Post,* Apr. 17, 1907, p. 3.

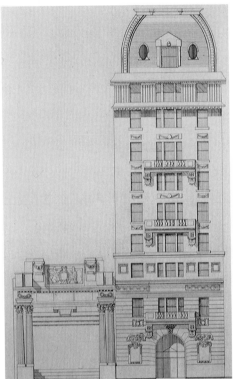

FIG. 17. Folger Building and Playhouse.
(Courtesy University of Maryland School of Architecture Visual Resources.)

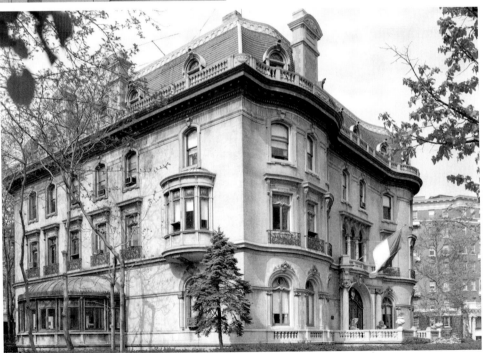

FIG. 18. The Walsh-McLean House, 2020 Massachusetts Ave., NW, designed by Henry Anderson, built 1901–3. Photograph by Jack E. Boucher, Historic American Buildings Survey, 1970. *(Courtesy Library of Congress.)*

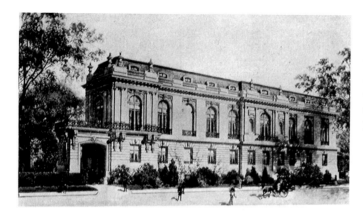

FIG. 19. Design and floor plans for Perry Belmont House, 1618 New Hampshire Ave., NW, by Paul-Ernest Eugène Sanson, 1909. *(Courtesy the author.)*

a replica of the Escalier des Ambassadeurs at Versailles. The closest precedent for Sanson's ingenious plan for the Belmont mansion was his design for sugar magnate Lebaudy, on the avenue de l'Alma, also demolished.

Washington's impressive contingent of homes in the Louis style have been often illustrated and described, although precise sources for their design have not been clearly identified.[65] To de Sibour, we owe the Thomas Gaff House, a take on the brick and stone architecture favored during the reign of Louis XIII and the Stewart House (fig. 20), now the Embassy of Luxembourg; to Nathan Wyeth, the Pullman Residence (figs. 21–23), now the Embassy of Russia, on Sixteenth Street. The creation of the personal income tax in 1913 was a serious blow to palatial townhouses. Nevertheless, the 1920s endowed Washington with two masterworks, exuding both stateliness and charm. Inspired by the Hôtel de Charolais, Horace Trumbauer's Anna Thomson Dodge House, now the residence of the Belgian ambassador (fig. 24), combines American

[65]The most recent of these abundantly illustrated books is Lily Urdolina de Bianchi, *Embassy Residences in Washington, D.C.* (Bogotá, Colombia, 2003).

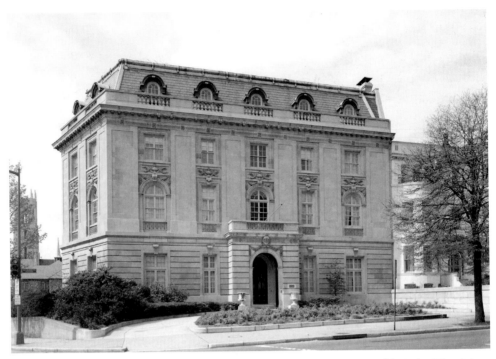

Fig. 20. Alexander Stewart House, 2200 Massachusetts Ave., NW, designed by Jules-Henri de Sibour, built 1908–9. Photograph by Jack E. Boucher, Historic American Buildings Survey, 1970. (*Courtesy Library of Congress.*)

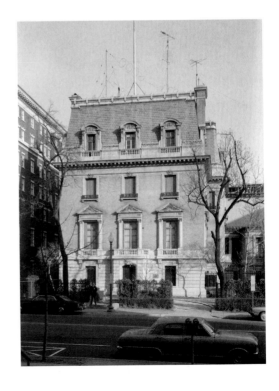

Fig. 21. Pullman House, 1110–1125 Sixteenth St., NW, designed by Nathaniel C. Wyeth, built 1909–11, sold to Russia in 1913, vacant 1920–33. (*Courtesy Library of Congress.*)

FIG. 22. Pullman House interior, first-floor reception hall showing staircase to ground floor. *(Courtesy Library of Congress.)*

FIG. 23. Pullman House interior, northeast corner of the first-floor salon. *(Courtesy Library of Congress.)*

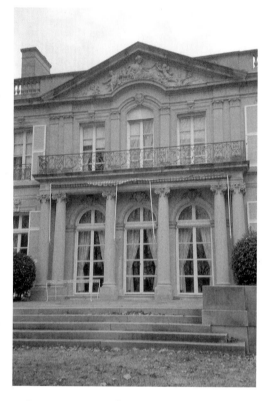

FIG. 24. 2300 Foxhall Rd., NW, designed for Anna Thomson Dodge by the Horace Trumbauer firm and completed in 1931, currently the residence of the ambassador of Belgium. *(Courtesy the author.)*

estate planning with an authentic Faubourg-Saint-Germain flavor.[66] Up to the clipped trees in its walled entrance court, John Russell Pope's Laughlin (Meridian) House, is reminiscent of these understated but supremely elegant homes hiding in royal cities of the Ile de France, such as Versailles and Saint-Germain en Laye.[67]

The Paris on the Potomac story does not end on such a nostalgic, even anachronistic, note (although builders of McMansions could learn a lesson or two from Trumbauer and Pope). The late 1950s and 1960s were again a period of heightened Francophilia. At the White House, Jackie Kennedy hired a French chef and called upon interior decorator Stéphane Boudin of the Maison Jansen to give rooms a new "sense of state, arrival and grandeur."[68] Hervé Alphand, the French ambassador from 1956 to 1965, took cultural diplomacy as serious business. His second wife, Nicole, the epitome of

[66]Clarke Andreae, "Horace Trumbauer's Belle Epoque Contribution to Washington, D.C., the Belgian Embassy," presented at "The French Connection in Washington," symposium organized by the Latrobe Chapter of the Society of Architectural Historians, National Building Museum, 1999. Trumbauer had no formal training; his chief draftsman, Julian Abele, was a graduate of the University of Pennsylvania.

[67]Steven Bedford, "John Russell Pope and Meridian Hill," in *Washington Renaissance: Architecture and Landscape of Meridian Hill* (Washington, D.C., 1989), pp. 13–26.

[68]Jacqueline Kennedy, quoted in James A. Abbott and Elaine M. Rice, *Designing Camelot: The Kennedy White House Restoration* (New York, 1998), p. 53. See also Maxine Cheshire, "White House Going Gallic Again," *Washington Post,* Mar. 12, 1961, p. F3.

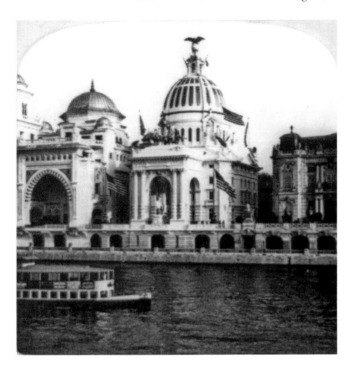

FIG. 25. U.S. pavilion at the 1900 Paris World's Fair. *(Courtesy Library of Congress.)*

French charm and piquancy, was a popular hostess sponsoring couture presentations at her house and a friend of Mrs. Kennedy. The French Market did a brisk business in Georgetown, and Marcel Breuer's HUD Building was inspired by the Paris headquarters of UNESCO.

Our story also involves a "Washington on the Seine" postscript. At the 1900 Fair, a rather odd take on the Capitol dome (indeed, erected right on the banks of the Seine River) served as the U.S. pavilion (fig. 25). At the Colonial Exhibition of 1931, Americans showed a replica of Mount Vernon, which still exists in the posh suburbs of Vaucresson, just a few houses away from Le Corbusier's famous Villa Stein.[69] The United States continued to convey the image of a country that deferred to history with its new embassy office building and consulate (fig. 26), a reconstruction of an eighteenth-century townhouse adjacent to the Place de la Concorde entrusted to Delano and Aldrich, with Victor Laloux as consulting architect.[70] Engineered from Washington and masterminded by Paul Cret, the erection of World War I memorials in France pursued ideals expressed in the McMillan Plan and the design of the Lincoln Memorial.

[69]Isabelle Gournay, "From Mount Vernon to Tract Houses: The American Neo-Colonial Home in XXth Century France," in *Re-creating the American Past: Essays on the Colonial Revival,* ed. Richard Guy Wilson, Shaun Eyring, and Kenny Marotta (Charlottesville, 2006).
[70]"The New U.S. Government Building in Paris," *Architecture* 70 (1934):121–28; Peter Pennoyer and Anne Walker, *The Architecture of Delano and Aldrich* (New York, 2003), pp. 164–69. See also P-E. Blanc, "L'Ambassade américaine à Paris," *La Construction Moderne,* 49 (Sept. 23, 1934), pp. 894–904, and F. Boutron, "L'Ambassade des Etats-Unis à Paris," *L'Architecture* 49 (Jan. 15, 1936), pp. 1–6.

FIG. 26. Proposed office building to house all U.S. government offices in Paris. *(Courtesy Library of Congress.)*

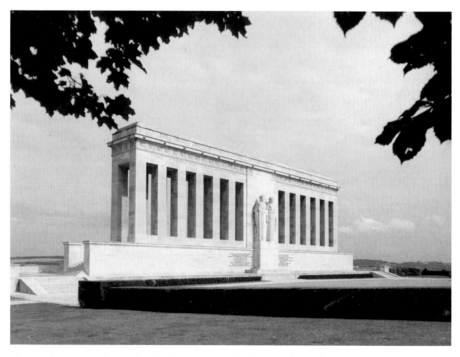

FIG. 27. The American Aisne-Marne Memorial (1926–33) at Château-Thierry, designed by Paul Cret to commemorate the American and French soldiers who fought there in World War I. *(Courtesy American Battlefield Monuments Commission.)*

The typically American dialogue between the formal and the picturesque, which was mentioned in the beginning of this article, characterizes the dramatic setting of the largest commissions, in particular of Paul Cret's stunning Aisne-Marne Monument in Chateau-Thierry (fig. 27).[71] Most recently, Paris has been infused with another dose of the Washington spirit. It is most certainly on the strength of his design for the East Wing of the National Gallery of Art—its site strategy, strict but refined detailing, and user-friendly amenities—that President François Mitterand decided to hire I. M. Pei to revamp the core of the Musée du Louvre. From William Corcoran's mini-Louvre to the Grand Louvre, the fruitful dialogue between two of the most beautiful capital cities in the world is an exciting and open-ended story.

[71]Elizabeth G. Grossman, "Architecture for a Public Client: The Monuments and Chapels of the American Battle Monuments Commission," *Journal of the Society of Architectural Historians* 43 (1984):119–43.

Remembering Paris

The Jefferson-Latrobe Collaboration at the Capitol

William C. Allen

ONE OF THE MOST FASCINATING CHAPTERS IN THE HISTORY OF THE CAPITOL involves the collaboration between America's most architecturally sophisticated president, Thomas Jefferson, and the first genius to practice architecture in America, Benjamin Henry Latrobe. Their association at the Capitol began in 1803 and flourished until Jefferson retired six years later. It was an amiable relationship marked by mutual admiration and respect, yet there were also famous arguments that highlight their important differences. Several significant aspects of their collaboration were rooted in Jefferson's love of French culture, particularly his pleasant and persisting memories of the modern buildings of Paris and his determination to re-create one of the least likely of them for the chamber of the House of Representatives.

It is difficult to overstate the influence that Paris had on Jefferson. During his five-year residence there, which began in 1784 when he arrived to negotiate a commercial treaty, he absorbed French culture like a sponge. He remarked to a correspondent that words would fail him if he attempted to express how much he enjoyed French architecture, sculpture, painting, and music.[1] This affinity was readily demonstrated by the fact that Jefferson returned home with no fewer than eighty-six crates of French furniture, art, and other household goods to refurbish Monticello, which he promptly remodeled and rebuilt to incorporate such Parisian features as alcove beds and parquet floors.

[1]Jefferson to Charles Bellini, Sept. 30, 1785, Fiske Kimball, *Thomas Jefferson, Architect* (New York, 1968), p. 37.

Jefferson was an enthusiastic tourist, going almost every day to see the sights around Paris and to explore what must have been a wonderfully exotic world. In addition to local forays, he took three extensive excursions out of town: he toured English gardens in the company of John Adams in 1786; he visited the south of France and northern Italy in 1787; and he traveled to the Rhineland and Holland in 1788. Although zealous in his European explorations, Jefferson had not come to the Continent as an experienced sightseer. Before going to France he had not traveled widely. His first trip outside Virginia occurred in 1766 when, at age twenty-three, he ventured to Philadelphia to be inoculated against smallpox and then continued north to New York City. His first extended stay away from home came ten years later when he was a delegate to the Continental Congress in Philadelphia. By the time he set sail for France at age thirty-eight, most of what he knew of the world he had learned in the tiny universe bounded by Charlottesville and New York City, augmented, of course, by his extensive reading. (Like other well-educated aristocrats, Jefferson most likely knew more about the classical world from reading Cicero and other authors than he did about the modern world from travel.)

Latrobe, on the other hand, had seen more of the world at a younger age. He had left his native Yorkshire at age twelve to pursue a Moravian education in Germany. He stayed on the Continent for seven years, the last of which he spent traveling in Italy and France. A year before Jefferson arrived in Paris, Latrobe was there visiting some of the same monuments that would prove so important in his later career in Washington. When he returned to England, he settled in London and worked briefly in the Stamp Office before pursuing his architectural and engineering studies. After the death of his first wife, he left England to start anew in America (his mother was a native of Pennsylvania). He arrived in Virginia in 1796 and spent a short time in Norfolk and Richmond before moving to Philadelphia in 1798. There he designed and constructed his first American masterpiece, the Bank of Pennsylvania. Soon after arriving in Philadelphia he became acquainted with Thomas Jefferson, who was then vice president of the United States and a fellow member of the American Philosophical Society.

By the time Latrobe and Jefferson met in 1798, the latter had already wielded considerable influence over the Capitol's destiny. As secretary of state in George Washington's cabinet (1790–93), Jefferson had been ideally positioned to affect the affairs of the new seat of government that the administration intended to build on the northern bank of the Potomac River. In that new city he could push his idea for patterning the public buildings after the two architectural models he admired most: contemporary French buildings and ancient Roman temples. Unlike Washington, who could barely articulate his concepts for the federal buildings, Jefferson had made his ideas clear as early as 1791 when he indicated that he wanted the President's House modeled after a

FIG. 1. *Construction of the Hôtel de Salm,* artist unknown, circa 1784. *(Courtesy Musée Carnavalet, Paris.)*

celebrated modern French building such as the Hôtel de Salm (fig. 1), which he had watched being built while on his daily walks around Paris. For the Capitol he wished the design to be patterned after an ancient Roman temple, preferably one that had been admired by all good judges for thousands of years.[2] He hoped that the public buildings in the federal city would fire a spark in gifted Americans with "natural taste" and "kindle up their genius and produce a reformation" in this useful art.[3] His low opinion of American architecture was stated in two well-known—and very funny—passages in his only book, *Notes on the State of Virginia,* written in 1781–82. In it he condemned the public buildings of Williamsburg as "rude, misshapen piles, which, but they have roofs, would be taken for brick kilns." Of the town's private buildings, he wrote, "It is impossible to devise things more ugly, more uncomfortable, and happily, more perishable."[4] Jefferson was quite serious about reforming American architecture, and he was determined to use every opportunity to improve it for the benefit of his fellow citizens.

In 1791 Jefferson had prodded Peter L'Enfant, the designer of the Federal City, to model the United States Capitol after a Roman temple, and when the designer failed to produce anything on paper and was dismissed, Jefferson suggested holding an architectural competition. The secretary of state reviewed and edited the competition advertisement that was placed in newspapers from Boston to Charleston. This ad was

[2] Jefferson to Pierre L'Enfant, Apr. 10, 1791, Saul K. Padover, *Jefferson and the National Capital* (Washington, D.C., 1946), p. 59.
[3] William Howard Adams, ed., *The Eye of Thomas Jefferson* (Charlottesville, 1981), p. 221.
[4] Ibid., p. xxxvi.

the first attempt at describing the physical aspects of this important building; for all his genius as a writer, however, Jefferson's role in its composition does him little credit. The advertisement called for a two-story brick building with two-story chambers for the House of Representatives and the Senate, two-story lobbies and a conference room, and twelve one-story rooms for committees and clerks. There was no mention of domes or porticoes, nor any words about grandeur or permanence. Should it therefore be surprising that the competition drew a hodgepodge of miserable designs? James Diamond's design (fig. 2), for instance, never fails to draw laughter or bewilderment, yet it faithfully fulfilled the terms of the advertisement. Andrew Carshore's entry (fig. 3) also answered the ad perfectly. Yet, as these designs so clearly demonstrate, adherence to the prosaic specifications for which Jefferson was partly responsible was bound to disappoint those seeking greatness and grandeur in America's principal building.

Looking over Washington's shoulder, Jefferson helped evaluate the entries, which disappointed them both. In time, their hopes came to rest with a French émigré, Stephen Hallet, who happened to be the only professional architect to have entered the competition. Washington and Jefferson encouraged Hallet to refine his precompetition design—dubbed the "Fancy Piece"—into something better suited to the needs of Congress. While Hallet was revising his design, another player arrived on the scene with yet another plan. Dr. William Thornton's exterior design immediately captivated all who saw it. It was, according to Jefferson, "simple, noble, beautiful, excellently distributed, and moderate in size."[5] Jefferson should have taken a second look before praising the floor plan, however; it had serious problems with the conference room, which had a screen of columns placed down its middle, a Senate chamber lighted and ventilated by just three little windows, and a president's office that had no windows at all. After Hallet pointed out these and other problems in a long report, the president ordered Jefferson to hold a conference at which the issues could be discussed.

The conference that Jefferson hosted in his office in July 1793 was a curious event. Stephen Hallet, the architect who had reason to believe he would be awarded the commission to design and build the Capitol, was there to defend his rights against Dr. Thornton, the newcomer whose design for the Capitol's exterior was so pleasing. Two impartial builders from Philadelphia attended the meeting along with James Hoban, the architect of the President's House. The agreement reached that day retained Thornton's exterior elevation but rejected his floor plan and replaced it with one by Hallet. Thus, a floor plan for one building was shoehorned into an unrelated exterior, which resulted in a hybrid scheme that was fraught with problems. One of the most distressing issues was where the legislative chambers were to be located. In Thornton's design, they were intended to occupy the second floor, while Hallet's plan

[5]Jefferson to Daniel Carroll, Feb. 1, 1793, Padover, *Jefferson and the National Capital,* p. 171.

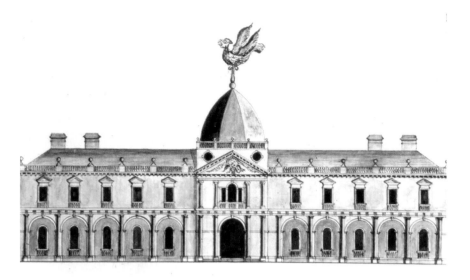

FIG. 2. *An Elevation for a Capitol,* James Diamond, 1792. *(Courtesy Maryland Historical Society.)*

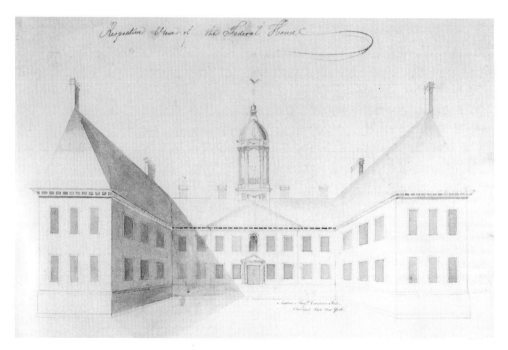

FIG. 3. *Respective View of the Federal House,* Andrew Carshore, 1792. *(Courtesy Maryland Historical Society.)*

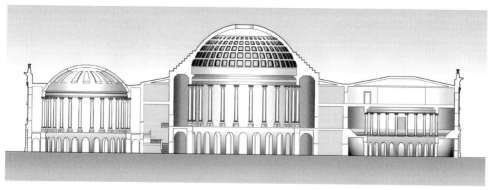

FIG. 4. Section of Capitol Plan, circa 1797, schematic reconstruction by the author; drawing by Michael J. Walton. *(Courtesy Office of Architect of the Capitol.)*

placed them on the ground floor. The hybrid scheme placed the Capitol's principal rooms in the basement story and thus violated a fundamental rule of architectural composition—and none other than Jefferson himself had blessed this situation. He approved the idea of lowering the House chamber to the ground (or basement) level so that the two-story room might be crowned by an interior dome carried on the room's colonnade. Because the wing was three stories tall, the exterior walls would hide the interior dome from view, the exterior would therefore match the other wing, and the building's symmetry would be preserved (fig. 4). Jefferson intended the interior dome to be modeled after the one he admired at his favorite building in Paris, the city's grain market—the Halle aux Blés (fig. 5). Jefferson did not just admire this landmark—he adored it. In praising this building and its unusual dome, Jefferson did not mince words: he claimed that it was the "most superb thing on earth."[6]

Completed in 1766, the Paris grain market was a large, donut-shaped building formed around a circular courtyard that was originally left open to the sky. In 1783 work began to cover the courtyard with a dome designed by Jacques Molinos, an architect who would later befriend Jefferson. The dome was unusual because it was constructed of laminated wood following the celebrated Delorme technique. Its extraordinary feature, however, was the design of the skylights, which were continuous ribbons of glass between the dome's ribs. These unusual skylights provided a surprising source of light, even on gray winter days, and had no more impassioned and lifelong admirer than Jefferson. He eventually proposed to re-create the Halle aux Blés dome for three buildings in the new capital city of Washington: the President's House, the dry dock at the Navy Yard, and the House chamber in the Capitol's south wing.

It may be enlightening to speculate about the reason why Jefferson was so fixated on the Halle aux Blés dome. This obsession (for that is what it was) would cause Latrobe

[6]Adams, *Eye of Thomas Jefferson,* p. 178.

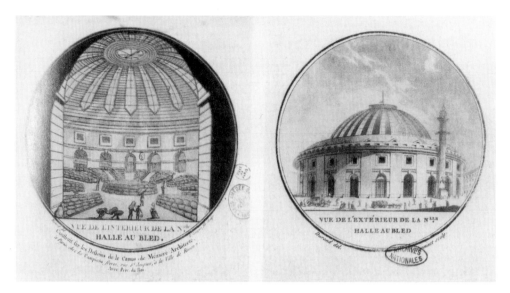

FIG. 5. Halle aux Blés, illustrated in *Picturesque Views of Public Edifices in Paris* (London, 1814). *(Courtesy Library of Congress.)*

considerable anxiety in due course, but what might one conclude about Jefferson's emotional attachment to this particular Parisian landmark? Was it perhaps due to the fact that he was introduced to Maria Cosway (fig. 6) at the Halle aux Blés? We know that she became Jefferson's favorite touring partner, a person in whose company he found such happiness, perhaps even love, and the object of his beautiful love letter— the "Head and Heart" letter. Could it be that his affection for this beautiful, intelligent, and inconveniently married woman somehow later resurfaced in his architectural projects for the city of Washington? Such a memory of Paris and one of the great loves of his life might explain why Jefferson wanted to re-create the Halle aux Blés dome not once but three times in the federal city.

Construction of the Capitol began in August 1793 with the intention that the building be ready for Congress to occupy in seven years. The enterprise soon proved too ambitious, however, as there were not enough workmen, materials, or money to create such a large building in such a sparsely populated place. By 1796 the government had decided to carry on with the north wing only, and in the summer of 1800, without a moment to spare, this wing stood ready to receive the Senate, the House of Representatives, the secretaries and doorkeepers, and a few clerks and books. Nothing of the south wing stood above its rudimentary foundations, and there were only a few foundation trenches where the great central rotunda would someday stand between the two wings.

President John Adams welcomed Congress to the Capitol in a speech delivered in the north wing on November 22, 1800. He lamented the unfinished state of the public

FIG. 6. Maria Cosway, engraving by Francesco Bartolozzi after Richard Cosway, 1785. *(Courtesy Thomas Jefferson Memorial Foundation.)*

buildings but hoped that the government would soon be more comfortably accommodated. Not long after Jefferson became president in March 1801, construction began on a temporary chamber for the House of Representatives, which was then crammed into the north wing's library. The temporary structure utilized the leftover foundations in the south wing that had been laid for the elliptical arcade, which was intended to support the chamber's colonnade and Jefferson's beloved Halle aux Blés dome. For the temporary room, only the brick arcade was built, its openings glazed, and a roof placed above. The odd little structure opened for business at the beginning of the Seventh Congress on December 7, 1801, and was immediately nicknamed "The Oven" because of its peculiar resemblance to a cooking kettle and its stuffy interior. Jefferson approved its design because he felt the elliptical arcade could be reused once construction of the south wing was resumed in earnest.

After two years in its temporary chamber, the House of Representatives appropriated $50,000 to construct the Capitol's south wing. Approved on March 3, 1803, the appropriation was remarkable for the fact that it was the first public money given by

Congress for the Capitol. Prior to this date, monies used to build the public building in Washington came from the sale of city lots, cash donations from Virginia and Maryland, and loans from the federal treasury and the Maryland legislature. Congress directed that the appropriation be spent at the president's direction, and Jefferson lost no time in writing Latrobe with an offer to appoint him "surveyor of the public buildings." Most of the money was intended for the Capitol's south wing, but some was also intended to keep the north wing and the President's House in good repair.

Soon after he assumed his duties in Washington, Latrobe wrote a fifty-six-page report outlining the many faults he found with the design of the Capitol, the construction deficiencies he observed in the north wing, and the many problems facing the proposed plan of the south wing. Latrobe stated that the south wing's plan consisted of just one three-story room that could not by itself meet the needs of the House of Representatives. There were no rooms for the Speaker, the clerk, or the doorkeeper; no committee rooms; no places to store important documents and records. There also were no "closets of convenience" (a common euphemism for privies). Lobbies were nonexistent and the galleries were inadequate. The outside walls would have no interior support and would be difficult to build. Troublesome, too, were the elliptical colonnade and entablature. If the entablature were circular, the stones could be cut on the same radius, but an elliptical shape would mean that only two stones would share any radius, and the cutting expense would therefore be enormous. He also said that designing decorations for an elliptical ceiling would not be easy. In short, Latrobe condemned the plan of the Capitol's south wings as being inadequate, expensive, inconvenient, unsafe, and unattractive. The problems could be solved, Latrobe wrote, if another plan that he had devised to occupy the same space were approved as a substitute. That plan, illustrating a chamber in the form of a half-domed semicircle without columns, has unfortunately not survived.

Despite the lack of drawings, there is ample evidence to show that Latrobe considered half-domed semicircles ideally suited for public speaking rooms. He had constructed such a room for the University of Pennsylvania's anatomical theater and knew of successful legislative chambers in Paris that had been designed on the same principle. The best room he had ever known for speaking, hearing, and seeing was the School of Surgery in Paris (fig. 7), which he had visited around 1783 and which surely served as the model for his proposed House chamber. Thus, the memory of another Parisian landmark had surfaced in the Capitol's early history.

One can only imagine Jefferson's thoughts as he read Latrobe's report. For a decade at least he had envisioned the House chamber with an elliptical colonnade covered by the Halle aux Blés dome, but he was now being told that the idea was faulty on several important counts. While he considered the report, he also allowed Latrobe to proceed with demolition of the long-abandoned foundations that framed the temporary House

FIG. 7. School of Surgery, illustrated in Jacques Gondoin, *Descriptions des Ecoles de chirurgie* (Paris, 1780). *(Courtesy Boston Athenaeum.)*

chamber—foundations laid in the 1790s meant for the south wing's outside walls, but which Latrobe had found too slipshod to trust.

While new foundations were being laid in the south wing, Jefferson studied Latrobe's recommendations and considered the options. He rejected Latrobe's first revised design because it was too great a departure from the accepted plan and gently prodded the architect to accept the design shown in the conference plan. From first-hand experience the president reminded the architect that "nothing impedes progress so much as perpetual changes of design."[7] Imagining the splendor of a sweeping elliptical colonnade holding a replica of the adored Halle aux Blés dome prompted Jefferson to conclude that the present plan would be more handsome than anything that could be newly designed for the same space. He urged Latrobe to give up his objections

[7]Ibid., p. 439.

and concluded with a flattering and indisputable remark: he said that "it was to overcome difficulties that we employ men of genius."[8]

Even as the perimeter walls of the south wing began to rise in the spring of 1804, Latrobe and Jefferson struggled with the question of its ultimate interior plan. Of course, the outside appearance had already been established and Latrobe had no choice but to follow what had already been built in the other wing. But the internal plan and accommodations were other matters. Latrobe soon hit upon an idea that would answer the practical needs of the House of Representatives and gratify Jefferson's obsession with the Halle aux Blés dome. He would design an "office story" at ground level that would house six committee rooms, a large working space for the clerk of the House, fireproof storage vaults for records, and indoor privies (fig. 8). Most of the practical requirements for the wing were provided in this newly devised office story. Upstairs, a two-story chamber would include a low-rising dome that would be hidden from view behind the exterior balustrade. Difficulties with the elliptical footprint of the great colonnade would be avoided by substituting two semicircles abutting a rectangle; yet the new arrangement would preserve the basic idea of the elliptical colonnade and would be much easier and less expensive to build.

It took Latrobe just three weeks to devise this new plan for the Capitol's south wing and make the drawing that conveyed his ideas so beautifully. Jefferson received them at Monticello on April 6, 1804, and wrote Latrobe of his general approval three days later. The idea of moving the chamber to the second floor was acceptable, but the president wanted more time to think about the ultimate shape of the colonnade. Because Latrobe had devised the office story to suit either arrangement, Jefferson's procrastination would not hold back construction.

In due time Jefferson was persuaded that two semicircles were just as effective as an ellipse (figs. 9 and 10). He accepted the change, but he and Latrobe soon became embroiled in a question regarding which style of column to use in the House chamber. From his books and from his time in France, Jefferson was stringently devoted to the high authority of Roman architecture. He was, after all, the first person in the modern world to design a public building using a Roman temple as a model. (The Virginia state capitol of 1785–98 was a landmark in the history of neoclassicism and was Jefferson's first success at architectural education.) Latrobe, on the other hand, had become devoted to the simpler architecture of ancient Greece. Jefferson also was familiar with the antiquities of Athens, but (like French architects) he nonetheless favored Roman models. A more perfect subject could not have been found for a Jefferson-Latrobe clash and one with a more unlikely outcome. Greatly abbreviated and simplified, the great column debate started with Jefferson's proposal to use Roman Doric columns

[8]Jefferson to Latrobe, Feb. 20, 1804, in *The Correspondence and Miscellaneous Papers of Benjamin Henry Latrobe,* ed. John C. Van Horne and Lee W. Formwalt, 3 vols. (New Haven, 1984), 1:440.

FIG. 8. Plan for the ground story of the South Wing of the Capitol, B. Henry Latrobe, 1804.
(Courtesy Library of Congress.)

made of plastered brick. Latrobe countered with an idea for stone columns modeled after the Tower of the Winds in Athens. He convinced the president that a Doric colonnade in this room was unworkable by illustrating it in a beautiful drawing showing that the metopes could not be made square as required by the canons of classical architecture. For his part, Jefferson objected to the Tower of the Winds order because it was too simple. Latrobe countered with a proposal for using the Grecian order of the Choragic Monument of Lysicrates (fig. 11), but Jefferson objected because its entablature did not have modillions and he felt that the Corinthian order should always have modillions. The resulting compromise may be seen today in the old hall of the House of Representatives (now National Statuary Hall): Grecian columns and a Roman entablature with modillions (fig. 12). Just outside this room is a small, circular lobby with columns modeled after the Tower of the Winds, which Jefferson permitted to be used because the room was a secondary space. Erected in 1807, these are the oldest Grecian columns extant in America (fig. 13).

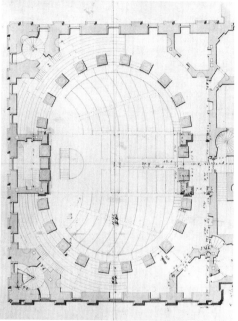

FIG. 9. Plan of the Capitol, detail of the South
Wing, William Thornton, circa 1797. *(Courtesy
Library of Congress.)*

FIG. 10. Plan of the second story of the South
Wing, B. Henry Latrobe, 1804. *(Courtesy
Library of Congress.)*

FIG. 11. Corinthian order of the Choragic
Monument of Lysicrates, illustrated in
The Antiquities of Athens (London, 1825).
(Courtesy Office of Architect of the Capitol.)

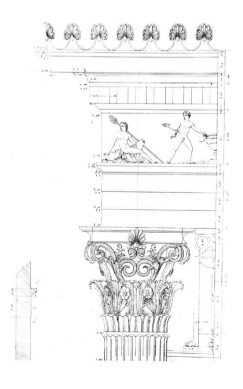

FIG. 12. Small House
Rotunda. *(Courtesy Office of
Architect of the Capitol.)*

FIG. 13. Columns, entablature, and eagle, Old Hall of the House of Representatives (National
Statuary Hall). *(Courtesy Office of Architect of the Capitol.)*

Soon after Jefferson and Latrobe reached their compromise regarding columns for the House chamber, it became clear that the few stone carvers then working in Washington could not be entrusted to make twenty-four elaborate capitals modeled on the Choragic Monument of Lysicrates. Foreign sculptors—preferably Italians—were needed for this work and for the allegorical sculpture that the two men were considering as well. The president asked Latrobe to write Phillip Mazzei, an Italian whom he had known in Paris, to act as their recruiting agent. Latrobe wasted no time in writing Jefferson's friend, describing the architectural and allegorical sculpture intended for the chamber and warning that only artists of good temper and morals would do. Life in a strange land would be difficult enough, but artists with hot tempers or licentious ways would find things in Washington too inhospitable to stay long enough to be of any use. Latrobe also requested Mazzei to ask Antonio Canova (the Western world's greatest living sculptor) if he were willing to make a seated figure of Liberty that would be about nine feet high. Perhaps he could do a plaster model and the carving could be done in America out of a block of native marble. Mazzei proved to be a diligent agent. In February 1806, two talented sculptors, Giuseppe Franzoni and Giovanni Andrei, arrived in Washington ready to enrich the Capitol with their art. Mazzei assured Latrobe that they were both well-tempered and were republicans at heart. Canova, on the other hand, was not interested in an American commission, but Mazzei claimed that Franzoni could sculpt a figure of Liberty just as well.

Franzoni immediately began working on a figure of an eagle for the entablature directly above the Speaker's rostrum. The first studies did not suit Latrobe, because the bird did not look American and he knew that members of Congress, especially those from western states, would be upset if the eagle were not authentically and anatomically American. Charles Willson Peale, the famous painter and naturalist, was asked to draw the features of an American eagle, paying special attention to the arrangement of feathers when the wings were extended. Along with a drawing, Peale sent an actual head and claw for Franzoni to study while making his model. Although the original sculpture was destroyed in a fire set by British troops in 1814, the reproduction now in the old Hall of the House (National Statuary Hall) shows evidence of Franzoni's skill. Other reproductions of Franzoni sculptures are the figures of Justice and Young America that were made for the Supreme Court chamber. These reproductions were sculpted by Franzoni's brother Carlo after the originals were destroyed by the British fire, which was soon followed by Giuseppe's death in 1815.

Latrobe claimed, incorrectly, that the Capitol had the first sculptures to adorn an American public building. (Sculpture in public buildings was not unknown, but it usually bore the provincial stamp of a sculptor more accustomed to carving tombstones than allegorical figures.) He praised Jefferson for having "planted" the arts in America and said that the sculpture by Franzoni and Andrei would perpetuate his love of art.[9]

Jefferson was particularly fond of sculpture and displayed quite a bit at Monticello. This lifelong love was nurtured in Paris, where he met the man who twenty years later would send him the first trained sculptors to work at the Capitol.

If sculptural enrichments were at the high end of the Jefferson-Latrobe collaboration, the topic of flooring might be considered to lie at the other end. Jefferson wanted to pave most rooms with hexagonal tiles imported from France, but Latrobe preferred to lay the corridors with marble, which would be handsomer although not as cheap. For offices and committee rooms, the architect would have laid wooden floors, which he claimed were safe from fire because of the incombustible vaults and fill materials underneath. Eventually, the floors of the corridors, vestibules, and committee rooms were paved with a combination of brick and imported French tile, a small amount of which survives today. The House chamber itself eventually had a wooden floor covered with carpet.

At the end of August of 1805, during the south wing's third year of construction, Jefferson received a startling letter from Latrobe. The architect listed several compelling reasons to abandon the Halle aux Blés dome for the House chamber. Of all things to which he might object, Latrobe had picked the one that was perhaps most dear to the president's heart. The first objection was how light would enter the hall during different times of the day and at different seasons of the year. Sunlight would be annoying to legislators sitting below and could be controlled only by employing Venetian blinds. The second issue was the probability of leaks. Each of the twenty skylights was to be five feet wide at the bottom, twenty feet long, and glazed with forty panes of glass. Thus, the twenty skylights would have eight hundred panes of overlapping glass with thousands of joints from which rain could leak and drip on the heads of the nation's legislators. Frost would make leaks unavoidable, and careless workers shoveling snow off the roof could easily cause an accident with the glass skylights. A hailstorm would break all the glass in less than a minute. Even if the glass did not break, condensation would drip every time the weather changed from warm to cool. While Latrobe also mentioned the price of glass and other obstacles, it was the possibility of leaks that troubled him the most about the Halle aux Blés dome.

Jefferson's response was quite uncharacteristic: he said that although he thought the dome would make the House chamber the handsomest room in the world, he was ready to yield the point in the face of so many objections. Latrobe's dilemma was the choice between going ahead with the Halle aux Blés dome, thus seating the House under a ceiling that he knew would leak, and disappointing the president by abandoning it altogether. He had always wanted to light the room with a central lantern that would have a vertical sash and a closed top. Thus, indirect light would filter into the hall, and

[9]Latrobe to Jefferson, Aug. 13, 1807, ibid., 2:463–65.

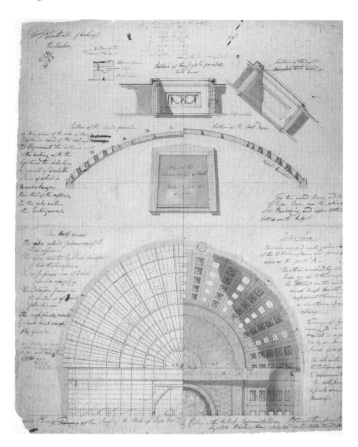

FIG. 14. House Chamber
ceiling and roof details,
B. Henry Latrobe, 1805.
(Courtesy Library of Congress.)

when the sash was open, hot air would be readily exhausted. But Jefferson disap-
proved of lanterns because he could find no precedent for them in classical architec-
ture. He supposed them to have been invented in Italy for hanging church bells and to
be therefore a degenerate form of modern architecture, which he disliked intensely.

With his lantern idea rejected, Latrobe racked his brain for a solution to the prob-
lem. By late November 1805 he had hit upon an idea that he thought might work: to
substitute five panel lights for each ribbon of glass. The panel lights would resemble
coffers with glass backs (fig. 14). Because each could be glazed with a single sheet of
glass, the problem with joints was virtually eliminated. Wire screens could protect the
glass from hail or careless workmen. Thus, with panel lights, Latrobe was able to ap-
proximate the visual effect the president wanted while avoiding the hazard of laying
glass like overlapping shingles in a continuous skylight.

When Jefferson learned of Latrobe's variation of the Halle aux Blés dome, he was
quite pleased, thinking it was perhaps better than the original Parisian model. An order
for glass was sent to Germany in December 1805, and while workers waited its arrival
the hundred panel lights in the ceiling were boarded over. High winds occasionally
drove rain through the openings and stained the plaster ceiling with the rust from

thousands of nails. Latrobe wanted permission (which was denied) to spend $1,000 to sheath the roof with lead in the hopes of defeating the leaks, yet he continued to despair about security against rainwater. In framing the roof, the architect had provided for a central lantern as well as the panel lights in the hope that Jefferson might change his mind and abandon skylights. A lantern would be acceptable to the president only if the glass for the panel lights failed to arrive from Europe, which would force them to light the chamber by a central aperture glazed with common window sash.

The German glass never arrived. In January 1807, Latrobe was obliged to place a second order to a London merchant. During one of the president's inspection trips to the Capitol, he climbed onto the south wing's roof and noticed that the panel lights had been covered over but the framing for the lantern remained. Irritated at what he perceived as Latrobe's subterfuge, he demanded an explanation. The architect again pleaded for the lantern and against skylights. He explained that it was not the look of a lantern that he was after, but rather its usefulness. He then lectured the president about the difference between the classical architecture of their time and buildings of the ancient world. He would copy Roman or Greek buildings if they could be made to suit the American climate or society; but modern churches were different from ancient temples, and modern amusements could not be performed in open-air theaters. Liberties were taken to adapt classical architecture to the American condition, and lanterns were one case in point.[10] In spite of his eloquence, Latrobe's argument fell on deaf ears. Unlike the contemporary French architects he admired, Jefferson took a rigid stance on this issue that shows him unduly and unnecessarily bound by classical precedent.

Following four years of construction, the House of Representatives first met in its splendid new chamber on October 26, 1807 (fig. 15). Within a matter of days, canvas sheets were placed over some of the skylights to help control glaring sunlight that members instantly found annoying. A dormer was built over one skylight to assist in the hall's ventilation. Leaks apparently were not a problem, but light and air were. By 1813, ninety of the one hundred panel lights had been covered with canvas, and the room was too dark to conduct business. Speaker Henry Clay asked Latrobe about improving the lighting conditions in the chamber: the architect recommended building a central lantern and informed the Speaker that the roof framing had been designed to accept one. Nothing came of the proposal, however, and the representatives continued to stumble around their chamber until an invading army of British soldiers torched it in 1814. In rebuilding the room, Latrobe finally got the chance to light it with a lantern, which, of course, Jefferson never saw.

With the south wing finished, Latrobe turned his attention to rebuilding the other wing, which he found in a serious state of decay—despite its being only a few years

[10]Latrobe to Jefferson, Apr. 14, 1807, ibid., 2:428–29.

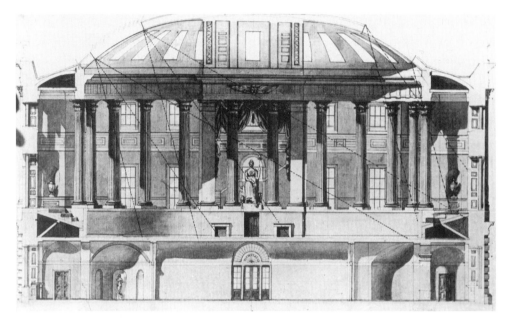

Fig. 15. Section of the South Wing, looking south, B. Henry Latrobe, 1804. *(Courtesy Library of Congress.)*

old. Here again he and Jefferson collaborated on design and construction issues, but because of the president's retirement in 1809, most of the actual work was undertaken in the Madison administration. One remarkable feature of the reconstruction work was the manner by which fireproof ceiling vaults and domes were supported without imposing additional weight or lateral pressure on the old walls. In the east vestibule, for instance, the brick ceiling was supported from below by new stone columns placed a few inches from the walls. Latrobe turned this structural necessity into one of his greatest design feats by designing the column shafts with bundled corn stalks and the capitals with ears of corn. The columns were carved by Giuseppe Franzoni and installed in the summer of 1809, a few months after Jefferson's return to Monticello. Latrobe presented the former president with the sculptor's model of the corn capital, which Jefferson used as a base for a sundial. A reproduction of this unusual timepiece has recently been made for the Thomas Jefferson Memorial Foundation and can been seen today at Monticello.

After Jefferson left Washington in March 1809, he and Latrobe never saw each other again. They did, however, continue to correspond. Latrobe's enemies in the Federalist press attacked him on a number of issues, usually for spending too much money and taking too much time to finish. Others accused the architect of disobeying Jefferson's instructions regarding the reconstruction of the north wing's interiors, which prompted Latrobe to write his former patron for reassurance. These attacks were pure party poli-

tics at their worst, but they nonetheless caused Latrobe considerable anxiety. Jefferson's reply must have been a great comfort to the wounded architect. He said that he considered Latrobe the only person who could have designed and built the House chamber and the only person who should design and build the long-awaited center building. Although sometimes not careful with money, Latrobe was, in Jefferson's opinion, a faithful public servant who had never been disobedient or disloyal.[11]

The most memorable tribute Jefferson wrote to Latrobe was contained in a letter dated July 12, 1812. Work at the Capitol had come to a halt because Congress had cut off funding in the face of an impending war with Great Britain. While Latrobe was no longer a public figure, attacks on him continued in the Washington press. There also was the annoying problem of a leftover bill for a supper Latrobe had hosted for the workmen who had finished building the Capitol's south wing. This and other topics were conveyed to the retired president in one of their last exchanges of letters. Jefferson replied by reminding the architect that his masterpiece, the Hall of the House, would outlive the small-minded people behind the attacks. He wrote, "Little disquietudes from individuals not chosen for their taste in works of art will be sunk into oblivion, while the Representatives' chamber will remain a durable monument to your talents as an Architect." He then concluded with an especially eloquent benediction: "I shall live in the hope that the day will come when an opportunity will be given you of finishing the middle building in a style worthy of the two wings; embellishing with Athenian taste the course of a nation looking far beyond the range of Athenian destinies."[12]

Throughout their involvement with the United States Capitol, both Jefferson and Latrobe drew upon their memories of Parisian landmarks for their own reasons. It is clear that Jefferson's experience in Paris resulted in a stronger emotional affinity than did Latrobe's, and the architect was obliged to humor the president's passion for his favorite French designs—particularly the Halle aux Blés dome—and to reconcile that passion to pragmatic necessities. Latrobe used every power of persuasion available to him—including incontrovertible reason and scientific facts—in an effort to change the president's mind on the skylight subject, but to no avail. Nothing Latrobe could say would alter Jefferson's determination to cover the hall of the House of Representatives with a dome like the one he so loved over the grain market in Paris. It may seem a pity that this blind-eyed obsession reflects so little credit on Jefferson, yet it is altogether a greater pity that the object of so much care and anguish should be last seen by British soldiers carrying lighted torches and gunpowder.

[11]Jefferson to Latrobe, Apr. 14, 1811, ibid., 3:57–58.
[12]Jefferson to Latrobe, July 12, 1812, Edward C. Carter, ed., *The Papers of Benjamin Henry Latrobe,* microform ed. (Clifton, N.J., 1976), 209/E10.

"The Son by the Side of the Father"

David d'Angers's Busts of Washington and Lafayette in the Rotunda of the U.S. Capitol

Thomas P. Somma

ABOUT 1827, THE GREAT NINETEENTH-CENTURY FRENCH PORTRAIT SCULPTOR Pierre-Jean David d'Angers (1788–1856) produced a bust of George Washington, probably in marble, which was presented to the United States by the French nation in late 1827 or 1828. The French costs related to the bust were funded through national subscription; and David, during the course of his work, benefited from the occasional advice and suggestions of his friend and fellow republican, Gilbert du Motier Lafayette (1757–1834), who followed closely the progress of the model. The bust was placed in the Congressional Library (then housed in the Capitol).[1] Early the following year (1829), a marble bust of Lafayette executed by David in 1828 was presented by the sculptor to the United States Congress. A letter from David dated September 11, 1828, and addressed to President John Quincy Adams accompanied the marble portrait. In that letter, the sculptor expressed his hope that the bust of Lafayette "might be set up in the Hall of Congress" next to his bust of Washington, "the son by the side of the father; or, rather, that the two brothers in arms, the two companions in victory, the two men of order and of law, should not be more separated in our admiration than they

[1] Charles E. Fairman, *Art and Artists of the Capitol of the United States of America* (Washington, D.C., 1927), p. 19; *Compilation of Works of Art and Other Objects in the United States Capitol* (Washington, D.C., 1965), pp. 169–70, 397; *Art in the United States Capitol* (Washington, D.C., 1976), pp. 196, 413; Henry Jouin, secretary of the Ecole des Beaux-Arts, to Paul Wayland Bartlett, Sept. 18, 1903, Paul Wayland Bartlett Papers, Manuscripts Division, Library of Congress (hereafter cited as Bartlett Papers, DLC); and Jules Boeufvé, French consul, French Embassy, Washington, D.C., to Elliot Woods, superintendent of the U.S. Capitol, June 11, 1903, Records of the Architect of the Capitol (hereafter cited as RAC).

were in their wishes and their perils."[2] Congress received David's bust of Lafayette on January 28, 1829, and had it placed in the Hall of the House of Representatives pending official disposition; it was subsequently moved to the Congressional Library, where it stood alongside the bust of Washington for nearly twenty-three years.

Both busts were destroyed (apparently), along with a number of other important paintings and sculptures, in a fire on December 24, 1851.[3] But in the early twentieth century, the Congress acquired replicas of the two sculptures, and today they stand together in the Capitol Rotunda just south of the room's east (main) entrance (figs. 1 and 2). Fed by a renewed strengthening of relations between the two modern republics during the last quarter of the nineteenth century, the acquisition of the two replicas was part of the production, peaking at the turn of the century, of an unprecedented number of public sculptures and monuments demonstrating French-American amity.

The purpose of this study is threefold: first, to provide basic documentation regarding the original acquisition of David's two busts, their later replacements, and the existence and disposition of additional replicas and related casts; second, to discuss briefly David's busts of Washington and Lafayette within the framework of French-American sculptural traditions; and, finally, to suggest some of the aesthetic, political, and economic circumstances and motivations behind the tremendous flowering of French-American statuary during the late nineteenth and early twentieth century.

The history of David's original *Bust of Washington* for the U.S. Capitol is not well documented. In fact, there is no official record of the gift in either the files of the Office of the Architect of the Capitol or the Library of Congress;[4] and the references that do exist variously cite the bust's medium as marble or bronze and its date as 1826, 1827, or 1828. However, in light of the evidence provided by David's letter to President Adams of September 1828 and documents related to France's gift of a replacement bronze in 1904, the original *Bust of Washington* was in the Capitol's collection by early 1828 and almost certainly was carved in marble. Other documentation suggests that the bust was probably the product of a national subscription opened in France in 1826, possibly for the purpose of presenting a gift to the United States to mark the fiftieth anniversary of the Declaration of Independence.[5]

Marble as a medium is consistent with one of the more curious aspects of the bust's history—the possibility that it was not destroyed by fire in 1851 after all. In the summer

[2]David d'Angers to John Quincy Adams, Sept. 11, 1828, published in *Journal of the House of Representatives,* 20th Cong., 2d sess., Feb. 9, 1829, pp. 269–70.
[3]*National Intelligencer,* Dec. 25, 1851, quoted in Senate Committee on the Library, *Marble Bust of General Lafayette,* 58th Cong., 2d sess., Dec. 17, 1903, S. Rep. 144, pp. 3–4; and *Proceedings in Connection with the Formal Presentation of a Reproduction of a Bust of Washington by Certain Citizens of the Republic of France* (Washington, D.C., 1905), p. 8.
[4]"Washington Bust, by David d'Angers," typed and handwritten notes, RAC.
[5]Boeufvé to Woods, June 11, 1903, RAC; Jouin to Bartlett, Sept. 18, 1903, Bartlett Papers, DLC; *Proceedings,* p. 32.

FIG. 1. Pierre-Jean David d'Angers, *Bust of Washington,* 1903. Bronze, Rotunda, U.S. Capitol. *(Courtesy Office of Architect of the Capitol.)*

FIG. 2. Pierre-Jean David d'Angers, *Bust of Lafayette,* 1830. Marble, Rotunda, U.S. Capitol. *(Courtesy Office of Architect of the Capitol.)*

Fɪɢ. 3. Pierre-Jean David d'Angers, *Bust of Washington,* 1827–28? Marble, collection of the Henry E. Huntington Library, San Marino, California. *(Courtesy Huntington Library.)*

of 1919, Mitchell Kennerley, an art dealer in New York City, purchased for a modest sum a "dirty" and "discarded" stone block from "an obscure marble cutter's establishment in Manhattan." According to Kennerley, the proprietor of the stone yard told him he had acquired it some ten years earlier from a servant in the neighborhood. Apparently, the owners of the house where the servant was employed "had kept the block in their backyard for years, and had given it to him in order to get rid of it."[6]

Kennerley, upon cleaning the marble, quickly recognized its form and suspected its provenance. Correspondence with Henry Jouin, David's biographer, and close examination by other competent authorities, including the American sculptors Paul Wayland Bartlett and Daniel Chester French, confirmed the bust to be an authentic marble version of David's *Bust of Washington* carved by the sculptor himself.[7] Soon thereafter Kennerley sold the bust to Henry E. Huntington; it is currently held in the collection of the Henry E. Huntington Library in San Marino, California (fig. 3).[8] Whether or not Kennerley's tantalizing story about the true identity of the Huntington bust is authentic remains yet to be proven.

[6]"Washington's Bust, France's Gift, Lost 70 Years, Found," unidentified newspaper clipping, Aug. 18, [1919], RAC; "Library Is Surprised by Discovery of Washington Bust Lost in 1851," unidentified newspaper clipping, RAC; and Frances Davis Whittemore, *George Washington in Sculpture* (Boston, 1933), pp. 65–66.

[7]"Washington's Bust," Aug. 18, [1919]; and Whittemore, *Washington in Sculpture,* p. 66.

[8]Documentation, permanent object file, Henry E. Huntington Library, San Marino, California.

The facts surrounding the initial acquisition of the Lafayette bust are more accessible. In 1828 David on his own produced from life an over-life-sized marble bust of his friend, whom he greatly admired for his commitment to natural rights and his close ties to the American republic.[9] As already noted, David presented the bust through President John Quincy Adams to the American Congress, and it was received and set up in the U.S. Capitol in early 1829. In a gesture of homage David reserved only for those he truly revered, the sculptor executed a marble copy, which he presented to the sitter, a particularly generous policy typical of David and "unparalleled in the history of sculpture."[10]

In response to a growing demand for images of Lafayette in the wake of his highly successful and much publicized Farewell Tour of America in 1824–25, David produced at least two other full-scale marble copies of his bust as well as a number of smaller bronze replicas of various sizes. One of the marbles is the replica in the Capitol; the other, dated 1832, was acquired in the 1830s by Stephen Van Rensselaer of Albany, New York. About 1932, the Van Rensselaer bust entered the collection of Lafayette College in Easton, Pennsylvania. It now survives in three pieces after being damaged in a fire (fig. 4).[11] Lafayette College also owns a reduced bronze replica of David's *Lafayette* dated 1832 (fig. 5); Winterthur Museum, Garden, and Library, in Winterthur, Delaware, has a reduced bronze variant dated 1830 showing Lafayette in the uniform of the Garde Nationale (fig. 6).[12]

Two notable examples of Lafayette portrait busts from this period by American sculptors are the plaster life cast by John H. I. Browere, done in July 1824 while Lafayette was on his Farewell Tour (fig. 7), and Horatio Greenough's marble *Bust of Lafayette* begun in Paris in late 1831. Stylistically, both works reveal a greater fidelity to actual physical appearance in contrast to the more ideal, generalizing style of David's bust. This distinction is especially striking with respect to Browere's life cast, which, in its uncompromising verism, set a standard of realism "against which all the other Lafayette portraits can be judged."[13]

A true eclectic, David mastered a full range of sculptural styles from academic neo-classicism to straightforward realism to romantic distortion, choosing, for each separate work, the style that best fit his intentions. For example, compare the Lafayette bust

[9]See Georges Chesneau and C. Metzger, *Ville d'Angers, Musée des Beaux-Arts, Les Oeuvres de David d'Angers* (Angers, 1934), p. 140; and Marc H. Miller, "Lafayette's Farewell Tour and American Art," in *Lafayette, Hero of Two Worlds: The Art and Pageantry of His Farewell Tour of America, 1824–1825,* ed. Stanley J. Idzerda, Anne C. Loveland, and Marc H. Miller (Flushing, N.Y., 1989), p. 173.

[10]H. W. Janson, "Historical and Literary Themes," in *The Romantics to Rodin,* ed. Peter Fusco and H. W. Janson (Los Angeles, 1980), p. 75.

[11]Object Files, Lafayette College Art Gallery, Easton, Pa.

[12]Object Catalog Record, Winterthur Museum, Winterthur, Delaware. See also Miller, "Lafayette's Farewell Tour and American Art," pp. 174–75.

[13]Miller, "Lafayette's Farewell Tour and American Art," pp. 171, 173–74.

FIG. 4. Pierre-Jean David d'Angers, *Bust of Lafayette* (in three pieces), 1832. Marble, Lafayette College Art Gallery, Easton, Pennsylvania. *(Courtesy Lafayette College Art Gallery.)*

FIG. 5. Pierre-Jean David d'Angers, *Bust of Lafayette,* 1832. Reduced bronze replica, Lafayette College Art Gallery, Easton, Pennsylvania. *(Courtesy Lafayette College Art Gallery.)*

FIG. 6. Pierre-Jean David d'Angers, *Bust of Lafayette,* 1830. Reduced bronze variant, Winterthur Museum, Garden and Library, Winterthur, Delaware. *(Courtesy Winterthur Museum.)*

FIG. 7. John H. I. Browere, *Life Mask of Lafayette,* 1824. Plaster, New York State Historical Association, Cooperstown, New York. *(Courtesy Fenimore Art Museum, Cooperstown, New York.)*

to David's *Thomas Jefferson* (fig. 8), 1832–33, originally installed in the U.S. Capitol Rotunda in 1834.[14] The descriptive detail and historical particularity of the *Jefferson,* the first statue to make a clean break with the international neoclassicism that still dominated French sculpture in the 1830s, focuses the viewer's attention on the practical application and dissemination of Enlightenment principles within the public sphere of political action. The classicizing style of David's *Bust of Lafayette,* by contrast, projects the image beyond the material world into a timeless realm of ideal thought and civic virtue.

David's expressed desire to have his Washington and Lafayette busts stand together in the U.S. Capitol reflected a popular strategy of creating pendant or double portraits of the two revolutionary heroes; and it reveals the extent to which the historical narratives of Washington and Lafayette had become intertwined by the late 1820s, especially for David and the American public.[15]

[14]For a recent study of this statue, see Thomas P. Somma, "Lost in America: David d'Angers' Bronze Statue of Thomas Jefferson, 1832–33," presented at the Sixth Annual Conference in the series *Perspectives on the Art and Architectural History of the United States Capitol,* sponsored by the U.S. Capitol Historical Society, Sept. 17, 1999, Washington, D.C..

[15]See Lloyd Kramer, *Lafayette in Two Worlds: Public Cultures and Personal Identities in an Age of Revolution* (Chapel Hill, N.C., 1996), pp. 2–3, 35.

Fig. 8. Pierre-Jean David d'Angers, *Statue of Thomas Jefferson,* 1832–33. Bronze, Rotunda, U.S. Capitol. *(Courtesy Office of Architect of the Capitol.)*

David's predecessor, Jean-Antoine Houdon (1741–1828), the leading French portrait sculptor of the late eighteenth century, created a similar pairing in the late 1780s when the General Assembly of Virginia commissioned him to produce a portrait statue of Washington and a portrait bust of Lafayette for the state capitol in Richmond. Spurred by Lafayette's four-month triumphal tour of America in 1784 during which he visited Washington at Mount Vernon—the last time the two men saw one another—Houdon's two sculptures are among the most important portraits of Washington and Lafayette from this period (figs. 9 and 10).[16] While Lafayette's return to America in 1784 was motivated by personal reasons—Washington had resigned his commission as the commander in chief of the army the previous year—his trip also served a larger political purpose by reaffirming French-American relations in light of America and England signing the Treaty of Paris in 1783.[17]

The Virginia General Assembly actually commissioned two copies of Houdon's *Bust of Lafayette,* presenting one as a gift to France. Its unveiling in the Hôtel de Ville in Paris on September 28, 1786, "marked the first time a portrait of Lafayette was exchanged as

[16]Miller, "Lafayette's Farewell Tour and American Art," pp. 98, 100.
[17]Ibid., p. 96.

FIG. 9. Jean-Antoine Houdon, *Statue of George Washington,* 1785–88. Marble, Rotunda, Virginia State Capitol Building, Richmond. *(Courtesy Library of Virginia.)*

FIG. 10. Jean-Antoine Houdon, *Bust of Lafayette,* 1785–89. Marble, Virginia State Library and Archives, Richmond. *(Courtesy Library of Virginia.)*

FIG. 11. Jean-Antoine Houdon, *Statue of George Washington,* 1909. Bronze replica, Rotunda, U.S. Capitol. *(Courtesy Office of Architect of the Capitol.)*

a diplomatic gift between America and France."[18] A plaster cast of Houdon's *George Washington* was ordered by Congress and placed in the U.S. Capitol about 1856; it was replaced in 1909 when the state of Virginia submitted a bronze cast of Houdon's marble as one of Virginia's quota of two statues for Statuary Hall (fig. 11).[19]

Beginning about 1875 French-American cultural and diplomatic relations entered a so-called golden age that continued unabated until the end of the First World War. The dramatic surge in friendship between the two nations coincided with the American Centennial in 1876 and the birth of the French Third Republic. As Pierre Provoyeur, June Hargrove, and Catherine Hodeir explain in "Liberty: The French-American Statue in Art and History: An Introduction" (1986),

> when the new French Republic was declared in 1875, the United States was the first power to recognize it. For her part, France, standing alone amid Europe's monarchies, eagerly grasped at the legitimacy thus conferred by her sister Republic. The young French Republic also saw in America a constitutional model to be imitated, if not in every particular, at least in its durability. The circumstances favored a flowering of

[18]Ibid., p. 104.
[19]"Plaster Cast of Statue of George Washington in Rotunda of United States Capitol," Report of Architect of the Capitol to Joint Committee on the Library, Mar. 18, 1950, RAC; Ronald E. Heaton, *The Image of Washington: The History of the Houdon Statue* (Norristown, Pa., 1971), p. 24.

French-American friendship. Indeed, France's affirmation of a republican form of government in the great tradition of 1789 occurred just as the United States was preparing to celebrate the centennial of its independence.[20]

One important manifestation of this reawakening of French-American esprit de corps was the largely state-sponsored ongoing cultural exchange between the two nations of an impressive series of public statues, monuments, and memorials. While a handful of these monuments are allegorical in nature, such as Frédéric-Auguste Bartholdi's *Statue of Liberty*, 1886, most are historical portraits. A list of the more prominent examples includes the following:

1. Bartholdi's *Statue of Lafayette* (fig. 12), 1874–76, Union Square, New York City. Commissioned by the French government and presented as a gift to the city of New York in honor of its aid to Paris during the siege of the winter of 1870–71. It was erected in Union Square in 1876 opposite American sculptor Henry Kirke Brown's 1856 *Equestrian Statue of Washington* (fig. 13), "thereby linking the two Revolutionary heroes."[21]

2. Bartholdi's *Washington and Lafayette* (fig. 14), 1895, Place des Etats-Unis, Paris, commissioned by the American Joseph Pulitzer to commemorate France's 1889 Centennial.[22]

3. A gilded bronze copy of Emmanuel Frémiet's *Equestrian Joan of Arc*, 1890, East River Drive, Philadelphia (fig. 15). Frémiet's original was erected in 1874 in the Place des Pyramides near the Louvre (replaced by a revised version in 1899). This copy, commissioned in 1889 by the "French colony" in Philadelphia, stands on East River Drive just below the Philadelphia Museum of Art;[23]

4. The *Lafayette Monument* (fig. 16), 1891, southeast corner of Lafayette Park, Washington, D.C., commissioned by the U.S. Congress from Jean-Alexander-Joseph Falguière (1831–1900) and Marius-Jean-Antonin Mercié (1845–1916), two of the preeminent French public sculptors of the late nineteenth century. The monument was erected in Lafayette Park in 1891.[24]

5. Paul Wayland Bartlett's *Equestrian Statue of Lafayette* (fig. 17), 1898–1908, Cours la Reine, Paris, America's reciprocal gift to France in exchange for Bartholdi's *Statue of Liberty*. The first version of Bartlett's statue was unveiled on the Fourth of July 1900, United States Day at the 1900 Universal Exposition in Paris. The final statue, erected in 1908, stood for nearly eighty years in the gardens of the Louvre until it was moved in 1984 to allow for the archaeological excavations that preceded the construction of

[20]Pierre Provoyeur, June Hargrove, and Catherine Hodeir, "Liberty: The French-American Statue in Art and History, An Introduction," in *Liberty: The French-American Statue in Art and History*, ed. Pierre Provoyeur and June Hargrove (New York, 1986), p. 27.

[21]Marvin Trachtenberg, *The Statue of Liberty* (New York, 1976), pp. 32–33; Janet Headley, "Bartholdi's Second American Visit: The Philadelphia Exhibition (1876)," in Provoyeur and Hargrove, *French-American Statue in Art and History*, 1986, pp. 145–46.

[22]To recoup his losses with respect to the commission, Bartholdi "managed through friends to sell a second cast to be given to the city of New York." June Hargrove, *The Statues of Paris: An Open Air Pantheon* (New York, 1989), pp. 181–82.

[23]Fairmount Park Association, *Philadelphia's Treasures in Bronze and Stone* (New York, 1976), p. 82.

[24]James M. Goode, *The Outdoor Sculpture of Washington, D.C.* (Washington, D.C., 1974), pp. 372–73.

I. M. Pei's glass pyramid. It is currently located in the Cours la Reine between the Seine and the Grand Palais.[25]

6. Daniel Chester French's *Equestrian Statue of Washington* (fig. 18), 1900, Place d'Iéna, Paris. The gift of a group of American women "from patriotic motives and with an affectionate regard for France," French's *Washington,* like Bartlett's *Lafayette,* was unveiled on United States Day at the 1900 Paris World's Fair.[26]

7. A slightly enlarged bronze replica of the *Comte de Rochambeau Monument* by J. J. Fernand Hamar (1869–ca. 1930), 1902, southwest corner of Lafayette Park, Washington, D.C. (fig. 19). The original monument was erected "by joint subscription in France and the United States" in the city of Vendôme, France, Rochambeau's birthplace, on June 4, 1900. The replica was commissioned by the American Congress, dedicated by President Theodore Roosevelt, and unveiled by the Comtesse de Rochambeau on May 24, 1902. President Roosevelt invited the French government and people to take part in the monument's inauguration, and descendants of both Rochambeau and Lafayette were in attendance.[27]

8. A full-scale plaster model of David d'Angers's *Thomas Jefferson,* 1833?, Galerie David d'Angers, Angers, France. Previously owned by Uriah Phillips Levy, who commissioned the original bronze statue of Jefferson from David in 1832 and presented it to the U.S. Congress in 1834, the plaster resided for many years at Monticello, which Levy had purchased in 1836 and restored at his own personal expense. The Levy family owned and maintained Monticello until 1923. The plaster model was donated to the Galerie David d'Angers in 1905 by Uriah Levy's nephew and former member of Congress Jefferson M. Levy.[28]

9. Anna Vaughn Hyatt Huntington (1876–1973), *Equestrian Joan of Arc* (fig. 20), 1909–15, Riverside Park Island at 93rd Street and Riverside Drive, New York City. Commissioned by New York City in 1909 and unveiled on December 6, 1915 (during World War I). The ceremony was attended by French ambassador to the United States Jules Jusserand. The French government awarded Huntington a purple rosette for her statue.[29]

10. Bronze replica of the *Equestrian Joan of Arc* by Paul Dubois (1829–1905), Meridian Hill Park, 16th Street and Florida Avenue, Washington, D.C. (fig. 21). A gift from the women of France to the women of the United States, the replica was donated by the Société des Femmes de France of New York and erected in the center of Washington's Meridian Hill Park in 1922. Madame Jusserand represented France at the unveiling. Dubois's original plaster model was exhibited in the 1889 Salon; the bronze was unveiled in front of Reims Cathedral in 1896.[30]

[25]See Thomas P. Somma, *The Apotheosis of Democracy, 1908–1916: The Pediment for the House Wing of the United States Capitol* (Newark, Del., 1995), pp. 52–53; Geneviève Bresc-Bautier and Ann Pingeot, *Sculptures des jardins du Louvre, du Carrousel et des Tuileries (II)* (Paris, 1986), p. 28.

[26]Hargrove, *Statues of Paris,* pp. 157, 365.

[27]Goode, *Outdoor Sculpture,* p. 379; Deb Randolph Keim, *Rochambeau: A Commemoration by the Congress of the United States of America of the Services of the French Auxiliary Forces in the War of Independence* (Washington, D.C., 1907), pp. 23–30.

[28]See Somma, "Lost in America."

[29]Beatrice Gilman Proske, *Brookgreen Garden Sculpture* (Brookgreen Gardens, S.C., 1968), pp. 168, 173–74.

[30]Goode, *Outdoor Sculpture,* pp. 418, 557.

FIG. 12. Frédéric-Auguste Bartholdi, *Statue of Lafayette,* 1874–76. Bronze, Union Square, New York City. *(Courtesy the author.)*

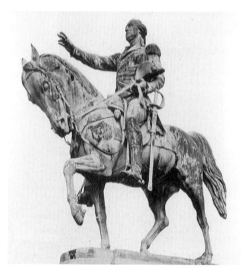

FIG. 13. Henry Kirke Brown, *Equestrian Statue of Washington,* 1856. Bronze, Union Square, New York City. *(Courtesy the author.)*

FIG. 14. Frédéric-Auguste Bartholdi, *Washington and Lafayette,* 1895. Bronze, Place des Etats-Unis, Paris. *(Courtesy the author.)*

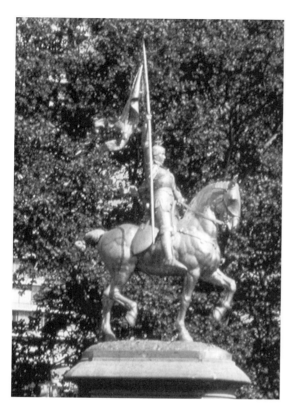

FIG. 15. Emmanuel Frémiet, *Equestrian Statue of Joan of Arc,* 1890. Gilded bronze replica, East River Drive, Philadelphia. *(Courtesy the author.)*

FIG. 16. Jean-Alexander-Joseph Falguière and Marius-Jean-Antonin Mercié, *The Lafayette Monument,* 1891. Bronze, southeast corner of Lafayette Park, Washington, D.C. *(Courtesy the author.)*

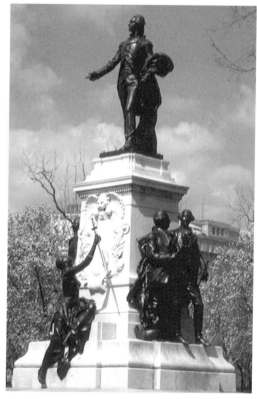

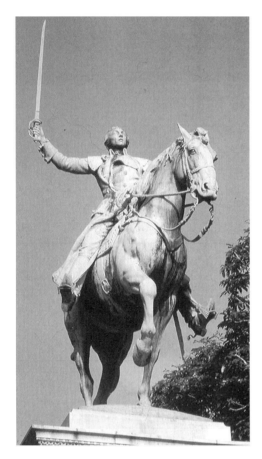

Fig. 18. Daniel Chester French, *Equestrian Statue of Washington,* 1900. Bronze, Place d'Iéna, Paris. *(Courtesy the author.)*

Fig. 17. Paul Wayland Bartlett, *Equestrian Statue of Lafayette,* 1898–1908. Bronze, Cours la Reine, Paris. *(Courtesy the author.)*

Fig. 19. J. J. Fernand Hamar, *Comte de Rochambeau Monument,* 1902. Slightly reduced bronze replica, southwest corner of Lafayette Square, Washington, D.C. *(Courtesy the author.)*

FIG. 20. Anna Vaughn Hyatt Hunting-ton, *Equestrian Statue of Joan of Arc,* 1909–15. Bronze, Riverside Park Island at Ninety-third Street and Riverside Drive, New York City. *(Courtesy the author.)*

FIG. 21. Paul Dubois, *Equestrian Statue of Joan of Arc,* 1922. Bronze replica, Meridian Hill Park, Sixteenth Street and Florida Avenue, Washington, D.C. *(Courtesy the author.)*

The acquisition of the replicas of David's busts of Lafayette and Washington by the U.S. Congress, both in 1904, is part of this remarkable manufacture and exchange of French-American statuary.

The replacement *Bust of Lafayette* was originally offered to Congress in early 1902 by Hawkins K. Jenkins, executor of the estate of Dr. Gabriel F. Manigault, of Charleston, South Carolina, who died in 1899. Dr. Manigault's father, Charles Manigault, had commissioned and purchased the marble directly from David in 1830 while visiting Lafayette at his country home in France, La Grange. Lafayette had, in fact, introduced Manigault to the sculptor for that very purpose.[31] The Manigaults understood their marble to be a replica of the one presented to Congress in 1828 and destroyed in 1851, and Dr. Manigault had wished to offer his *Bust of Lafayette* as a replacement for the lost original.[32]

Jenkins had addressed his offer to Sen. George P. Wetmore, chair of the Joint Committee on the Library. Soon thereafter, Wetmore contacted New York art dealer Samuel P. Avery regarding the pedigree and relative value of the bust. Avery recommended, somewhat halfheartedly, that the government purchase the bust, adding that if the sculpture were consigned to him he could probably find a buyer for $2,000.[33] In mid-June 1902, Senator Wetmore wrote Jenkins stating that if he were willing to sell the bust for $2,000, then Wetmore would introduce a bill at the next session of Congress for its purchase. Jenkins was disappointed in the low figure quoted by Wetmore but accepted his offer if the government agreed to pay for the packing and transport of the bust.[34] Several joint resolutions were passed during the next two years proposing that Congress acquire the Manigault bust, but no action was taken. Finally, in late April 1904, Congress approved an appropriation bill authorizing the Joint Committee on the Library to purchase the marble replica, and, on July 15, 1904, the bust was shipped from Charleston, South Carolina, to the Capitol in Washington.[35]

Unlike the Manigault bust, the new bronze replica of David's *Bust of Washington* was created in the early twentieth century with the express purpose of replacing David's lost nineteenth-century marble. It was cast in bronze in late 1903 by the Parisian sculptor Hubert Louis-Noël from the original plaster model that survived in the collection of the Galerie David d'Angers.[36] Louis-Noël produced at least one other bronze copy

[31]*Marble Bust of General Lafayette,* S. Rep. 144, Dec. 17, 1903, p. 4; Hawkins K. Jenkins to George P. Wetmore, Jan. 27, 1902, RAC.

[32]Jenkins to Wetmore, Jan. 27, 1902, RAC.

[33]George P. Wetmore to Samuel P. Avery, Apr. 30, 1902, RAC; Samuel P. Avery to George P. Wetmore, May 3, 1902, RAC.

[34]George P. Wetmore to Hawkins K. Jenkins, June 11, 1902, RAC; Hawkins K. Jenkins to George P. Wetmore, June 14, 1902, RAC.

[35]George P. Wetmore to Hawkins K. Jenkins, Apr. 30, 1904, RAC; Hawkins K. Jenkins to Elliot Woods, Aug. 19, 1904, RAC.

[36]See *Proceedings,* 1905, p. 38; Alice L. Felton, Photograph Division, Library, Metropolitan Museum of Art, to Charles E. Fairman, Nov. 27, 1931, RAC.

of the *Bust of Washington,* which is now located at New York City Hall in a second-story alcove outside the entrance to the Art Commission of the City of New York. It was donated to the city by Jefferson Levy, probably in 1905, the same year he donated the plaster model of David's *Thomas Jefferson* to the Galerie David d'Angers.[37]

In mid-September 1903, about the time that Louis-Noël began casting the *Washington,* Henry Jouin, secretary of the Ecole des Beaux-Arts and David's biographer, contacted American sculptor Paul Wayland Bartlett to ask his advice regarding a national subscription that had just been launched in France to present a bronze cast of David's *Bust of Washington* to the United States.[38] Jouin explained that the idea for the intended gift was generated initially by America's recent offerings to France of Bartlett's own *Equestrian Lafayette* and French's *Equestrian Washington* in 1900; and, even more particularly, responded directly to the extensive American celebrations marking the 1902 inauguration of the *Rochambeau Monument* in Washington, D.C.[39]

Then, in a letter dated October 10, 1903, the project's four key donors—Comte de Rochambeau, Marquis de Lafayette, and Marquis de Grasse, descendants of the three major French military figures to participate in the American Revolution, and Jouin—formally announced their intentions to Horace Porter, American ambassador to France.[40] About two months later, Porter and Madame Leferme, David d'Angers's daughter, viewed the newly completed bronze cast of *Washington* at Louis-Noël's studio in Paris. And, by January 8, 1904, the French government had forwarded the bust to its embassy in Washington. It was officially accepted by joint resolution of Congress on April 28, 1904, and the Joint Committee on the Library was instructed "to make arrangements for the formal presentation" of the bust and to arrange for it "to be placed in an appropriate and conspicuous place in the Capitol Building."[41]

The bust was set up in the Rotunda, and after a conference with Jusserand, the French ambassador, the date of February 22, Washington's birthday, was chosen as the most fitting for its inauguration. A short unveiling ceremony was held in the Rotunda attended by numerous members of Congress and interested citizens. Ambassador Jusserand gave a short address, after which Madame Jusserand pulled a cord releasing the French and American flags that had draped the portrait. The ambassador then stepped forward and placed a booklet listing the names of the bust's donors into a small bronze escutcheon attached to the front of the pedestal.[42]

As stated a moment ago, great motivations for the gift were the equestrian statues by Bartlett and French unveiled in Paris in 1900, works that had, in turn, been stimulated

[37]Felton to Fairman, Nov. 27, 1931, RAC; e-mail, Victoria Jennings, special projects coordinator, Art Commission of the City of New York, to Thomas Somma, Aug. 27, 2002.
[38]Jouin to Bartlett, Sept. 18, 1903, Bartlett Papers, DLC.
[39]Ibid.
[40]The Donor Committee letter, dated Oct. 10, 1903, is published in *Proceedings,* 1905, pp. 31–36.
[41]Ibid., pp. 28, 38, 41, 43.
[42]Ibid., pp. 3–4, 6–9, 44–45.

by the French gifts of the two Bartholdi statues, his *Lafayette, 1876,* and *Statue of Liberty,* 1886. But the most immediate inspiration for the gift was the unveiling of America's 1902 copy of the *Rochambeau Monument,* and the warm "never-to-be-forgotten" treatment received by the Rochambeau mission, the several dozen donors, dignitaries, and government-selected representatives who came to the United States to attend the ceremonies surrounding the monument's inauguration.[43] Other important incentives cited by the Donor Committee included the "Prix de Reconnaissance des Architectes Américaines," a competitive prize for French pupils at the Ecole des Beaux-Arts funded by American architects since 1887, and the recent publication at American expense of the lists of French soldiers who had fought in the American Revolutionary War.[44]

Entitled *The French Combatants in the American War (1778–1783), Based upon Authentic Documents Deposited in the National Archives and in the Archives of the Ministry of War,* the lists were published in Paris in 1903, in cooperation with the Illinois Society of the Sons of the Revolution based in Chicago.[45] In one of their letters, the Donor Committee for the bronze replica of David's Washington described how there were many in France who had been "profoundly touched" by the publication of the lists:

In recalling after more than one hundred and twenty years, in an official document . . . thousands of our countrymen, [who] contributed to the liberation of the American colonies, the United States gives France a proof of great sympathy. This grand enumeration of distinguished captains and unknown soldiers. . . . is the sign of a gratitude which has been too rare in the history of nations. Your country . . . did not wish to allow the names of its brave friends in the hour of trial to perish from history. She has collected them with pious care; she has engraved them on tablets of stone, which it would be fitting to call the "French Golden Book of American Independence."[46]

Of course, there were broader cultural, national and international incentives for both France and America to enact such prominent, public sculptural exchanges. Albert Boime argues convincingly in *Hollow Icons: The Politics of Sculpture in 19th-Century France* (1987) that nineteenth-century French-American sculptures "should not be understood simply as tokens of sympathy between sister republics in commemoration of their partnership during the American Revolution" but that they should also be seen as public tributes to the essentially conservative republican values championed by "the dominant elite of the two countries."[47] Considered from this perspective, late-nineteenth-century French-American statuary can often be interpreted as addressing

[43]Ibid., pp. 7–8, 32; Comte de Rochambeau to [Elliot Woods], Sept. 26, [1903], RAC.
[44]*Proceedings,* 1905, pp. 31, 34–35; and S. Res. 68, 58th Cong., 2d sess., Dec. 18, 1903, RAC.
[45]*Proceedings,* 1905, p. 31, note a.
[46]Ibid., pp. 31–32.
[47]Albert Boime, *Hollow Icons: The Politics of Sculpture in Nineteenth-Century France* (Kent, Ohio, 1987), p. 113.

specific nationalist, foreign relations, or commercial government policy needs, or as supporting various imperialist and neocolonial practices.

While artistic, economic, and political questions dominated relations between France and America during the 1880s and 1890s, each nation on its own, hoping to secure its political destiny, was intent during this period on defining and redefining what it actually meant to be a modern republic. Reflecting the egalitarian values of the Enlightenment, which had been gaining strength throughout the century, and the middle-class belief in the potential for famous figures from the past to be effective role models for the present, the secular commemorative historical portrait statue emerged as one of the leading paradigms in both countries for negotiating these various cultural issues.[48]

Gabriel P. Weisberg, for example, has noted that French officials with key leadership roles in education and the arts during the late nineteenth century—such as Henry Roujon (1853–1914), director of the Beaux-Arts in the late 1890s; Léone Bénédite (1859–1925), curator of the Musée Nationale du Luxembourg; and Georges Leygues (1857–1933), minister of public education and the beaux arts (1893–94; 1898–1902)—often adopted an extremely open attitude to the visual arts in America as one way of improving educational conditions under the Third Republic.[49] Leygues, in particular, was enamored with American art and was "instrumental in helping to secure Bartlett's *Lafayette* for the courtyard of the Louvre."[50]

June Hargrove writes in *The Statues of Paris: An Open Air Pantheon* (1989), that, during the last quarter of the century, "the French were absorbed by the question of defining their political structure." "The commemoration of the founders of the successive Republics," Hargrove continues, "legitimized the status of the present system. In glorifying their historical precedents, the republicans gave credibility to their bid for power."[51] According to Boime, for conservative French republicans French-American statuary celebrated "sovereign power set-up against monarchy on the one hand and anarchy on the other," the visual constructions "of certain French conservatives intended for certain American conservatives."[52] Many of the sculptures discussed in this study operated comfortably within these political parameters.

Finally, in the face of economic instability and stagnant or shrinking demand at home, both France and America considered overseas expansion and the globalization of their markets to be essential elements of their foreign policies during the late

[48]See Hargrove, *Statues of Paris,* pp. 105, 109, 363 n. 11, 12.

[49]Gabriel P. Weisberg, "The French Reception of American Art at the Universal Exposition of 1900," in *Paris 1900: The "American School" at the Universal Exposition,* ed. Diane P. Fischer (New Brunswick, N.J., 1999), pp. 146, 148–51.

[50]Ibid., pp. 175–76.

[51]Hargrove, *Statues of Paris,* pp. 106, 114.

[52]Boime, *Hollow Icons,* p. 115.

nineteenth and early twentieth centuries, and they were not afraid to use military intervention to help secure their commercial interests.[53] Public monuments that revived the revolutionary spirit and republican symbolism surrounding similar interventions in the eighteenth century could help shield the expansionists in both countries from their critics who were much less comfortable with the implications of overseas imperialism. Many imperialist Americans at the end of the century, for example, often invoked the name of Lafayette and French support during the American Revolution to justify recent American actions in Cuba and the Philippines during the Spanish-American War (1898).[54]

Neither the public monument as a viable instrument of statecraft nor the legitimacy of the historical portrait as a cultural icon survived fully intact much beyond the First World War. Late-nineteenth-century deterministic theories and mass political and economic movements undercut the belief that individual thought and action fueled the engines of history, and a new ironic view of history questioned the integrity and selflessness of once inviolate political and military figures from the recent past.[55] Such developments help to explain why many of these French-American monuments and statues, including David's *Bust of Washington* and *Bust of Lafayette,* have attracted so little public or scholarly attention since the early twentieth century. Nevertheless, these works do endure, not only as symbols of French-American friendship but also, like all good cultural history, as living memories of past experiences that, in our search for contemporary public meaning, allow us to expand our spheres of reference beyond the tyranny of the present moment.

[53]For two recent studies that address the interrelationships among American global commercial expansion, overseas military interventions, and participation in the 1900 Universal Exposition, see Linda J. Docherty, "Why Not a National Art? Affirmative Responses in the 1890s," and Robert W. Rydell, "Gateway to the 'American Century': The American Representation at the Paris Universal Exposition of 1900," in *Paris 1900,* pp. 95–117, 119–44.
[54]See, for example, Rydell, "Gateway to the 'American Century,'" pp. 126, 213 n. 21–25.
[55]For an interesting discussion of Lafayette's historical reputation in light of modern ironic historiography, see Kramer, *Lafayette in Two Worlds,* pp. 2–8, 282 n. 4–7.

Private Homes, Public Lives

*Francophilia among Government Officers
and the Washington Elite*

Liana Paredes

AFTER THE CIVIL WAR, WASHINGTON, D.C., EXPERIENCED AN ECONOMIC expansion that triggered a period of feverish building and configured the small urban center as a residential city par excellence. A concerted effort on the part of the territorial and federal governments made the city primarily the seat of government, a meeting place for captains of industry and politicians, and a center for sightseeing. Inherently, this decision kept Washington outside the fields of commerce and industry.

This economic expansion led to a public improvement program of the urban landscape. In 1871, Congress approved an urban development program—explained at length in Cynthia Field's chapter—to repave streets, build new sidewalks, implement a system of street lighting, and plant more than six thousand trees. The plan was carried out almost overnight (bankrupting the city and bringing an end to territorial government in the district), but Washington was clearly on its way to becoming a grand capital city.

By the 1880s, Washington had become a desirable place of seasonal residence for the wealthy and the powerful. The residential character of the city was quite apparent to visitors in those years. As the Reverend S. Reynolds Hole observed, "Washington, although it is full of commotion and energy, is a city of rest and peace."[1] Another Englishman spoke of its "air of comfort, of leisure, of space to spare, of stateliness you

[1] S. Reynolds Hole, *A Little Tour in America* (London, 1895), pp. 309–10.

77

FIG. 1. Staircase, Perry Belmont House, 1618 New Hampshire Avenue, currently the International Temple of the Order of the Eastern Star. *(Courtesy Order of the Eastern Star.)*

hardly expected in America. It looks a sort of place where nobody has to work for his living, or, at any rate, not hard."[2]

Joseph West Moore in *Picturesque Washington* described the city in the following terms: "It is on this spacious plain, but a few years ago an almost valueless area of swamps, that those palatial mansions, the pride and boast of the capital, are erected. Here are the residences of the wealthiest citizens, and those of the millionaires from sections of the U.S. who make Washington their winter home. . . . Here are the foreign legation buildings, and here the leaders of society. . . . On every side is a dazzling spectacle of luxury and grandeur, . . . a realization of the enormous wealth that is centering in Washington at the present time."[3]

The residential growth of Washington as a fashionable watering hole attracted public officials to build houses in the city. Industrial tycoons from around the country, armed with the power of money, also flocked to the city with the aspiration of acquiring national political power and social prestige. Building great structures enhanced the presence and social status of this moneyed class.

Prior to the Civil War, most public officials and people who came to hold governmental offices had rented homes or lived in hotels and boardinghouses, since their stay was merely seasonal. After the Civil War, some men holding important public office, who could afford to, made a point of owning their houses, and scores of other temporary residents hastened to build or buy. The number of public officials building homes in Washington, however, was still few at the turn of the century. In the words of Julia B. Foraker, whose husband was a senator from Ohio, "Of the 90 senators in Congress then, only about seven or eight had large houses and entertained on an important scale. (A number of senators were there without their wives)."[4]

Washington became a place to see and to be seen. Joining ranks with the new wealthy residents were "those senators and representatives who have built, bought or leased within the precincts of the moneyed zone habitations far more costly than would be justified by their federal salaries."[5]

Even with their political prestige, only a small number of government officials could join in these high ranks of society. Henry James ranked nine-tenths of senators, including their wives and daughters, at the fringe of the social structure.[6] Those who could afford lavish entertainment saw it as their fiduciary duty to do so. For example, Mrs. Florence Lowden, wife of Congressman Frank Lowden from Illinois and

[2] G. W. Steevens, *Land of the Dollar* (Edinburgh, 1897), p. 92.
[3] Joseph West Moore, *Picturesque Washington* (Providence, R.I., 1884), p. 240.
[4] Julia B. Foraker, *I Would Live It Again* (New York, 1922), p. 191.
[5] Waldon Fawcett, "Washington, an American Versailles," *World Today,* Apr. 1910, p. 369.
[6] Henry James, *The American Scene* (1907; reprint ed., New York, 1994), pp. 245–68.

daughter of railroad tycoon George Pullman, hosted tea and dinner parties and theatrical evenings costing far more than her husband's annual salary of five thousand dollars could afford.[7]

Just as European monarchs had held Versailles as a model since the eighteenth century, so the wealthy Americans of the late nineteenth century generally turned to France for inspiration. Of all government officials, diplomats built the most French-looking houses. They were cognoscenti of French architecture, and the group with a better understanding of French styles.

The main core of significant domestic buildings with French connections was built for government officials around the first quarter of the twentieth century. Unlike in Europe, in the United States there was no stock of grand aristocratic homes to refurbish and redecorate. In Washington, people had to build their palaces from scratch. The last examples of residences built in the grand traditional manner date from the 1950s. The last significant French-style decoration of the period covered in this chapter is the work of Maison Jansen for the Kennedy White House.[8]

A conservative approach to decoration dominated in this circle. Their houses offered many reinterpretations of past historical styles. Few government officers adopted a modern style for decorating. Modern twentieth-century design, be it art nouveau, art deco classicism, or machine-age, had virtually no impact in the spheres of government and power in Washington, D.C.

Although prominent in Washington official circles, this historicist trend also prevailed in most American cities, where the idea of modern interiors still had not sunk in by 1915. The arts-and-crafts style, instead of being superseded by modern styles, was followed by a period of renewed interest in revival styles: Louis XV, Louis XVI, Tudor, Italian or Spanish baroque, and American colonial, to name a few.

The same can be said of many Europeans who built at the end of the nineteenth century. When a renowned Moscow architect asked merchant prince Arseny Moronzov in what style he wanted to build his new mansion, he replied: "In all styles. I can afford them all." A *Punch* cartoon of 1891 shows an elegant businessman telling his architect that he wants something "nice, baronial, Queen Anne and Elizabethan, and all that; kind of quaint Nuremburgy, you know—regular old English with French windows opening to the lawn and Venetian blinds, and sort of Swiss balconies and a loggia."[9]

The Washington residences built for government officials and others who orbited in their circles were constructed with special attention to grand entertainments. Many

[7]See William T. Hutchinson, *Lowden of Illinois: The Life of Frank O. Lowden* (Chicago, 1957), pp. 146–47, 192–94.

[8]Because it so well documented and more official than domestic in its scope, the Kennedy White House decoration is not included in this essay.

[9]See Alexis Gregory, *Families of Fortune: Life in the Gilded Age* (New York, 1993), p. 104.

FIG. 2. Second-floor gallery, Anderson House, 2118 Massachusetts Avenue, currently the Society of the Cincinnati. Historic American Buildings Survey, Society of the Cincinnati photograph. *(Courtesy Library of Congress.)*

believed that the families of public officials who could afford it should contribute to social life while Congress was in session.

Most house plans had a distinct public area that comprised a vestibule, entry hall, library, dining room, a conservatory and breakfast room, and one or two salons. The larger and more ambitious dwellings might also boast a music room, a ballroom, and even a gallery to display works of art (fig. 2).

The furnishings were for the most part not antique. The practice of using antique furniture was not de rigueur in the 1890s, and many of these houses were furnished with reproductions of Renaissance, baroque, and eighteenth-century furniture made by contemporary cabinetmakers on both sides of the Atlantic.

Even those spaces that followed more closely the precepts of period architecture were, however, unequivocally modern in the arrangement of furniture and furnishings. An obeisance to a furniture plan dictated by the architecture of a room was not paramount in the nineteenth or twentieth centuries. The scattering of furnishings about

the floor is a late-nineteenth-century idea that lingered throughout the twentieth century. In previous centuries, the furnishings in formal rooms would have been placed around the perimeter of the room. Additional furniture would have been brought into a room as needed. The interpretation of sixteenth- and seventeenth-century spaces went further, since these rooms originally would have been even more sparsely furnished.

Where the role of the architect ended and that of the decorator began is not clear in most of these interiors. The surviving records for the most part do not shed much light on this issue. The names of few decorators, unfortunately, can be associated with this group of houses.

The Forerunners of the Official French Style: The Pre–Civil War White House

During the decades before the Civil War, the practice of interior decoration in America, which for the most part was in the hands of cabinetmakers and upholsterers, was transformed from a craftsman trade into a vast manufacturing business.

In this period, sculptors, architects, upholsterers, or even cabinetmakers designed homes. The profession of decorator was mostly in the hands of craftsmen, many of whom owned shops. In France, these were called *ensembliers*. But no matter how refined their sensibilities were, they were not professional decorators.

The work of these *ensembliers* is eloquently illustrated in the design work that the firm of Pottier and Stymus did for the Grant White House in the late 1860s.[10] The cabinet room and the president's office were two of the rooms entrusted to the firm. Pottier and Stymus was considered one of the most prominent American cabinetmaking and decorating establishments of its day. Auguste Pottier was born in Coulommiers, France. In 1850, he arrived in New York, where he worked as a journeyman sculptor. In the late 1850s, he founded Pottier and Stymus, which was listed in the New York directory as a firm of upholsterers and cabinetmakers.

Pottier and Stymus was one of the forerunners of the full-service interior decorating firms that characterized the business in the early twentieth century. Their Lexington Avenue factory was divided into ateliers, or workshops, for bronze casting, mosaics, painting on wood, painting on porcelain, and the manufacturing of mantel ornaments and gas fixtures.

The work they carried out for the Grant White House was in the neo-Renaissance style. The suite of French walnut furniture for the cabinet room still survives (fig. 3).

[10]The project is thoroughly examined in Betty Monkman, *The White House: Its Historic Furnishings and First Families* (New York, 2000), pp. 143–49.

Fɪɢ. 3. Table for President Grant's Cabinet room, Pottier and Stymus Manufacturing Company, New York, 1869. *(Courtesy White House Historical Association.)*

This massive style, which appeared in the Crystal Palace Exhibition in London in 1851, became popular in France during the reign of Emperor Napoleon III and Empress Eugénie. In America, it was reinterpreted by several firms, most notably Herter Brothers, L. Marcotte, and Pottier and Stymus, all founded by Europeans.

The 1870s

In the eyes of new city dwellers, Washington in the 1870s was still a backwater. In the opening year of the decade, Sen. William S. Stewart, of Nevada, opposed Washington's proposal to be the site of the World's Fair in 1871: "None of us are proud of this place," he said. "The town is nicely located and with plenty of money and a little enterprise it might be made a city, but let us have a city before we invite anybody to see it."[11]

During those years, the land north and west of Sixteenth and M streets was an uninhabited swamp. However, as it turned out, Stewart was one of the first contributors to changing the face of the city. In the early 1870s, Stewart and Curtis Hillyer acquired property in the areas bounded by New Hampshire and Connecticut avenues, and Connecticut, Massachusetts, and Florida avenues, respectively, thus becoming the first developers of the Massachusetts Avenue corridor from Dupont Circle northward.

The house that the German-born architect Adolph Cluss built for Stewart in 1885 (the site of the former Riggs Bank) went on record as the "earliest of the grand residences of the city, and which has been the scene of so many elegant entertainments."[12]

[11]Mabel Murphy, *When Washington Was Young* (Chicago, 1931), p. 210.
[12]Ida Hinman, *Washington Sketch Book: A Society Souvenir* (Washington, D.C., 1895), pp. 103–5.

FIG. 4. Drawing room, ca. 1893, Stewart Castle, 1913 Massachusetts Avenue, razed. *(Courtesy Huntington Library.)*

The house was badly damaged by fire only four years later. Although the exterior resembles a Rhenish castle, the German style was not carried into the interiors. An 1893 photograph of the drawing room shows a rather cohesive neorococo interior following the Second Empire revival of this eighteenth-century style (fig. 4). At the time, this would have been considered a modern, fashionable room. Many of the furnishings, with their deep cushioning, are typical of furniture of the Second Empire style, when Empress Eugénie introduced wholly upholstered pieces of furniture. This was an era in which the fabrication of matched sets or a suite for the parlor, dining room, or bedroom grew into a vast manufacturing business. At one end of the spectrum were hastily put together mass-made sets. At the other extreme were custom-ordered sets, like the ones in the Stewart mansion. A newspaper reported after the fire that many of the furniture and textiles had been made to order in Europe.[13] The house had cost $80,000 to build and nearly that much again to furnish.

[13] *Washington Star,* Dec. 31, 1879.

The 1880s

In the 1880s, Washington was well on its way to becoming a sophisticated city. However, the decision to keep the Washington area free of industry and services directly impacted the availability of ornamental workers and decorative suppliers in the city. There was a patent scarcity of artists, artisans, and architectural suppliers in Washington if one compares it with the other important cities of the Northeast and Mid-Atlantic regions. The pages of the *Architectural Record* of the period reveal that the majority of suppliers of architectural elements were based in New York, Philadelphia, and Boston. According to the census of 1880, only some 251 individuals worked in the building and construction trades, and the value of their product amounted to barely two million dollars. Twenty years later, the census of 1900 recorded 744 workers in the same category. The value of this industry had multiplied nearly sevenfold, to almost fourteen million a year.[14] Yet it still did not compare to the volume of activity and revenue of the other major cities in the Northeast.

Among the most outstanding homes built in the 1880s are the Hay-Adams houses (razed in 1927 and now the site of the Hay-Adams Hotel). Longtime friends John Hay and Henry Adams were leaders of Washington's intellectual and power circles during the 1880s. Hay served as one of two private secretaries to President Lincoln in 1861, and later as ambassador to Great Britain under Presidents McKinley and Roosevelt. Adams was the grandson of President John Quincy Adams. When his father, Charles Francis, was appointed minister to Great Britain, Henry served as his secretary. During his years in Washington, Adams wrote *Mont Saint Michel and Chartres,* an account of France during the medieval period.

Henry Hobson Richardson, a friend from Harvard and an architect trained at the Ecole des Beaux-Arts, built for them a pair of townhouses with a combined facade. The houses were designed in the red-brick massive Romanesque style with Byzantine decoration, one of the European vernacular sources that prevailed in that decade but that had no contemporary revival in France.

For the Hay House, Richardson called upon the New York– and London-based decorator Daniel Cottier. A native of Glasgow and proponent of aestheticism, Cottier effectively created interiors in the arts-and-crafts style. Of the modern styles, the arts-and-crafts reform movement was embraced more openly by Washingtonians.

The French connection was introduced to Hay House, the larger and more expensive of the two, by John La Farge (1835–1910). In 1890, Hay commissioned two stained-glass windows from La Farge to install in the dining room (figs. 5 and 6). In

[14]Data drawn from consultation of the Manufacturing and Allied Enterprises in the District of Columbia tables from Constance McLaughlin Green, *Washington,* 2 vols. (Princeton, N.J., 1962–63), 2:27.

works like *Peonies in the Wind,* La Farge rekindled the art of stained glass, an art that the French held as their own. His development of opalescent glass and mastery of the cloisonné technique made him an indisputable artist in the field. The floral motifs on these windows are of Japanese inspiration. The treatment of the glass, however, is rather impressionistic. The glass itself had a painting-like quality and created the illusion of movement in the peonies enhanced by outline and brushstroke. This treatment of nature, the organic elements, and the Japanese aesthetics have a direct link to the French art nouveau movement. La Farge was a friend of Samuel Bing, who owned the art nouveau shop in Paris and was a principal promoter of the style. Son of wealthy French émigrés in New York, La Farge traveled extensively through Europe. In the 1850s, he studied with the academic painter Thomas Couture in Paris. He also befriended the pre-Raphaelites as well as the symbolist Puvis de Chavannes. The French government bestowed upon him the Legion of Honor. "He is the great innovator. . . . He has created in all its details an art unknown before, and entirely new industry, and in a country without tradition he will begin one followed by thousands of pupils."[15] La Farge must have felt proud about these words and comforted by the unspoken recognition of a tie of blood; he liked to feel that officially, in a sense, he was now a Frenchman.[16] As a result of the increasing demand for his work, La Farge opened a major glass workshop at Union Square in New York City, supplying stained glass for the fashionable decorative firm Herter Brothers, among others.

The 1890s

In her memoirs, Julia B. Foraker recalled life in fin-de-siècle Washington: "The opening 'nineties' saw the *old regime,* Anglo-Saxon, conservative, making its last stand at the White House. The Harrisons [President Benjamin Harrison and his wife Caroline] gathered around them a fine best-families group: women who could give all their time to social perfections undistracted by suffrage, divorce, interior decoration or other extraneities."[17] Despite this blatant lack of interest in aesthetics, there were a few magnificent structures built in this decade.

The 1890s were marked by a return to neoclassical architecture. The Chicago Columbian Exposition of 1893, with its dazzling white classical buildings, was largely responsible for the change in the architectural scene for the next forty years. Dark brick houses, picturesque in detail and outline, gave way to light stone and marble

[15]Royal Cortissoz, *John La Farge: A Memoir and a Study* (Boston, 1911), p. 184.
[16]Ibid., p. 185.
[17]Foraker, *I Would Live It Again,* p. 185.

FIG. 5. Dining room, John Hay House, corner of Sixteenth and H streets, razed. *(Courtesy National Museum of American Art, Smithsonian Institution.)*

FIG. 6. John La Farge, *Peonies in the Wind,* stained glass and lead. Gift of Sen. Stuart Symington and Rep. James W. Symington. *(Courtesy National Museum of American Art, Smithsonian Institution.)*

structures, formal in shape and plan. In decorative terms, the 1890s produced the first orchestrated reactions against the confusion and clutter that prevailed in most residential interiors of the period. In their 1897 book *The Decoration of Houses,* American writer Edith Wharton and architect Ogden Codman set out to reclaim the importance of architectural proportions, harmony of style, and classical European furnishings for the new interiors.

Yet most of the notable Washington houses of that period harked back to historicist patterns of interior decoration, presenting an eclectic mix of styles: Gothic, Renaissance, baroque, rococo, and neoclassical rooms often coexisted under the same roof. In direct opposition to the harmony and unity exhibited by exteriors of the period, the interior design of spaces were as stylistically unrelated to the exterior as they were with one another.

The most sublime example of this eclecticism is perhaps the McLean House (1500 I Street), one of the major private residences built at the turn of the century. Although John Roll McLean was not a member of government, his home became a center of power where the very rich and influential owners entertained on a grand scale. The Florentine Renaissance–inspired house had been remodeled by John Russell Pope in 1890 for this shrewd Ohio businessman who moved to Washington to acquire interests at the Riggs Bank, the Washington Gas Light Company, the Old Dominion Railway (naming one of the stops, McLean, Virginia, after himself), and the *Washington Post.*

The house could be described in a word: grand (fig. 7). The entire thirty-foot-high first floor was designed for entertaining: it contained three massive reception rooms with balconied galleries. The interiors—of unequivocally European flair—were laden with fountains, tapestries, massive fireplaces, and French gilt furniture. With the exception of the highly ornate baroque salon, the relatively subdued interior design of the house was overwhelmed by Elsie de Wolfe's decorative efforts.[18]

The reference to the Rothschild family mansions, with their large and imposing two-story halls, is inescapable: the grouping of principal rooms around a central entry hall is featured in many of the Rothschild homes of the last quarter of the nineteenth century. It endowed the family with homes of certain theatricality and plenty of grand spaces to receive a monumental style of decoration as well as large-scale works of art.

The last grand structure begun in the nineteenth century was Carrère and Hastings's Townsend House. In 1899, Richard Townsend and his wife commissioned the firm to rebuild the Hillyer mansion "in the style of the Petit Trianon." The classical appearance of the exterior was not transferred inside. Rather than adhering to the neoclassical style for the interiors, a compendium of French styles prevailed inside the mansion:

[18]Steven Bedford, *John Russell Pope: Architect of Empire* (New York, 1998), p. 53.

FIG. 7. Gallery, McLean House, 1500 I Street, razed. Photograph by Frances Benjamin Johnston. *(Courtesy Library of Congress.)*

Louis XVI in the entry hall, Louis XV in the ballroom and grand salon, Louis XIV in the foyer hall, Henri II in the library. Townsend did not enjoy his new home, for he tragically died in 1902 before the house was finished. His wife entertained lavishly in the house, which then passed to their only daughter, who married Sumner B. Welles, later the undersecretary of state for Franklin D. Roosevelt. The Cosmos Club bought the mansion in 1950.

At this time, the profession of decorator was in its infancy. Decorative matters were often entrusted to sculptors, upholsterers, cabinetmakers, or architects. Thomas Hastings was an extremely able designer and surely had a hand in the interiors of the houses he designed. It was a well-known practice of architects like Hastings and Stanford White to act as antiquarians and buy hundreds of objects, architectural and decorative, in Europe to fit out the interiors of the mansions that they designed. The flatness of the wall treatments in the Townsend House is characteristic of Hastings's work, with elements more flush to the wall than were their historical prototypes.

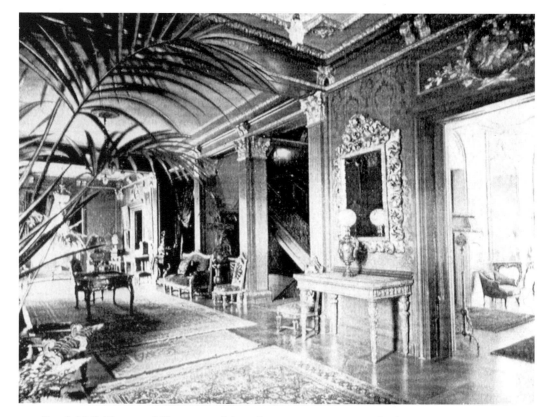

FIG. 8. Hall, Townsend House, 2121 Massachusetts Avenue, currently the Cosmos Club. Photograph reproduced from *Architectural Record* 10 (1901).

Only the best materials were used for the interiors. White Caen stone lined the walls of the main hall (fig. 8). Designed in a subdued neoclassical style, the walls are rhythmically divided with pilasters and columns of *brèche violette* marble alternating with green Campan. Solid Caen stone was used for the main staircase. Italian velvets and silks from Lyon were used for upholstery and to cover the walls.

The ballroom is a riotous amalgam of decorative elements in the rocaille style. As Wharton and Codman explained, ballrooms should be relatively free of furniture, with walls and ceilings providing the decorative elements.

The sitting room is the more rococo of the spaces (fig. 9). Exuberant plaster decoration flows freely from the cornice to the ceiling. This interior has only a superficial eighteenth-century character, and Victorian overtones are still apparent in such details as the oversized and overabundant decoration. Carrère and Hastings seldom used period architectural fragments, a practice that had only started gaining ground in America at this time.

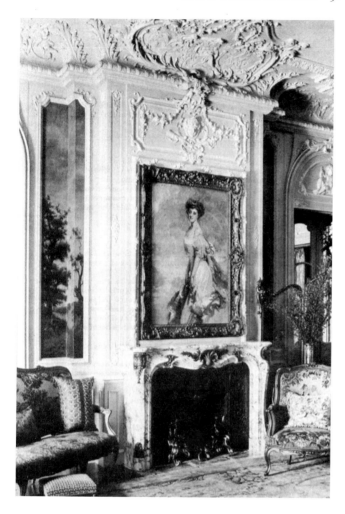

FIG. 9. First-floor reception room, Townsend House, 2121 Massachusetts Avenue, currently the Cosmos Club. Photograph by Frances Benjamin Johnston. *(Courtesy Library of Congress.)*

The 1900s

In the 1900s, Washington was on its way to establishing a reputation as a worldly city. The turn of the century opened up a golden era of building in the city. The proposals of the Park Commission to beautify the national capital (the so-called McMillan Plan of 1902) intensified the desire of private citizens to built large new homes in a city with a promising urban plan of beautification.

The *Washington Post* praised the building up of "New Washington," an attractive place of residence for those people "who wish to shine socially or to enter a political, scientific or even an official atmosphere."[19]

[19]W. T. Bingham "Unique Capital Homes," *Washington Post,* Feb. 7, 1907, p. E7.

French influences became more emphatic in this period. Waldon Fawcett in his article "Washington: An American Versailles"[20] vividly linked the architecture of Washington to that of royal Versailles in eighteenth-century France. Fawcett explained that what changed Washington at the turn of the century was not the growth of the political class and the number of officials in government service but more so the "influx of an entirely new class of population, the wealthy leisure class from all parts of the country, which has discovered in Washington the ideal residential Mecca of the continent."[21] This new group was attracted to Washington by the restful, noncommercial character of the city, where the private residence was still the predominant unit, and by the increasing importance of Washington as the site of official life.

Wealthy government officials and the moneyed classes that gravitated around circles of power raised not only classicizing structures but also great houses of eclectic design —symbols of the lavish tastes and the extreme wealth of the Belle Epoque.

A colorful example is the mansion built by Thomas F. Walsh (1851–1910) at 2020 Massachusetts Avenue (now the chancery of the Republic of Indonesia). This grand private residence, designed by Danish-born architect Henry Andersen, of New York City, has a conspicuous curving facade and roof that translate into the interiors by means of undulating walls and ceilings. The curving architectural features are vaguely reminiscent of art nouveau motifs. Most notable is the three-story staircase with its stained-glass skylight. The galleried staircase was apparently inspired by a stair aboard a German steamship on which the Walshes had traveled. A room built around a monumental organ was used for parties and dances. Wealthy Americans had developed a peculiar partiality for organ music at the turn of the century. In Sarasota, Florida, the Ringlings had ordered for their fabulous Ca' d'Zan residence a $50,000 organ from Aeolian-Skinner Organ Company of New York. A few years later John Deering ordered an organ for Vizcaya, his palatial estate in the Bay of Biscay, so that music would come through the court into the dining room upstairs.

The Irish-born Walsh was the sole owner of the Camp Bird Mine (Ouray, Colorado), one of the richest gold mines in the world. In 1899, he was appointed by President McKinley as one of the U.S. commissioners to the 1900 Paris Exposition. While in Paris, the Walshes entertained and traveled in lavish style, once chartering a train of five palace cars, fitted with silk and decorations, for a tour of France and Belgium. Like many other rich industrialists, the Walshes decided to move from Colorado to Washington at the turn of the century. During Theodore Roosevelt's administration, the Walsh residence was the scene of some of the most lavish entertainment in Washington.

According to their daughter Evalyn Walsh McLean (1887–1947), the Massachusetts Avenue house cost $835,000 to build. "My father had hired Mrs. Anna Jenness Miller to

[20]The article appeared in *World Today,* Apr. 1910, pp. 363–73.
[21]Ibid., p. 365.

scout around and help my mother buy what was needed for the house; it was a job that lasted several years. . . . [My mother] even went abroad to get some choicer paintings and the bric-a-brac we needed. Rugs from Persia, pictures and aquarelles from dealers in the Boulevard Poissonière in Paris, from the Avenue Louise in Brussels; sometimes her shipments came from Montreux, Switzerland. How the money went!"[22] There is no evidence that Miller ever acted as an interior decorator. Her position must have had more to do with consulting about art and style than strictly with interior decorating.[23]

The first decade of the twentieth century was critical in the formulation of classical principles of decoration. The first group of professional decorators in America was also formed at that time. The decorative theories of the Wharton-Codman team and their style in decorating went hand in hand with the work of architects such as Stanford White and Carrère and Hasting, the greatest exponents of a new classicism in architecture. These architectural firms also designed interiors. All of them were proponents of clearly structured, lighter, and delicate classical interiors.

Interior design was not in the curriculum of any American school at the end of the nineteenth century. Not until 1904 did the New York School of Fine and Applied Arts, which had been established as a school for painting in 1896, begin to offer courses in interior decoration. Those courses began under the initiative of Frank Alvah Parsons, for whom the school was renamed.

However, one of the most formidable personalities in the field of interior decoration at the turn of the century did not have formal training. Elsie de Wolfe was the first American female professional interior decorator. She was different from the leaders of the designing firms previously examined in that she was not a craftsperson: she was an interior designer. In the early 1910s, she excited the country with her blithe and fresh style of decoration. De Wolfe advocated abandoning the dark and cluttered late Victorian manner of decorating and proposed a much more airy and light approach to interiors. De Wolfe was a master in lightening up spaces, and her skill in quoting French styles, particularly the Louis XVI style, is legendary. She had been a Francophile from her early years and eventually bought Villa Trianon, a house on the fringes of the park of Versailles, where she began spending summers but later lived year round. As an expatriate she kept strong links with America and patronized the Paris branch of the Parsons school.

The second project that Elsie de Wolfe is known to have carried out in Washington was for Edward B. McLean and his wife, Evalyn Walsh. He was the only son of John R. McLean; she was the only child of Sen. Thomas F. Walsh, of Colorado. Evalyn was a

[22]Evalyn Walsh McLean with Boyden Sparkes, *Father Struck It Rich* (Boston, 1936), p. 92.

[23]Anna Jenness Miller is known principally for her role as an advocate of correct principles of physical development and dress for women. About 1885, she became editor and proprietor of the *Jenness Miller Monthly,* in which she advocated her views.

well-known socialite in Washington, D.C. She was also noted as the last private owner of the 44½-carat Hope Diamond, which she acquired through Pierre Cartier in 1911. The couple were close friends of President and Mrs. Warren G. Harding. The McLean house on I Street was the site for many of their parties.

In her memoirs, Evalyn recalled a little house behind the McLean house on I Street where the elder McLean had his office. The place came to be known during the Harding administration as the "love nest." According to Evalyn, "Elsie de Wolfe had supervised the decorations; it was one of the first things she ever did. In the front was the dining room with stone serving tables and a small fountain Upstairs were two bedrooms. The rear one in lovely chintz; the front one . . . covered with pale pink taffeta, a gilt bed sheltered with pink draperies and curtains."[24]

Seven years after she finished the decorative project, de Wolfe, unsuccessful in collecting an overdue bill from Evalyn Walsh McLean, took the case to court. The suit was tried in Washington before a jury. During cross-examination, asked with some scorn by McLean's lawyer what she *did* do, de Wolfe eloquently replied that "I create beauty." The spectators cheered, and de Wolfe pressed on to note that the bed for which she had charged McLean the scandalous sum of $7,000 was not even the finest bed to be had, since Mrs. Adelaide Frick had already happily paid $10,000 for another that de Wolfe considered even better. By Monday morning, the decorator had won her case.[25]

Anderson House

Anderson House was one of the costliest homes in the city when it was built between 1902 and 1905. Its owner, Larz Anderson, was the great-grandson of the founder of the Society of the Cincinnati. In 1891, he was appointed second secretary to the U.S. embassy in London under President Benjamin Harrison, and in 1893 President Grover Cleveland appointed him first secretary of the embassy in Rome, where he met his future wife, Isabel Weld Perkins. Upon the couple's return to Washington, they commissioned the Boston firm Little and Brown to design their house. The house became a center of lavish entertaining in the early decades of the twentieth century. Anderson wrote, "We remained, I believe, the only house in Washington, except the embassies, that turned out servants in full-dress livery, shorts and stockings, buckled shoes and braided coats. The dinners were swan songs to the old order."[26]

The layout of the house is one of the most truly European in the city, with an arrangement of wings surrounding a carriage court and with an entrance off the street. The

[24]Walsh, *Father Struck It Rich,* pp. 187–88.

[25]J. Smith, *A Life in the High Style* (New York, 1982), p. 216.

[26]James L. S. Jennings, Sue A. Kohler, and Jeffrey R. Carson, *Massachusetts Avenue Architecture,* 2 vols. (Washington, D.C., 1973–75), 1:160.

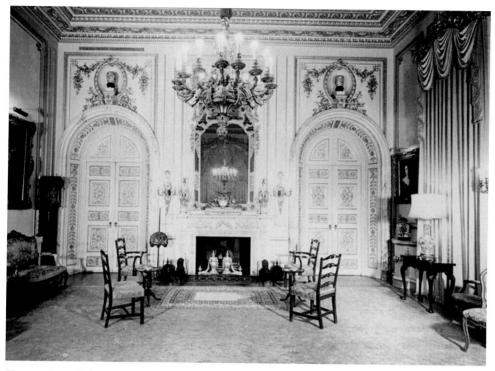

F<small>IG</small>. 10. Second drawing room, Anderson House, 2118 Massachusetts Avenue, currently the Society of the Cincinnati. Historic American Buildings Survey, Society of the Cincinnati photograph. *(Courtesy Library of Congress.)*

two-story great hall is an impressive space. The stair rail follows French eighteenth-century designs. The vista created by the long enfilade of rooms is truly baroque and palatial in spirit.

A second-floor gallery extending seventy-nine feet along the front of the house is one of the few in the city. It follows in the tradition of long French and English galleries that served no other purpose than showcasing collections or the portraits of noble lineage of a family. Here hung part of the famous Diana tapestries made in Brussels in the sixteenth century, which came to enrich the famed Barberini collection through the generosity of Louis XIII. The remaining tapestries hung in the dining room. The second-floor salon was lined with French-style boiseries in cream and gold and furnished with Aubusson tapestry-covered chairs (fig. 10).

The list of firms employed in the construction and furnishings of the Andersons' residence is long and impressive.[27] Among the notable firms that contributed to the

[27]See a compiled list of "Firms Employed on Residence and on Stable of Capt. Larz Anderson, Washington, D.C.," in the archives of Anderson House at the Society of the Cincinnati.

interiors is F. Caldwell and Company, of New York City, which must have been in charge of lighting fixtures and other decorative metalwork in the French style. Because of the high cost of custom-made fixtures at the turn of the century, lighting was almost always a separate contract.

The Andersons' comprehensive list of out-of-town suppliers is another indication of the scarcity of highly skilled artisans and decorative workers in the Washington area. The majority of suppliers were concentrated in New York, Philadelphia, and Boston, with Washington lagging far behind. A notable exception was the plaster ornamentation that was carried out by the Washington firm of B. F. Larcombe.

The house showcased the most advanced technologies for residential comfort, such as elevators, intercom systems, central vacuum systems, and washers and dryers.

Gaff House

At 1520 20th Street, another great home was erected in 1906 by the New York City–based firm of Bruce Price and de Sibour in the seventeenth-century French château manner (now the house of the ambassador of Columbia). In 1905, Thomas T. Gaff, a businessman from Indiana, was appointed by Secretary of War William Howard Taft as a commissioner for the construction of the Panama Canal.

The house combines eclectic interiors of seventeenth- and eighteenth-century inspiration. Rich wainscoting and paneling line the spacious hall and dining room. Only two rooms are reminiscent of French interiors. The reception hall, which doubled as a reception hall and as a living room, has a richly carved stair rail with bold baroque scrollwork and walls of deep, rich oak paneling in a Louis XIII style. In contrast, the drawing room is of eighteenth-century inspiration. The wood paneling has been simplified to basic geometric lines, and the room is thus lighter than the foyer.

A transitional room that could function as an antechamber to the ballroom or as a sitting room—although it does not literally quote any past interior—is nevertheless reminiscent of all those intermediate, half-secret, multipurpose spaces so dear to French eighteenth-century elites, where false hidden doors were at the center of court intrigues and illicit love affairs. The secret doors lead into a disconcertingly big Edwardian two-story ballroom with a multivaulted ceiling marked at each partition by ribs of elaborate ornamental plasterwork (fig. 11). In the center, a dome with an open stained-glass cupola illuminates the space.

In 1924 and 1925, the house was occupied by Sen. Peter Goelet Gerry, of Rhode Island. In 1910, Gerry had married Mathilda Scott Townsend, daughter of Richard and Mary Townsend, owners of the palatial structure at 2121 Massachusetts Avenue.

Fig. 11. Ballroom, Gaff House, 1520 Twentieth Street, currently Colombian ambassador's residence. From J. L. Sibley Jennings, *Massachusetts Avenue Architecture* (1975), vol. 2. *(Courtesy U.S. Commission of Fine Arts.)*

Huff, Depew, and Ffoulke Houses

Rep. George F. Huff, of Pennsylvania, hired Horace Trumbauer to build a large and spacious home on the northwest corner of Q Street and New Hampshire Avenue. The interiors were elegantly appointed in the Louis XVI neoclassical style with reception rooms, including an oval salon in an understated neoclassical style and a dining room.

At 2107 Massachusetts Avenue stood a very French-looking townhouse, the home of Sen. Chauncey Depew from New York. The interiors by the firm Schuyler and Lounsbery were impressively French eighteenth century in inspiration. The drawing room, with eighteenth-century paneling, was furnished with fine period French furnishings, including a Louis XVI suite covered in Aubusson tapestries and a Regency table laden with small decorative objects.

Not much is known about the house Charles Mather Ffoulke built at 2013 Massachusetts Avenue. He is nevertheless relevant to this study, for he was the man who financed one of the most important decorative enterprises of the twentieth century in America. Ffoulke, a wealthy wool merchant, had amassed one of the most important collections of tapestries in the country, which he proudly displayed in his Washington

home. The *New York Times* declared it "one of the finest collections in the world," and it included more than 135 exceptional examples of fine Flemish, French, and Italian tapestries.[28] Ffoulke, who had consigned some of the tapestries with Sypher and Company in New York, had grown impatient at the slow rate of their sales. In 1906, he made an offer to Mitchell Samuels, their most avid purchasing agent: to buy the company for Mitchell if he would sell Ffoulke's tapestries. Samuels accepted the offer, took Percy W. French as a partner, and changed the name of the firm to French and Company.[29] Samuels's firm became art provider and decorator to most of America's wealthiest families, including the Astors, Huntingtons, Gettys, Mellons, du Ponts, Rices, Rockefellers, Vanderbilts, Whitneys, and Wideners, to name a few. In Washington, their most significant work is still extant at Hillwood, home of Marjorie Merriweather Post.

Grand Houses along Sixteenth Street and Meridian Hill

In the opening decade of the twentieth century, Mrs. Mary Foote Henderson, wife of a former senator from Missouri, started campaigning for the development of Meridian Hill and Sixteenth Street. This then remote area, on hilly terrain with pure air, seemed an ideal location for the determined Henderson to develop into a residential hill, park, and elegant avenue lined with embassies and grand residences. Architect George Oakley Totten received most of Henderson's commissions to erect houses that she then rented or sold to influential people or foreign legations.

This urban and residential development went hand in hand with the acknowledged and growing importance of the United States in world affairs and the subsequent elevation of foreign legations to the rank of embassies. Britain and France did so in 1894, and in 1897 Italy followed suit. Foreign diplomats came to see Washington as a desirable place of assignment, like Paris, London, Rome, or Vienna.

Ambassador Jules Jusserand was one of the diplomats who bought into Henderson's vision and acquired a Totten house as the site for the new French embassy. A bright politician and a brilliant literary man, he was awarded many honors for his writing in the field of literature and history. Jusserand was a member of the Institute of France and one of the forty immortals of the French Academy. Jusserand's role in the bridging of Franco-American relations was extraordinary. In 1916, he received a Pulitzer Prize for his book on American history, *With Americans of Past and Present Days*. The French embassy at 2460 Sixteenth Street was built in 1907 and occupied until 1936. It was the site of many conferences during World War I.

[28]*New York Times,* Dec. 2, 1894.
[29]For a comprehensive story on the history of the firm, see Charles Bremer David, "French & Company and American Collections of Tapestries, 1907–1959," *Studies in the Decorative Arts* (2004):38–63.

FIG. 12. Decorative mantel wall, former French ambassador's residence, 2460 Sixteenth Street. From Sue A. Kohler, *Sixteenth Street Architecture* (1978–88). *(Courtesy U.S. Commission of Fine Arts.)*

Because Mary Henderson had Ambassador Jusserand in mind when she built the house, she specified the building to be in the French style. The Belle Epoque house was endowed with singular, grandiose interiors and profuse ornamentation throughout.

The decorative details are French Second Empire throughout. The mantel wall on the entrance hall is decorated with oversized caryatids, classical motifs reinterpreted in a bold, exaggerated form that characterized most ornamentation of the last quarter of the nineteenth century (fig. 12). The dining room is in Louis XVI style but with details such as the curved doors and curved mirror panels over the sideboard that indirectly allude to the art nouveau style that developed concurrently with the historicism of the Belle Epoque.

At 2600 Sixteenth Street stood another Henderson-Totten collaboration known as the "Pink Palace" (1905). The house's exterior is Venetian in character. This style, however, was not carried into the interiors. Soon after it was finished, the house was leased to Oscar S. Strauss, who served as secretary of commerce and labor under President Theodore Roosevelt in from 1906 to 1909. In 1909, it was occupied by Franklin McVeagh, secretary of the Treasury under President William Howard Taft. Mrs. Delia Field, second wife of retailer Marshall Field, acquired the house in 1914.

The ballroom, with its oversized ornamentation in white on white, was quite characteristic of the Belle Epoque. Its seating arrangement was more appropriate for a parlor than for a salon.

Further south, at 1125 Sixteenth Street stands the house that architect Nathan Wyeth designed for Mrs. Harriet Pullman's daughter Florence and son-in-law, Frank O. Lowden, a congressman from Illinois. Pullman believed that the main avenue for political preferment was a social one, and she set out to build an impressive mansion for the Lowdens in this most fashionable district. It was designed for entertaining in a grand manner befitting their large income, so that "Frank might easily reach the highest office in the land."[30] Pullman spent $360,000 in building the house and furnished it just as expensively (fig. 13).

Early in 1910 Mrs. Pullman was planning the decoration of the house. The daughter of Anna Jenness Miller, in a letter to the Commission of Fine Arts, wrote: "In my mother's diary for 1910, I have just found an entry for February 25, written while my grandmother was ill saying 'This evening Mr. Wyeth and the man from New York who has made plans for the interior of mama's house were here. That man, I think, was from the firm of Alavoine.'"[31]

Alavoine was one of the most important Parisian firms of interior decoration at the turn of the century. The firm took pride in its stylish revival interiors, particularly those of the Louis XV and Louis XVI periods. Encouraged by the success of their installation at the 1893 Chicago Exposition, the firm opened an office in New York City with a facade decorated by Lalique.[32]

This splendid house has an imposing reception area in a Second Empire reinterpretation of the Louis XVI style. In the salon, symmetry reigns and the rhythm of the walls is dictated by the ornamented pilasters, heavily picked in gold. The elaborate chandeliers are original to the house.

In spite of its the expense, the Lowdens never lived in the house.[33] In 1913, it was sold to Mrs. Natalie Harris Hammond, who shortly thereafter resold it to the government of Tsar Nicholas II as the residence for the Russian ambassador.

The *Goût Rothschild* East of Dupont Circle

The end of the first decade of the twentieth century was marked by the building of the Perry Belmont House, one of the grandest houses in the city (1909). The press of the day observed that "it is among the costliest of these 'show places' at the capital."[34] The

[30]*Washington Post,* Feb. 2, 1908, quoted in Hutchinson, *Lowden of Illinois,* 1:191.

[31]Quoted in Sue A. Kohler and Jeffrey R. Carson, *Sixteenth Street Architecture* (Washington, D.C., 1978), p. 165.

[32]A reproduction of Queen Marie Antoinette's bedroom at the Petit Trianon was shown in the French section of the Manufacturers Building.

[33]During their last three years in Washington, the Lowdens leased for their own house the McVeagh residence at 1710 Massachusetts Avenue. Previously, they had stayed at the New Willard Hotel (1906–7) and at a rented house in Columbia Heights (1907–8).

[34]Waldon Fawcett, "Washington: An American Versailles," *World To-Day,* Jan. 1910, p. 363

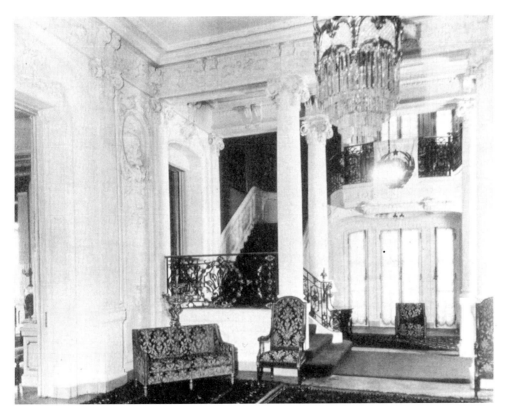

FIG. 13. Reception hall, Pullman House, 1125 Sixteenth Street, currently the Russian Federation ambassador's residence. From Sue A. Kohler, *Sixteenth Street Architecture* (1978–88). *(Courtesy U.S. Commission of Fine Arts.)*

Perry Belmont house best represents the perplexing opulence and decorative rhetoric of the Second Empire style.

Perry Belmont (1850–1947) was born in New York City, the son of international banker August Belmont and Caroline Slidell Perry, daughter of Commodore Matthew C. Perry. A Harvard University graduate with a law degree from Columbia University, Belmont was elected to Congress in 1881. In 1888, he was appointed ambassador to Spain. Two years later in New York he met society beauty Mrs. Jessie Sloane. Belmont and Sloane fell in love, causing quite a public scandal. They married in April 1899, on the very day the former Mrs. Sloane's divorce became final.

In matters of interior decoration, the new Mrs. Belmont would have been more versed than most ladies of her station. Her former husband was the son of the founder of the W. and J. Sloane Company, importers of fine furniture and rugs. To distance themselves from the scandal, Belmont and his new wife abandoned their plans to build a Trumbauer-designed mansion on Fifth Avenue and decided to settle in Washington, D.C.

Belmont's attempt to emulate the best Parisian domestic architecture is corroborated by his choice of Paul-Ernest Eugène Sanson, architect to the Parisian elite of the Belle Epoque. In the summer of 1906, the Belmonts met with Sanson in Paris, where the architect drew the initial plans. Sanson objected to coming to Washington to take charge of the project, but he sent his son to supervise it. It was, nevertheless, Horace Trumbauer who directed the works.

In its interior distribution, the house has a typically French arrangement—thought quite novel in Washington—in that the private quarters of the house, including bedrooms, are located on the first floor; the second floor was given over to the grand state apartments, which included a petit salon, an art gallery doubling as a ballroom, a grand salon, and a Venetian dining room. One accessed the house through a domed circular entrance hall with walls lined with Caen stone, brought from France in ground form and then made into blocks in the United States.

Just as in the Walsh mansion, there are manifest references to the *goût Rothschild* throughout the Belmont house. This term alluded to the grand architecture and interiors of the houses of the Rothschild family from the mid- to late nineteenth century. The Rothschild houses illustrated a skillful alliance of seemingly disparate styles. The alliance of Louis XIV with Renaissance or of Louis XV and XVI with the Second Empire became a hallmark of their taste. These houses must have been familiar to Perry Belmont. His father, August, had been the U.S. financial representative for the Rothschilds. It is safe to assume that through the family's connections to the powerful family of Jewish financiers (especially to Lionel Rothschild in London in 1863 and James R. Rothschild in Paris in 1874), Belmont became familiar with the family style in matters of architecture and interior decoration, which had been already recognized as the *goût Rothschild*.

The music room is one of the best neorococo interiors in Washington (fig. 14). It makes reference to the *salon du prince* and *salon de la princesse* at the Hôtel de Soubise in its oval plan and its arched doors interspersed with paneled areas. The curved and coved ceiling, where the boundaries of walls and ceiling seem to dissolve, is perhaps the best emulation of high rococo in the city.

Decorative painters came from Paris to do the bird panels in the gold room. The style of these paintings is reminiscent of the work of Jean Pillement, one of the main exponents of the high French rococo and chinoiserie style of the mid-eighteenth century.

The love of polychromy and profusion, the use of singularly rich and precious materials so characteristic of Rothschild interiors, is also manifest in Belmont's house. Walls in the dining room are lined with Italian marbles (fig. 15). The coffered ceiling was decorated with rich polychrome painting. All the decorative hardware was custom-made in England and France. Many pieces bear the mark "ST," the hallmark of

Fig. 14. Music room, Perry Belmont House, 1618 New Hampshire Avenue, currently the International Temple of the Order of the Eastern Star. *(Courtesy Order of the Eastern Star.)*

Fig. 15. Dining room, Perry Belmont House, 1618 New Hampshire Avenue, currently the International Temple of the Order of the Eastern Star. Photograph by Charles Baptie. *(Courtesy Charles Baptie Photograph Collection, Special Collections and Archives, George Mason University.)*

lock manufacturer Bricard, who had acquired the stock of lock retailer Sterlin in the 1760s.[35]

It was not only the grandest home of its time but also the most technologically advanced. The Belmont home was the first residence in Washington to be electrified.

The house was admired on both sides of the Atlantic. One of the most significant tributes to the architecture of the house was paid by a Belgian aviator, Henri de Ligne, who came from an aristocratic family for whom Sanson had executed several commissions. De Ligne said that after seeing many examples of Sanson's work in Paris and Belgium, the Belmont house equaled anything that the French architect had ever done.[36]

There is no doubt that Belmont was a Francophile of the first order. His choice of architect and decorative style said so. We also know that he moved comfortably in Parisian circles, that he befriended French artists and those who were inspired by French art, that he was active on the Fine Arts Commission,[37] and that he spoke, read, and wrote French "like the most cultivated Parisian."[38] In 1932, he closed his Washington and Newport homes and moved into a suite of rooms at the Hotel Ritz in Paris. In 1935, Belmont sold the house to the Order of the Eastern Star, which still owns it.

The 1920s

Government officials gained prominence in the social circles of Washington during this decade. A book of etiquette contemplating all manners of protocol in addressing holders of high offices from the White House to the diplomatic corps was published in Washington in 1929. The author, Anne Squire, mentioned in the foreword how "nearly every year American men come to Washington in official positions of great importance. They represent sovereign States. An affront to them is an affront to these States."[39]

[35]The same initials (but differently stamped) can be found in late-nineteenth and early-twentieth-century regency and rococo gilt bronze window and door fittings. For examples of this hardware sold recently at auction, see Christie's, New York, May 24, 2000, lots 301–11 and Christie's, New York, Arts of France Sale, Nov. 2, 2000, lot 127.

[36]Perry Belmont, *An American Democrat: The Recollections of Perry Belmont* (New York, 1940), pp. 578–79.

[37]In the 1890s, Perry Belmont joined the Commission on Fine Arts. He had been a proponent of Washington as the site of the celebrations of the 400th anniversary of the discovery of America (in the end Chicago prevailed). He believed in the planning of beautification around the Washington monument and the need to get artists involved in the process. He had close relations with painters, sculptors, and architects of the period, many of whom he called upon when he was appointed to the art committee for the 1892 Columbus celebrations in New York. Among them were Francophiles and French artists such as Stanford White, John La Farge, and Augustus Saint-Gaudens, to name a few. He was instrumental in the introduction of a bill in 1893 providing that "no duties shall be levied or collected in any works of art, either ancient or modern, or on any objects of classical antiquity imported to the United States."

[38]*Washington Post,* May 19, 1907, p. E10.

[39]Anne Squire, *Social Washington* (Washington, D.C., 1929), p. ix.

In the 1920s, European traditions lost the supremacy they had enjoyed for years, and a number of decorators began to re-create American traditions. The newly rediscovered colonial period houses of America swept the country with a colonial revival fever.

However, many architects and interior designers in America during the 1920s still worked in the eclectic historical idiom of the Beaux-Arts style. Paris continued to be the undisputed center of art. What most inspired Washington, however, was not the modern French design presented at the Paris exhibition of decorative arts in 1925, but its past historical styles.

Indeed, one of the great houses of the 1920s was built in the French eighteenth-century style. Meridian House, home of Irwin Boyle Laughlin, a diplomat who had made a fortune in the Pittsburgh steel industry, was one of the most truly French-style homes built by architect John Russell Pope. It was after his retirement from the diplomatic corps in 1919 that Laughlin approached Pope. Laughlin was a true Francophile and an avid collector of French art. His taste for eighteenth-century art was reflected in the architecture, interiors, and furnishings of his house. Pope's mastery of the Louis XVI style was patent, both inside and outside. In shape and scale the house recalls the small country homes of the French aristocracy, their hunting pavilions in particular rather than their Parisian townhouses.

The approach to the interior is through a sweeping double staircase from the foyer to the public floor of the house (fig. 16). The walls of the foyer—and the rest of the house—are in the architectural style of so many interiors of the Louis XVI period. The elegantly proportioned drawing room has paneling of a contained severity typical of Pope's work. The hardware was specially made in France, as were the light fixtures and many pieces of furniture.

In 1925, Sen. William Andrews Clark, of Montana, donated several French works of art to the Corcoran Gallery, including Falconet's bronze figure *L'Amour Menaçant,* thirty-three Corots, one Theodore Rousseau, and the paneling from his New York "grand salon," all of which enhanced the public presence of French art in the capital city. The donation of the senator's *salon doré* from his New York residence was made at a time when reconstitutions of interiors were making rapid strides in America. Senator Clark's salon is one of the earliest examples of period paneling set in an American home. Clark had purchased the room and its original ceiling sometime between 1902 and 1904 from the Comte Duchâtel without really knowing its origin. It turned out to be the salon of the Comte d'Orsay's (1748–1809) Parisian townhome.[40] Displacements of this kind were second nature to wall paneling. French paneling of the eighteenth century has been movable since conception. The panels, created in workshops of *menuisiers*

[40]For general historical background information, see Dare Myers Hartwell, *The Salon Doré* (Washington, D.C., 1998).

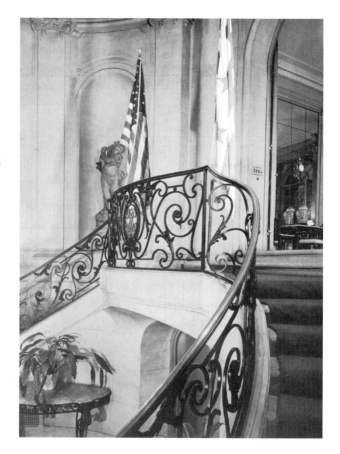

FIG. 16. Staircase, Meridian House, 1630 Crescent Place, former home of Irwin Boyle Laughlin, currently Meridian International Center. Photograph by Charles Baptie. *(Courtesy Charles Baptie Photograph Collection, Special Collections and Archives, George Mason University.)*

en bâtiments, had to be easily transportable to their destination. In some cases, the decorations were moved from one house to another and adjusted to a newer environment shortly after they were made. So, when the practice of dismantling took hold in the twentieth century, the process was done quickly and with minor damage to the paneling. The increased number of displacements in France caused a public outcry. Acts of this nature were typically described on the press as pillage.[41]

While no documentary evidence links Clark with Jules Allard (1831–1907), the quality of the workmanship and the elements added to the *salon doré* paneling does suggest that Allard and his workshop might have been involved.[42] Allard was one of the most prominent dealer-decorators versed in the practice of reinstalling original paneling. Allard designed all the high-style French rooms in the Vanderbilt mansions in New York City, Newport, and along the Hudson River.

[41]For the rise in consciousness in France about the displacement of architectural interiors, see "Urbanization: Demolition and Chance Salvage" and "Safeguarding the National Heritage: Arouses in Public Opinion," in Bruno Pons, *French Period Rooms* (Dijon, 1995), pp. 84–90.

[42]Hartwell, *Salon Doré.*

The 1930s

While the battle raged in international and national circles between traditional architectural interiors and the streamlined machine-made spaces of vanguard modernism, Washington stood aside from the debate and carried on building and decorating residences in the traditional manner. This was not surprising, in view of the city's long commitment to Beaux-Arts architecture and French-inspired interiors.

The construction of great houses waned in Washington after the 1920s as the expenses of maintaining and staffing such lavish homes became a major drain on resources. Yet one of the most genuinely French-inspired homes in Washington was built in the 1930s. The home was commissioned by Horace Dodge's widow, Anna, for her daughter Delphine and her new husband, Raymond T. Baker, a successful Nevada banker who came to Washington during the Wilson administration to become director of the U.S. Mint. It was the last residence that architect Horace Trumbauer built in Washington. The house was inspired by the Hôtel Rothelin-Charolais (built between 1700 and 1704 by Lassurance for Mademoiselle de Charolais, Princesse Louise-Anne de Bourbon Condé). If the hôtel has an early-eighteenth-century appearance, the interiors are more Louis XVI in inspiration.

On his larger domestic projects Trumbauer collaborated with internationally acclaimed decorators. In the early years of the twentieth century, he worked closely with the firm of William Baumgarten and Company, André Carlhian, and the Parisian decorator Jules Allard.[43]

The Dodge interiors were entrusted to one of the greatest Parisian houses of decoration: Alavoine et Cie. The founder of the firm, Lucien Alavoine, began his professional life as a subcontractor to Jules Allard.[44] In the 1930s, the firm was run by one of the masters of progressive historicism, Henri Samuels, a young designer with Jansen who took over Alavoine in the 1930s. Samuels was a master at mixing styles. He delighted in juxtaposing Louis XVI decor with modern details. Edouard Hitau, director of the New York City office, personally oversaw the design and installation of the principal interiors.

The Caen stone vestibule, nearly devoid of ornament save for architectural details, follows the eighteenth-century pattern of sparse furnishing and an absence of textiles, since this was an area where visitors of varying ranks were received before being allowed further entry.

[43]Carlhian had turned his family's exporting company, founded in 1867, into a decorating concern in 1905. Carlhian also got many of his commissions through the art dealer Joseph Duveen.

[44]Alavoine bought Allard's New York and Paris businesses as well as the inventory for both operations on Allard's retirement in 1905.

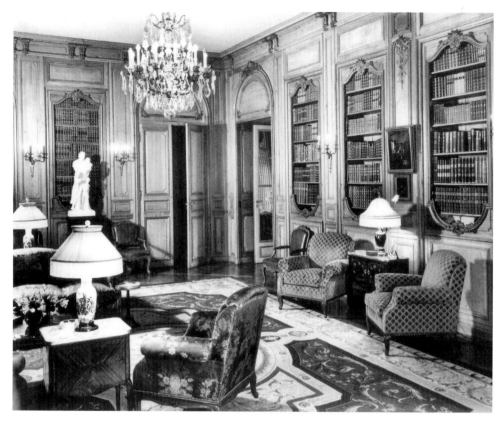

FIG. 17. Library, Delphine Dodge House, 2300 Foxhall Road, currently the Belgian ambassador's residence. *(Courtesy Embassy of Belgium.)*

The interiors, although truly French in inspiration, do not present any original eighteenth-century paneling. The boiseries in gold and gray of the Grand Salons carved with musical trophies alluded to Dauphine's interest in music (she was an accomplished pianist). In the library, the Regency-style paneling was inspired by the paneling at the Château de Bercy that J. P. Morgan had donated to the Metropolitan Museum of Art in New York in 1908 (fig. 17).

The eastern pavilion is covered with green treillage (fig. 18). This technique, used in the eighteenth century, including at Versailles, was reclaimed by twentieth-century decorators such as Alavoine. In America, it was first introduced in modern decoration by Elsie de Wolfe for the Colony Club. The western pavilion has a highly decorative character with faux marble paneling. Oval decorative portraits of exotic birds above panels recall the birds of J. B. Bachelier from the eighteenth century.

One of the most exquisite French-style spaces in Washington is the powder room (fig. 19). The decorative panels were inspired by the boiseries of the *boudoir de la reine*

F<small>IG</small>. 18. Eastern pavilion, Delphine Dodge House, 2300 Foxhall Road, currently the Belgian ambassador's residence. *(Courtesy Embassy of Belgium.)*

at Fontainebleau. These boiseries were painted with grotesque decorations and griffins superbly executed under the direction of architect Pierre Rousseau (1786). The panels of the boudoir present the same disposition of medallions, terms, and arabesques around a central axis, with griffins at the bottom.

Soon after the house was finished, it was rented to Dwight F. Davies, who had served as U.S. secretary of war and governor general of the Philippines. In 1945, the house was sold to the Belgian government, which owns it to this day.

The 1940s

In post–World War II Washington, one formidable woman, Marjorie Merriweather Post, almost single-handedly carried on the tradition of building and remodeling in grand residential scale. French art, particularly that of Louis XVI, had been her first

FIG. 19. Powder room, Delphine Dodge House, 2300 Foxhall Road, currently the Belgian ambassador's residence. *(Courtesy Embassy of Belgium.)*

interest. Her palatial homes in the capital city were the last expressions of a bygone era of building and decorating in grand old styles.

The Causeway estate, originally built by James Platt in 1910 between Klingle Road and Macomb Street, became the home of Marjorie Merriweather Post and her husband, ambassador Joseph E. Davies, upon their return to Washington at the beginning of World War II.[45] They purchased the house in 1942 and renamed it "Tregaron," after the small Welsh town where the Davies family originated.

At Tregaron, Post made a few minor architectural changes to the exterior and the landscaping. The interiors, however, where completely redesigned (fig. 20). For the job, she hired Fred Vogel, an interior designer from New York. The repairs and replacement of furnishings were by far the most costly chapter in the remodeling of the

[45]The house was originally the home of James Parmelee, an Ohio industrialist, and his wife. The Parmelees were avid collectors and deeply involved with the city's cultural institutions. James served as vice president of the Corcoran Gallery of Art, as well as on the executive committee of the National Gallery of Art Commission. See Kristine Larsen, *Tregaron: A Magical Place* (Washington, D.C., 2002), p. 10.

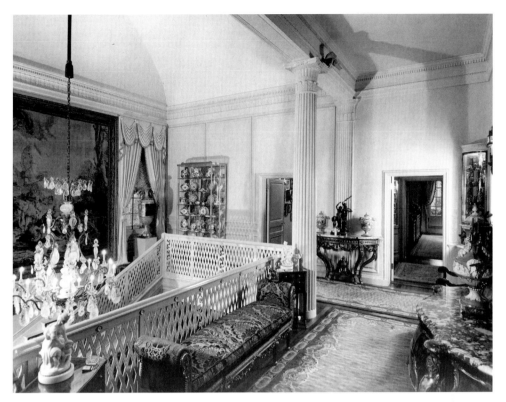

FIG. 20. Staircase to second floor, Tregaron, residence of Marjorie Merriweather Post and Joseph E. Davies, currently the Washington International School. *(Courtesy Hillwood Museum and Gardens.)*

house. The itemized bills prepared by her business office show that after the house was finished, Post spent large sums with art dealers in New York, London, and Paris to buy artworks for the new Washington residence.[46] The work that Post required from interior decorators went beyond the obvious tasks of designing and furnishing rooms. Most designers that she engaged also acted as agents for purchasing works of art. Decorators were also in charge of arranging for conservation and repairs to her objects and furnishings and for transferring furniture and paintings among her many residences.

[46]The cost of repairs and replacement of furnishings amounted to almost $300,000. Expenditures for new furnishings amounted to $315,000. Fred Vogel acted as an agent to purchase items at auctions in New York and from New York dealers. Additionally, Post bought Sèvres porcelains from the Antique Porcelain Company. French and Company supplied several French works of art for Tregaron. Post also made purchases from antique dealers in Paris, including Arnold Seligman et Fils and J. R. Ostins. She bought Russian art from A la Vieille Russie and Hammer Galleries. (Information provided to Post by her business manager Meyer Hendelman and Company in a document dated Sept. 27, 1954, itemizing expenditures for Tregaron, 1941–54, in Hillwood Museum and Gardens Archives.)

In addition to the French collection that Post had lovingly built since the 1910s, the Davieses showcased their Russian collection, begun while he was ambassador to the Soviet Union (1936–38) and enlarged through purchases from specialized dealers in Europe and America.

The Davieses became the toast of Washington. Tregaron was the site of many political events. The Soviet delegation headed by Ambassador Maxim Litvinov was hosted there on several occasions. President Harry Truman and his wife Bess were invited to dinner there, as were President Lyndon Johnson and Lady Bird Johnson. The Davieses also entertained Supreme Court justices, foreign diplomats, senators, and cabinet members. The *Evening Star* called Tregaron a "veritable museum with its many fine collections of French furniture . . . and a Russian room with objects of art."[47]

When Post divorced Davies in 1955, she bought another residence in Washington at 4155 Linnean Avenue. Hillwood, as she named it, is the ultimate statement of Post's taste and aesthetic. This was the last residence that she refurbished and the one that ultimately became a museum to showcase her collections of French and Russian decorative and fine arts. The original structure, an English-style manor house with neo-Tudor interiors, was converted into a larger, more palatial dwelling in the French style. The "Frenchification" of the architectural interiors at Hillwood is not an isolated episode in Post's decoration of her homes. It is, however, the culmination of the development of a taste for things French that she adhered to and that took hold in some New York circles just after World War I. Post had been introduced to eighteenth-century France by interior designer Jules Allard and art dealer Sir Joseph Duveen.

When Post bought Hillwood in 1955, her mandate to architects and designers was to remodel and reconstruct the Georgian-style house and turn it into a collector's personal home. To direct the architectural project, she called Alexander McIlvaine, a young architect from the firm of Delano and Aldrich in New York. Hillwood was built for a dual purpose: to serve as a home and as a museum to exhibit her extraordinary collection. This idea, although only realized at Hillwood, had been already considered as early as 1952. In that year, the firm of French and Company had discussed with Post the idea of establishing a museum. In a letter addressed to Post in Paris on August 1, Mitchell Samuels mentioned several collectors' personal museums in the city, including the Jacquemart André and the Cognacq-Jay. However, he proceeded to state that "the best models for individual museums are in this country [the United States]. Of course the Huntington ranks number one, Mrs. Jack Gardner's in Boston is number 2."[48]

For the dining room, which French and Company conceived to be "one of the best in America, and lighter than your previous one . . . in a perfect Louis XV taste,"[49] the

[47]Quoted from Larsen, *Tregaron,* p. 49.
[48]Letter dated Apr. 1, 1952, in French and Company files at Hillwood Museum and Gardens.
[49]Letter dated June 28, 1955, ibid.

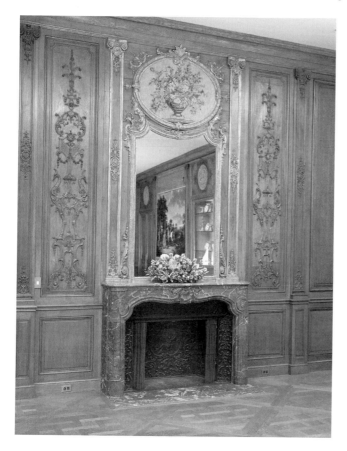

FIG. 21. Dining room, Hillwood Museum and Gardens, 4155 Linnean Avenue, former residence of founder Marjorie Merriweather Post. (*Courtesy Hillwood Museum and Gardens.*)

firm installed oak paneling dating from the 1730s. Pieces had to be added to complete the perimeter of the room, and these are clearly discernible. The old parts have spirited carvings of lively scrolls and long, tall birds accented with gilding. The mirror stands over a superb marble mantelpiece of the same period (fig. 21).

Like many paneled rooms installed after World War I, this one was in at least its third incarnation: from its original setting in the *hôtel particulier* of the Harjes family in the rue de la Faisanderie in Paris (fig. 22),[50] it was moved to the same family's property in Tuxedo Park, New York, and then to the French and Company showrooms in New York City. (In a conversation with her architect, Post stated that "an old French boiserie must be found for this room."[51] She mentioned that she had seen one she liked at French and Company and gave him instructions to investigate whether it would be suitable.) Period rooms transported directly from their original settings were rare because, since World War I, French public opinion and the press had been quick to call

[50]I am indebted to Paul Miller, curator of the Preservation Society for Newport County, for providing me with photographic and literary documentation on the provenance of this paneling.

[51]Transcription of conversation on Jan. 20, 1955, in files at Hillwood Museum and Gardens.

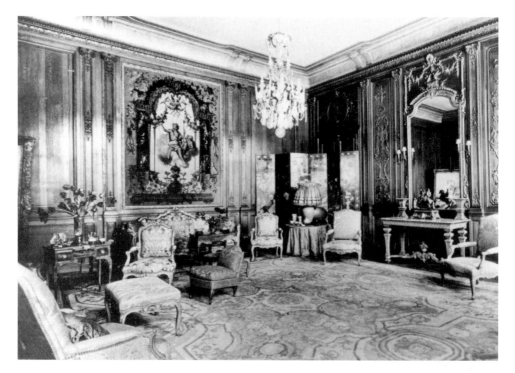

FIG. 22. Salon, Harjes residence, rue de la Faisanderie, Paris. *(Courtesy Preservation Society of Newport County.)*

attention to the demolition and displacement of rooms. For designers, the best solution was to procure a set of paneling that had already been sold and was being sold again.[52]

French and Company wisely marketed these panels by setting old boiseries in their showrooms to serve as a fitting background for their antique furnishings. These arrangements created a look that became a hallmark of the firm (fig. 23). Clients, particularly those who were collectors, found these roomlike settings attractive because they allowed them to envision complete and harmonious interiors. They were designed to live in, while at the same time showing works of art to their best advantage.

For the work at Hillwood, crews of painters, woodworkers, plasterers, and upholsterers were brought from New York City. According to one of the decorators at Hillwood in those years, the scarcity of good local craftsmen was such that they felt the need to bring them from New York. French and Company employed approximately one hundred people, including gilders, carpenters, upholsterers, repairmen, and glaziers who handled the inventory, restoration, and maintenance of the works.[53] Their involvement caused the cost of the whole operation to skyrocket. Post, alarmed at the bill sub-

[52]See note 41.
[53]See introduction to the French and Company sales catalog, Christie's, New York, Nov. 28, 1998.

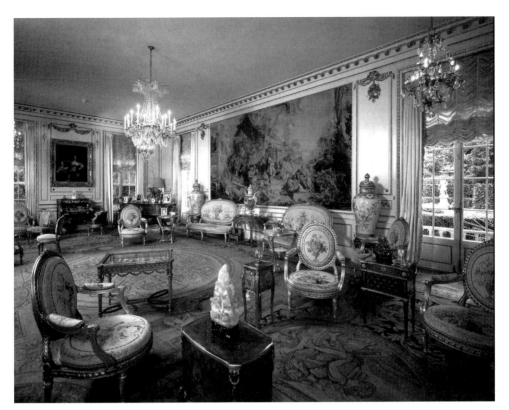

FIG. 23. Drawing room, Hillwood Museum and Gardens, 4155 Linnean Avenue, former residence of founder Marjorie Merriweather Post. *(Courtesy Hillwood Museum and Gardens.)*

mitted by French and Company for the installation of the paneling in the French Drawing room, finally protested: "The cost involved in doing the Drawing room paneling horrifies me. . . . The layout from the architect of the existing panels for the room, showing where it had to be new and what existed, seemed to leave not very much to be done."[54]

After many trials and tribulations, the house was finally ready in May 1957. In 1965, Post received the National Society of Interior Designers award for inspiring good design in her environment and influencing public taste. Hillwood, her culminating project, was opened to the public as a museum three years after her death in 1976.

SINCE THE 1920s, voices of dissent could be heard in some learned circles. Lewis Mumford announced in a 1927 article on "American Taste" that the modern American house could tritely be described as a house that is neither modern nor American. He

[54]Letter dated Aug. 5, 1957, in French and Company files at Hillwood Museum and Gardens.

went on to complain that "no period has ever exhibited so much spurious taste . . . so much taste derived from hearsay, from imitation, and from desire to make it appear that mechanical industry has no part in our lives and that we are all blessed with heirlooms testifying to a long and prosperous ancestry in the Old World."[55]

These poignant commentaries attacked at its core the beloved aesthetics of many rich and powerful patrons, including the Washington establishment of that time. Every style, every idea needs to oppose some existing style or idea in order to advance, and modernist tendencies seemed to have set themselves in radical opposition to traditional aesthetics. Now, a century later, we have enough perspective to see the legacy of the Beaux-Arts architects and the interior designers as something to be reckoned with. The survival and presence of these somewhat decadent homes endows Washington with the grandeur of a bygone era and has become part of its history.

The city was self-conscious of its urban changes from the beginning: "New Washington is indeed unique, and justifies the prediction so often and so confidently made for it, that within the next quarter of a century, it will become the most beautiful Capital city in the world."[56]

[55]Nicholas Fox Weber, *Patron Saints: Five Rebels Who Opened up America to New Art, 1928–1943* (New York, 1992), pp. 7–8.

[56]W. T. Birmingham, "Unique Capital Homes," *Washington Post,* Feb. 17, 1907, p. E7.

Interpreting the Influence of Paris on the Planning of Washington, D.C., 1870–1930

CYNTHIA R. FIELD

IN 1910, JOHN MERVEN CARRÈRE, A PARISIAN-TRAINED AMERICAN ARCHITECT whom we shall meet later as a consulting architect of the U.S. Capitol complex, wrote an article stating that "learning from Paris made Washington outstanding among American cities."[1] Carrère laid down a few cardinal principles that he derived from both plans and that he said should "underlie all city planning." Those determining principles were circulation, hygiene, and art. As the firm of Carrère and Hastings applied these principles to the buildings that would frame the Capitol, we might keep them in mind to see how they recur.

Circulation

Improving upon Paris must have been much discussed in the eighteenth century, as it would be in the nineteenth century. Abbé Laugier and Pierre Patte addressed planning issues, each in his own framework. France's renowned eighteenth-century author, Voltaire, published his views in an essay entitled "On the Embellishments of Paris" in 1749. Recognizing the chaos and overcrowding of Paris, he sought to establish standards

[1] John Merven Carrère, "City Improvement from the Artist's Standpoint," *Western Architect* 15 (1910):40–41, 44; found on the John Reps Web site, Urban Planning, 1794–1918: An International Anthology of Articles, Conference Papers, and Reports, accessed at http://www.library.cornell.edu/Reps/DOCS/homepage.htm.

Fig. 1. The L'Enfant Plan of the city of Washington in the territory of Columbia: ceded by the states of Virginia and Maryland to the United States of America, and by them established as the seat of their government, after the year MDCCC/engrav'd by Sam'l Hill, Boston. *(Courtesy Library of Congress.)*

for health, efficiency, and ease of communication. Voltaire called for great new avenues, fountains, squares, and marketplaces.[2]

Peter L'Enfant's ideal plan (fig. 1), his new town, was a vision such as that indicated by Voltaire; Paris improved with greater space, wider streets, and a thoughtful approach. So he imagined the spaces needed by the new federal entity, architectural monuments, and memorials located in or near the square and plazas. He connected them by his inventive system of symbolically named avenues. He used the idiom of the boulevard for the most significant of these, the national mall. It was, of course, the French-born L'Enfant who established the hegemony of France in the planning of Washington and the influence of Paris on its plan.

[2]Ulla Kolving, ed., *The Complete Works of Voltaire* (Oxford, 1994), vol. 31B, pt. 2, pp. 200–226. See David P. Jordan, *Transforming Paris: The Life and Labors of Baron Haussmann* (New York, 1995), p. 15 n. 5. The pamphlet *Recueil de pièces en vers et en prose par l'auteur de la tragédie de Sémiramis* (1750) was well known even a century later to Haussmann, who quoted from it in a letter to the emperor of May 20, 1868, as recorded in his *Mémoires*. See Georges-Eugène Haussmann, *Mémoires du baron Haussmann*, 3 vols. (Paris, 1890–93), 2:531.

L'Enfant had correctly observed in his proposal to George Washington that it would take a long time for Washington to reach its potential as a city. Most are familiar with the comment of Charles Dickens, who gave Washington its vivid epithet, "the city of magnificent intentions."

Early nineteenth-century Washington was not "a vision of baroque magnificence," as John Reps observed.[3] Rather, Washington developed unevenly, even somewhat haphazardly, neglecting in practice but not entirely forgetting L'Enfant's plan in concept. In the mid-nineteenth century, Washington again turned toward Paris. The *Critic,* a contemporary paper, reported on Parisian fashion, music, dance, and literature. The attention to Parisian mores makes it evident that there was a taste for keeping up with French fashions among Americans. The *Evening Star* was a more mainstream paper with a focus on political news. The *Star* regularly reported on foreign news, which was supplied by telegraphic service with an immediacy akin to that of the Internet. The paper of March 5, 1872, carried a complete account of the actions of the French Legislative Assembly as it sought to act amid the various factions vying for power. On the same page was a prominent advertisement for various goods in the latest French style or even imported directly from Paris.[4] Paris, experiencing its own urban revival, was invoked by the editor when urging his readers to vote against a mayoral candidate if they wished "to make [this capital] the Paris of America."[5]

After the disturbance of the Revolution and the Directoire period, Napoleon was eager to see planning recommenced in Paris. The planning of his era was an extension of the formal avenues and monuments of the royal regime. After the empire fell, there was piecemeal planning, but governments continued to provide improvements to Paris, especially during the July Monarchy of Louis-Philippe. During this period, efforts toward improved circulation included a canal, similar to Washington's, and railroad lines. Between 1830 and 1848, 237 streets were built or substantially improved. Much of the street improvement work was a matter of paving or repaving, as it would soon be in Washington.[6] However, little was done to accommodate the large influx of workers who came to the city in search of opportunities. Their social conditions contributed to the uprising of 1848.

In response, a new Napoleon imposed a grand plan for the reordering of the city. By the time he took control of France in 1851 as Napoleon III, Louis Napoleon had already published his own social contract. Elements of the physical city mentioned in

[3]John Reps, *The Making of Urban America* (Princeton, N.J., 1965), p. 262.

[4]*Foreign News,* Jan. 18, 1860, p. 1, carried news of the negotiations going on in Paris to settle the conflict between the Turks and the Persians. By 1870, these daily reports were being supplied by the Associated Press, such as a report of political maneuvering in Paris and a brief report on the smallpox epidemic in the *Star,* June 7, 1870, p. 1.

[5]*Evening Star,* June 3, 1870, p. 4.

[6]Douglas Klahr, "Le Development des rues parisiennes pendant la monarchie de juillet," in *Modernité avant Haussmann,* ed. Karen Bowie (Paris, 2001), p. 226.

this document, *L'Extinction de paupérism* (1844), included wide streets, buildings of masonry that were fireproof, and demolition of older, largely wooden structures—and the accompanying displacement of the population. Planning for hygiene influenced Napoleon to follow the ideas of the English sanitation pioneer Edwin Chadwick and the influential sanitary engineer William Lindley. In their work on improving sanitation, they favored wide streets lined with fireproof buildings.

Georges-Eugène Haussmann, the consummate bureaucrat, was employed to carry out the sweeping renovation of Paris that Napoleon III proposed.[7] Napoleon's plan became, in Haussmann's hands, the vehicle for change envisioned by Voltaire and others in the eighteenth century. In brief, the Second Empire (1851–70) left Paris with new avenues and improved circulation, at the expense of ancient areas of the historic city (fig. 2). The new infrastructure of sewers was renowned. The government built showy public buildings and parks. Private development boomed as a result. Another concern of the urban planners was the prevention of fire. Medieval buildings of flammable wooden construction were knocked down to be replaced by masonry structures. The *Evening Star* followed technical experts in expressing admiration for "the French practice of building" these houses internally so that they were "thus rendered more 'fireproof' or rather less combustible."[8]

Washington, too, experienced explosive growth of population during the years of the Civil War, growth that could not be accommodated by new building while every effort was being bent toward the war. This pent-up demand fueled a building explosion in the 1870s encouraged by the creation of the territorial government. The District of Columbia had at that time a local government with a mayor and a board of aldermen. However, local government was relatively weak in relation to the control of Congress and had little in the way of funding. Chafing to gain greater control, citizens pressured for a new form of government. The Citizens Reform Committee, represented by Alexander Shepherd, was active in the movement. Congress passed the act creating the new territorial government in February 1871.

President Ulysses Grant appointed financier Henry Cook as governor and Alexander Shepherd as vice president of the Board of Public Works. Cook and Shepherd were members of a small, tightly knit group of men who invested in the same endeavors and served on boards together. They were entrepreneurs all, impatient for results. As

[7]David van Zanten, "Mais quand Haussmann est-il devenu moderne?" in Bowie, *Modernité avant Haussmann,* pp. 154, 155–59. Fialan de Persigny and Louis Frémy employed Haussmann to carry out the fiscal and social reorganization that Napoleon III had outlined in his *Extinction de paupérism* (1844). The plan followed Edwin Chadwick and William Lindley's concept of wide streets, buildings of masonry that were fireproof, demolition of old wooden structures, and the movement of the poor to institutions and off the streets or out of hovels. Chadwick also suggested laying gas lines and providing improved sanitation.
[8]*Evening Star,* Mar. 5, 1872, p. 3, in an item copied from *Manufacturer and Builder.*

FIG. 2. Paris in the age of Napoleon III. "Paris und Umgebung." From *Mittheilungen aus Justus Perthes'* Geographischer Anstalt . . . , *by Dr. A. Petermann,* 1871. *(Courtesy University of Texas.)*

a consequence of their personal goals and experience, they wanted improved circulation and hygiene. Their vision also required a city that was attractive.

Specifically, it was the work of the Board of Public Works that provided sewers, expanded water delivery, and graded and paved city streets, enhancing them with trees and sidewalks. Under the Board of Public Works, 120 miles of sewer lines, 30 miles of new water mains, and 208 miles of sidewalks were constructed, and 157 miles of roadways were paved (fig. 3). Public lighting was greatly expanded to 2,954 public lamps. A hallmark of this administration was what was called at the time "parking," the planting of many thousands of trees in newly greened areas along boulevards and in new squares and parks. New bridges and markets were built, and more were planned.

Funds for this work were not readily available, but Shepherd, eager to advance the project, was not punctilious about how it was supported. Like Haussmann, Shepherd's financing was creative. When he could not get adequate funding from Congress, Shepherd arranged for loans from New York bankers. Haussmann, too, eschewed state funding for capitalist financing. Haussmann's bankers (the Péreire brothers) were also the most successful developers of the new residential areas created by his improvements.

Washington's development, too, was beset by cronyism. Shepherd, often compared to Haussmann, was not trained as an administrator, so he was, at best, careless about detail. In Washington, as in Paris, the effort to beautify and regularize the visible fabric

FIG. 3. Streets paved 1872 and 1873. From the *Report of the Board of Public Works* (1873).

and to undergird it with civic services was a suspect effort. Surely, observers felt, the work was benefiting someone. Who was benefiting? The developers.

The municipal market provided control over many disparate small businesses, improved hygiene, and furnished relief for traffic.[9] In Washington, as in Paris, new facilities and greater space for markets in the heart of town were tied to regional commercial improvement. One can determine from the maps published in the reports of the Board of Public Works that they sought purposefully to concentrate their efforts on the streets that connected the markets with the outlying areas that supplied the goods and produce. As Helen Tangires described the role of the market house, "In this single structure [the market house] government's pride and reputation were at stake. Local businesses and nearby property owners depended on its success, as did country producers and street vendors."[10]

In Washington, as in Paris, the new market structures were a result of the national government, the local government, and the private interests working together. The attention of the territorial government to the aspects of city planning that best served the business interests was not unusual for the period. The tradition of American city governance in the late eighteenth and early nineteenth centuries was to encourage busi-

[9]Helen Tangires, *Public Markets and Civic Culture in Nineteenth-Century America* (Baltimore, 2003), p. 173.
[10]Ibid., p. 26.

ness and, indeed, to regard the role of the city as being the place of business, while the outlying areas were the areas of production.[11] The diagonal streets radiating from fixed centers created by the L'Enfant plan were considered modern because they seemed to allow for commercial flow to and from urban centers.[12]

Of the top men working with the territorial government as engineers, at least three —Montgomery Meigs, Alfred Mullet, and Adolf Cluss—had traveled in Europe and would have been especially aware of the engineering and sanitation debates. Mullett and Meigs had been educated according to the system of instruction of the French civil engineers at the Ecole Polytechnique and had traveled extensively in Europe. Adolf Cluss, whose professional education also seems to have been along polytechnique lines, was born and educated in Germany. He was acquainted firsthand with Paris and the work of the engineers.[13] When traveling to Paris, these men would certainly have noticed with approval the improving condition of the streets and boulevards.

Cluss, Meigs, and Mullet typified those involved in public service, taking on large-scale problems for solution. Mullett's State, War, and Navy Building (now the Eisenhower Office Building) and James Renwick's Corcoran Gallery (1859–61) were loosely based on the new Louvre. The architecture of Adolf Cluss shows the nearly universal adoption of such contemporary French design elements as the mansard roof. It stands to reason that the Board of Public Works planning projects, in which Cluss and Meigs had roles, leaned heavily on the French example of circulations through improving roads and hygiene. The roads were not only paved but also improved with plantings in the manner of the French boulevards.

As far back as the fourteenth century, all French rulers had been interested in streets that would open up the dense Parisian fabric,[14] but it was Louis XIV in the late eighteenth century who established the first boulevards. These broad avenues with plantings and multiple roadways were called boulevards for the fortification walls or ramparts they replaced. The ribbonlike open area created by tearing down the walls was first transformed into the promenade—that is, a road with a capacious central carriageway wide enough for several carriages to travel abreast and two side roads for pedestrians on each side. The whole composition was bordered by double rows of trees. This characteristic Parisian boulevard had replaced the earthen fortification walls of the city by 1705.

[11]Martin Melosi, *The Sanitary City* (Baltimore, 2000), p. 19. Melosi relates this to Sam Bass Warner's concept of privatism.

[12]An article of 1891 (*Engineering News,* Oct. 10, 1891, pp. 334–35, on the John Reps Web site). "The present beauty of Paris, a beauty which is recognized by all nations, and attracts the traveler and his dollars to that city, is due entirely to its wide tree planted boulevards, its fine public and private buildings that are displayed to the best advantage, and to the studied irregularity of its streets."

[13]Cluss was in Paris in 1847 and 1859. The period between 1840 and 1848 was one of growing socialist prominence in French thinking. Among the prominent thinkers, many were associated with the Ecole Polytechnique, the professional school for civil engineers.

[14]Klahr, "Le Development des rues parisiennes," p. 222.

Writing for the Board of Public Works annual report in 1873, Adolf Cluss said that "the energy with which the streets of Washington and Georgetown have been regenerated . . . is unparalleled in the history of cities." The streets were not only paved and reconditioned but also totally rebuilt after a tremendous amount of regrading (3,340,000 cubic yards of earth moved). The paving of choice for Washington consisted of specially treated wooden pavers. In this report, Cluss set up a comparison with the French when he took Haussmann to task by name for the Frenchman's choice of paving four million yards of Parisian streets with macadam.[15] The newspapers made frequent reference to the comparison of Paris and Washington. For instance, in the *Washington Evening News* of November 5, 1889, T. F. Schneider, a builder and developer who had worked in the office of Adolf Cluss, was called "the young Napoleon of F Street." Characterizing the prolific Schneider as a younger Napoleon in the headline of the Washington paper demonstrated a local familiarity with the rebuilding of Paris under Napoleon III.

Hygiene

The attention to public health came from another aspect of life in the nineteenth-century city, deadly epidemics. It has been said that Haussmann's plan was slum clearance driven by cholera epidemics.[16] Cholera is an acute, infectious disease spread by feces-contaminated water and food, thus related to the efficacy of waste disposal. The efforts of the Board of Public Works in this area were the laying of sewers to move water and waste. In this both Shepherd and Cluss were active.

Washington was like other American cities in its vulnerability to all the many infectious diseases that plagued urban areas. Between 1865 and 1873, a series of recurring epidemics of smallpox, cholera, typhus, typhoid, scarlet fever, and yellow fever occurred in Philadelphia, New York City, Boston, New Orleans, Baltimore, Memphis, and Washington, D.C. It was not clear at first how these pestilent diseases spread. In 1828, the prestigious French Academy of Science endorsed the concept of environmental causes for the spread of certain diseases such as cholera.[17] France mandated public health measures by the late eighteenth and early nineteenth centuries based on the bold decision to accept the cause as being waterborne. In Paris, the government removed the relatively recently built canal, which could be a source of infection through the in-

[15]Adolf Cluss, "Report of the Chief Engineer," *Report of the Board of Public Works of the District of Columbia,* Nov. 1, 1873, pp. 5–11.
[16]Richard A. Etlin, *Symbolic Space: French Enlightenment Architecture and Its Legacy* (Chicago, 1994), p. 11.
[17]Melosi, *Sanitary City,* p. 43. See also Edwin Ackerknecht, "Anticontagionsism between 1821 and 1867," *Bulletin of the History of Medicine* 22 (1948):573–74. By midcentury, British and French sanitarians shared research and findings, and doctors in the United States followed both.

sects bred in moist conditions. Their splendid new system of water mains and sewers became a famous attraction. Washington's great leap forward under the territorial government was in its attention to sewers and water. One hundred twenty miles of sewers were laid in three years. The canal, a remnant of the L'Enfant plan that had become an open sewer, was covered and controlled, producing Constitution Avenue in the process.

The territorial government changed the conditions that had bred urban plagues. While the Board of Public Works made extensive inroads in the laying of sewers and water mains, the Board of Health worked to improve public health and educate the population.[18] It had been observed and become established as medical fact that environmental diseases arose most frequently in crowded districts with little open space. The Board of Public Works' street improvement project served also as a factor in planning for hygiene. Broad avenues and open spaces for parks improved the flow of air.

Paris remained a model for Americans, and Washingtonians legitimated their efforts by associating themselves with the European city. In the 1880s, a commercial directory, *Historical and Commercial Sketches of Washington and Environs,* bore on its title page the epithet "the Paris of America." In 1892, an article appeared in *American Architect and Building News* suggesting that Congress should secure a well-considered plan for the layout of the entire city, a plan "like that of L'Enfant." In the 1890s, American engineers still considered Paris the desirable model for U.S. cities. An *Engineering News* article said "We want a Baron Haussmann."[19]

Art

In 1900, the American Institute of Architects took the lead in turning Washington's attention to its original plan.[20] Glenn Brown, architect and executive director of the American Institute of Architects (AIA), had already argued for the renewal of the

[18]The summer of 1873 was a plague season in Washington. In June 1872, an Act for the Prevention of Diseases in the District of Columbia was passed, giving the Board of Health the right and obligation to issue orders for emergency measures whenever, in its judgment, there was an epidemic in the city. In August 1873, for instance, the Board of Health, having declared a state of epidemic, issued a set of rules concerning the reporting of disease and the burial of victims, among other matters ("Notice to the Public from Chris Cook, MD, Pres, Board of Health," *Evening Star,* Aug. 2, 1873).

[19]Frank Sewall, "Washington and Its Public Buildings," *American Architect and Building News,* May 7, 1892, p. 87; *Engineering News,* Oct. 10, 1891, pp. 334–35, on the John Reps Web site.

[20]Nicholas Murray Butler, "The Place of Art in Civilization," in *The Promise of American Architecture: Addresses at the Annual Dinner of the American Institute of Architects,* ed. Charles Moore (Washington, D.C., 1905), pp. 19–24. "To the fine imagination, delicate technique and the broad architectural scholarship of the French, we owe still more" (p. 22). It is not surprising that the AIA conference celebrated the L'Enfant plan because the organization was heavily influenced by the Ecole des Beaux-Arts experience of its members. However, the education at the Ecole was not concerned with city planning in any major way. Rather, the student architect at the Ecole was to absorb the lessons of Paris.

L'Enfant plan in articles in architectural publications in 1894 and 1896.[21] As a result of AIA agitation, the Senate adopted a resolution calling for improvements to the park system of the District of Columbia in 1901. The resolution enabled the Committee on the District of Columbia to seek the advice of a team of experts who came to be known as the McMillan Commission, after Sen. James McMillan, chair of the Senate District Committee.[22] The members of the commission were Daniel Burnham, Charles McKim, Frederick Law Olmsted Jr., and Augustus Saint-Gaudens, who had already worked together at the World's Columbian Exposition. After their appointment, the members of the commission devoted themselves to studying the L'Enfant plan. They became convinced that they should proceed by "carrying to a legitimate conclusion the comprehensive, intelligent, and yet simple and straightforward scheme devised by L'Enfant under the direction of Washington and Jefferson."[23] This quotation contains three guiding principles for the development of the plan—the design principles of L'Enfant, the philosophical principles of the Founding Fathers, and the comprehensive nature of a plan achieved simply.

April 1901 saw the primary commission members, McKim, Burnham, and Olmsted, hard at work studying the site, the L'Enfant plan, and the political and social circumstances in Washington that related to their charge. They began to lay out the plan, especially the National Mall, using drafting rooms in the Senate press gallery.[24] Having done their initial planning, the commission looked to L'Enfant's European roots on a six-week European trip.

The beginning and ending site of this study tour was Paris. They disembarked and sped by train to Paris, where their first action was to view the city as a whole from the balcony of the Hôtel Continental at 3 rue de Castiglione and rue de Rivoli, overlooking the Tuileries garden. The point of comprehensive planning was inculcated at this crucial moment. The visitors looked first at the system as a whole, standing that morning on an overlook. This view of Paris as a comprehensive plan was to have great influence on the Washington work. In no other site visited on the trip did they identify the integrated view as they did in Paris.[25]

[21]Glenn Brown, "The Selection of Sites for Federal Buildings," *Architectural Review* 3 (1894):27–29. Glenn Brown, "History of the United States Capitol, Part I," *American Architect and Building News* 52 (May 1896):51–54.

[22]*The Improvement of the Park System of the District of Columbia,* 57th Cong., 1st sess., 1902, S. Rep. 166, p. 7. "Resolved: That the Committee on the District of Columbia be, and it is hereby directed, to consider the subject and report to the Senate plans for the development and improvement of the entire Park system of the District of Columbia. For the purpose of preparing such plans, the committee may sit during the recess of Congress, and may secure the services of such experts as may be necessary for a proper consideration of the subject. The expenses of such investigation shall be paid from the contingent fund of the Senate."

[23]Ibid., p. 25.

[24]Charles Moore, *Daniel H. Burnham: Architect and Planner of Cities,* 2 vols. (1921; reprint ed., 1968), 1:142. See Daniel Burnham to Frederick Law Olmsted Jr., Apr. 10, 1901, in the Burnham Papers, Ryerson and Burnham Library, Chicago Art Institute.

Fig. 4. Vaux le Vicomte gardens, 1990s. Photograph by Beatrice Quette. *(Courtesy the author.)*

During the trip, a great deal of attention was paid to the designs of André Le Nôtre.[26] All three of Le Nôtre's landscape designs—Vaux le Vicomte, Versailles, and the Tuileries—were visited. Members of the commission commented in print that there was a relationship between the planning of the classic French garden and the plan of Washington. In his biography of Burnham, Charles Moore, who was with the party in Europe, said, "A close study of Lenôtre's [*sic*] work in France, together with reflections of it in other countries, revealed subtleties and perfections applicable to the American work."[27]

Le Nôtre's idea of planning, so impressive to the members of the commission, was apparent at the chateaux and grounds of Vaux le Vicomte (fig. 4). Le Nôtre's use there of a monument to mark the visual effect of a vanishing point as it would occur in a painting was the first introduction of this principle in France. Standing on the terrace

[26]Daniel Burnham, diary, June 22, 1901, Burnham Papers, Ryerson and Burnham Libraries, Chicago Art Institute. Burnham also commented in his diary: "We are going to see great grounds this time, not buildings."
[27]Moore, *Burnham,* 1:156.

of the chateau, the observer looked down the central axis toward a far distant point at a height. Beyond this point, the landscape continued but, falling below the vanishing point, was not part of the composition itself. This effect was copied in Paris between the Tuileries and the Arc de Triomphe and even later in Washington.

When the McMillan Commission visited Vaux le Vicomte on that hot day in July 1901, all the fountains were turned on, cooling the sultry air with plumes of spray. Looking over the vista, they pictured L'Enfant's design restored and adorned with decorative details and water effects.[28]

The plan of Versailles, unlike that of Vaux le Vicomte, cannot be perceived as a single composition (fig. 5).[29] One moves through this landscape, experiencing changing viewpoints, new architectural effects, and sculptural monuments. At the same time, there remains, as at Vaux le Vicomte, a central axis that creates balance and control while suggesting the line of progression through this space. Moving along this central axis implies that the viewer's relationship to the space and to the monument at the vanishing point is always changing, thus creating multiple experiences of spatial relationship.[30] In L'Enfant's mall as reimagined by the McMillan Commission, one would experience again the manipulation of perspective and the molding of spatial experience characteristic of the work of Le Nôtre.

To a city plan already so influenced by French ideas on planning, what did the McMillan Commission add? In France, they grasped the formal planning model in the measured ordering of spaces along an extended central axis. Transverse axes, as seen in Paris and already prominent in the L'Enfant plan, served a double purpose in giving scale to the perspective and opening up new spaces adjoining the central axis.

As to the plan itself, to which they returned with some new ideas, unity was to be the keynote, unity of areas and harmony of buildings with their surroundings. They felt that in order to be effective, public buildings should have both a landscaped setting, as exemplified by Paris's Luxembourg palace and garden, and a relation to one another that created order.[31] They adopted the L'Enfant plan with revisions, drawing

[28]Charles Moore, *Life and Times of Charles Follen McKim* (New York, 1929), p. 197.

[29]Allen S. Weiss, *Mirrors of Infinity* (New York, 1995), p. 47. Weiss notes that Louis XIV wrote a pamphlet on the path to take in viewing the gardens.

[30]Ibid., p. 61. At Versailles,

the system of linear perspective organizes the visual field into a self-reflexive, self-reverential, narcissistic system, insofar as the vanishing point—which indicates the point at which the gaze must intersect the canvas—always refers beyond the surface of the painting (or the scene) back to the position of the spectator. This unique viewpoint thus implies the existence of an individual ego, the one looking at the scene; but this self is fully replaceable by other selves. The system of linear perspective is thus a social and historical system of exchange by means of articulating diverse subjects as potential viewers, interchangeable and identical before a given scene. As viewpoint is related to vanishing point, so is the spectatorial ego related to infinity . . . at Versailles—structured according to the optical and symbolic signification of the central alley leading from the chateau to infinity—it is rather a sign of the Sun King's hyperbolic hubris.

[31]*Improvement of the Park System,* p. 24. Note that Burnham wrote to his wife that the Luxembourg Garden was "the nearest to a perfect one that can be imagined" (DHB to Mrs. Burnham, July 11, 1901, in the Burnham Papers, Ryerson and Burnham Libraries, Chicago Art Institute).

Fig. 5. Versailles, *A Corner of the Park,* 1902. Photograph by Eugène Atget.

from it the principles of design that would govern the placement of future buildings and new additions. They sketched out an enlarged park system beyond the limits of the L'Enfant plan but fully in scale with the parks in the Paris of Napoleon III.

The focus of the revived L'Enfant plan was to be the recovered National Mall. Here revisions were thought necessary in order to restore the relationship of the Washington Monument and the Capitol because the monument had been placed off this symbolically vital axis. The commission redrew the Mall axis, slightly deflecting it from its original line. The addition of a linear green down the middle of the Mall in place of L'Enfant's avenue was an inspired choice for obfuscating the altered geometry of the visual relationship. The commission emphasized the unity of the composition by demonstrating that the buildings, sharing similar design characteristics and a common cornice height, were secondary to the great urban space of the Mall (fig. 6).

Likewise, the invention of the Monument Gardens for the section they called the Washington Monument Division (fig. 7) was a revision of the L'Enfant plan that restored the intended cross-axial relationship between the executive to the north and the congressional to the east. On land that did not even exist in L'Enfant's time, the commission proposed to extend the Mall along the line of perspective familiar to them

Fig. 6. Bird's-Eye View of McMillan Commission Plan for Washington. Rendering by F. L. V. Hoppin, National Archives and Records Administration. *(Courtesy U.S. Commission of Fine Arts.)*

from their comprehensive view of Paris as they had seen it from the balcony of the Hôtel Continental. The Lincoln Memorial crowned a newly designed circle of roads or rond point "as the Arc de Triomphe crowns the Place de l'Etoile at Paris."[32]

Paris exerted a less direct influence through the planning efforts of the world's fairs. The Court of Honor of the World's Columbian Exposition of 1893 (fig. 8) was developed from the central area of the Paris exposition of 1889, the Champs de Mars. From the beginning, Chicagoans had measured their exposition against the European standard, especially those glittering fairs held in Paris. In 1889, two prominent Chicagoans, Edward T. Jeffery, a railway executive, and Octave Chanute, the famous engineer, were sent to Paris by the World's Columbian Exposition to study the Universal Exposition in detail.[33] They published their report in a privately printed volume titled *Paris Universal Exposition 1889* and provided drawings of the French example.

Frederick Law Olmsted, the famous father of the namesake commission member, was responsible for the landscape design and planning of the fair. He read an article by W. C. Brownell in *Scribner's Magazine* describing the Paris fair and pointing out the sense of harmony created by the formal design unified on a central court and the cooperative approach of the corps of artists. Olmsted quoted the article with approval, especially the passage from Brownell. This sense of competition with the French fair

[32]*Improvement of the Park System,* p. 512.

[33]Daniel Burnham, "The Organization of the World's Columbian Exposition," *Proceedings of the Twenty-seventh Annual Convention of the American Institute of Architects and World's Congress of Architects, 1893* (Chicago, 1893), p. 133.

FIG. 7. Monument Gardens Plan of Senate Park Plan Commission, 1901–2. (*Courtesy Library of Congress.*)

imparted some formal principles to the emerging planning concept that would carry on from Chicago to Washington. The subordination of details to the larger plan, which both Olmsted and Brownell identified, related to the Ecole des Beaux-Arts' emphasis on the fine interrelationship of the parts of the building or project.[34]

In the McMillan Commission plan for Washington, the grouping of public buildings repeatedly suggests the organizational and visual principles of the Court of Honor. Several bills had already been introduced for the Supreme Court building on the lot north of the Library of Congress. The commissioners knew that other buildings in the area would soon be necessary for the use of congressmen. Therefore they foresaw, fronting on the Capitol grounds, a group of buildings sharing like functions (all related to legislature and judicial work) and like appearances (harmonious in design and uniform of cornice line). They spoke from the success of the White City, as the World's

[34]Frederick Law Olmsted to Lyman Gage, Aug. 18, 1890, Olmsted Papers, Library of Congress Manuscript Division, quoting from W. C. Brownell, "The Paris Exposition: Notes and Impressions," *Scribner's Magazine* 8 (1890):21, 23: "This effect of unity was powerfully assisted by the general excellence of all the structural details of the Exposition. There were no jars, no discordant notes of eccentric taste, nothing to break the agreeable uniformity of a high level of competence and culturation. . . . I hope, however it will be deemed neither supercilious nor unpatriotic if I suggest that, should the Exhibition of '92 as a spectacle possess the unity and excellence of the Paris Exposition, we shall certainly have cause for celebration."

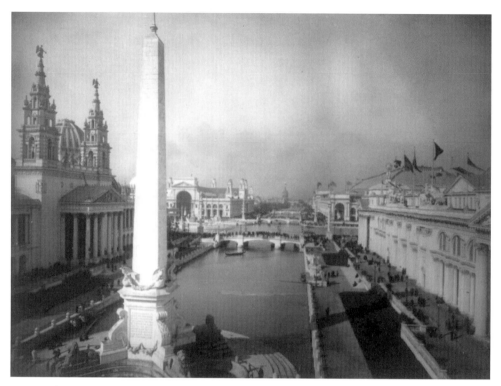

FIG. 8. The 1893 World's Columbian Exposition in Chicago. Photograph by Frances Benjamin Johnston. *(Courtesy Library of Congress.)*

Columbian Exposition was often called, when they asserted the following: "If the reciprocal relations of the new buildings shall be studied carefully, so as to produce harmony of design and uniformity of cornice line, the resulting architectural composition will be unequaled, in magnitude and monumental character by any similar group of legislative buildings in the modern world."[35]

As William Allen has illustrated in his *History of the United States Capitol,* acting Architect of the Capitol Elliott Woods had been developing the concept for a new House office building at the time that the McMillan Commission called for the creation of a unified architectural composition of government buildings and grounds to frame the Capitol itself. Woods submitted plans for several sites, but the composition for all was for a classically French composition of an Ionic order on a high basement. Woods declared that he based this design on that of the Capitol.[36] The Capitol plaza buildings were eventually developed by Carrère and Hastings, both of whom had studied at the Ecole des Beaux-Arts in Paris in the early 1880s, where they had met. By

[35]*Improvement of the Park System,* pp. 28–29.
[36]William Allen, *History of the United States Capitol* (Washington, D.C., 2001), p. 378.

agreement of 1904, Carrère and Hastings undertook to create an architecturally correct garment for the skeleton devised by Woods.[37]

Their House and Senate office buildings of 1905–9 (figs. 9, 10), designed to balance each other and bookend the Capitol, gave solidity to the McMillan Commission's vision of an architectural framework for the Capitol. Their contribution was the colonnade of paired freestanding columns, a clear reference to the colonnade of the Louvre. This element created the deeply shadowed articulation of the facade that gave a dynamic architectural quality to the two secondary structures.

Federal Triangle was a part of the McMillan Plan in concept.[38] Both in plan and articulation, however, the buildings of the Federal Triangle were developed nearly thirty years later (fig. 11). The planning of this complex had much iteration during its design (1928–37). A team of Beaux-Arts–trained architects developed the idea of adapting the planning of the Louvre for this complex of interlocking buildings around courtyards. The use of interlocking voids appears in other iconic French buildings, such as the widely admired Hôtel de la Monnaie, with its complex of connected courts. The French academic author Julien Guadet, in his classic turn-of-the-twentieth-century book on French architecture, *Eléments et théorie de l'architecture,* listed among the attributes of a beautiful composition courtyards that extended from one to another thorough leading perspectives. This aspect of the Federal Triangle reflects Guadet's definition of "a composition that has the beauty of details and the wise succession of perspectives."[39]

Within the Federal Triangle complex, the articulation of this series of formal squares and plazas reflected those of Paris. These urban adornments first appeared in Paris in the seventeenth century. Place Dauphine (1607) is triangular in plan, with brick buildings articulated with stone trim defining two of the three sides. The Place des Vosges provided a uniform facade with common cornice (1605, originally Place Royale). The rule of the common cornice line continued to characterize the squares and plazas of Paris and was adopted for the Federal Triangle complex.

[37]Ibid., p. 381. Carrère and Hastings agreed to become consulting architects to the Architect of the Capitol. The title indicated that they would accept a flat fee for design rather than the percentage of project fees for which the AIA had fought so hard. Perhaps they agreed to the unusual arrangement for the prestige of the association. Perhaps they even felt a sense of mission in providing a needed polish to the design work of acting Architect Elliott Woods. In his *American National Biography* entry, architect and critic H. Van Buren Magonigle described their partnership: "Hastings was as helpless as a shredder crab when anything practical was in question, and although Carrere was a thoroughly trained designer and for years by his sensible and penetrating criticism kept Hastings within bounds, he found himself forced to handle the practicable and business aspects of the practice."

[38]McKim to Burnham, Nov. 25, 1901 (reel 8, Library of Congress Manuscript Division), says that he conferred with Charles Moore in New York City "in order to determine the location of the buildings, and the treatment of the grounds in the triangle bounded by north B. Street and Pennsylvania Avenue. He has conferred with Senator McMillan in regard to this, and is coming up, with the Senator, this week, to settle these points definitely, so they can be placed upon the model."

[39]Julien Guadet, *Eléments et théorie de l'architecture,* 3d ed., augmented by J-L. Pascal (Paris, 1901), pp. 126–28.

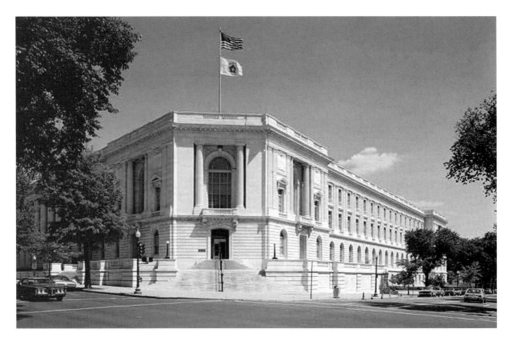

FIG. 9. House Office Building. *(Courtesy Library of Congress.)*

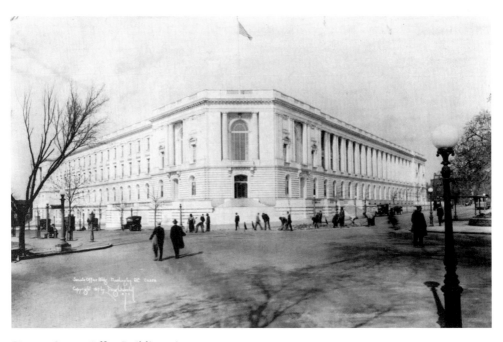

FIG. 10. Senate Office Building, circa 1917. *(Courtesy Library of Congress.)*

FIG. 11. An aerial view of Federal Triangle photographed by Theodor Horydczak, circa 1920–1950. *(Courtesy Library of Congress.)*

By 1686, Paris had two more monumental plazas, Place des Victoires (fig. 12) and Louis le Grand (Place Vendôme), both by Hardouin-Mansart. In planning terms, these differed fundamentally: one was nearly circular, and the other was a rectangle with canted corners. In elevation, however, both conformed to the architectural expression that created a framework for the plaza much as a stage set does for the stage where the action will take place. The distinctive ovoid form of the Place des Victoires was chosen for the Federal Triangle, an unmistakable reference to Paris.

Place Vendôme presented a similar architectural vocabulary (fig. 13). Here, as in the previous examples, the upper floors sat on an arcaded base. The repetitive facades defined the perimeter of the space and formed the theatrical backdrop for the royal monument. Like stage scenery, they lack sculptural bulk—for they are flat and shallow —but suggest depth through the incorporation of layered detail. They create a setting both scaled to the idea of the state or monarchy and appropriate to the surrounding development. It is this concept of appropriate monumentality that influenced planning in Washington.

The same was true of Place de la Concorde. Jacques-Ange Gabriel's buildings framing the Place de la Concorde (originally Place Louis XV), were central in the dialogues of the McMillan Commission. They saw Gabriel's buildings as backdrop,

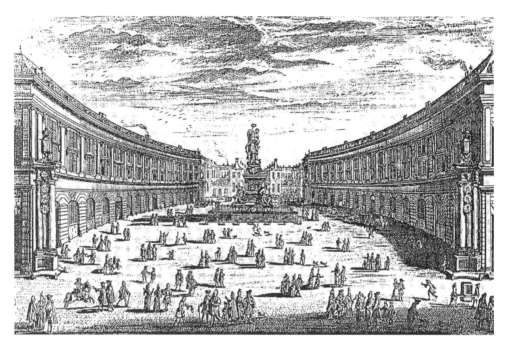

Fig. 12. Place des Victoires. Pugin/Heath print, 1834. *(Courtesy Library of Congress.)*

subordinated to the sense of place. Thus it is no surprise that in the later design of Federal Triangle, the articulation of the facades framing the entrance to the Grand Plaza strongly recalls the buildings of the Place de la Concorde. Observers writing for French publications in the 1930s were especially interested in the French-inspired arcaded semi-circular plaza of the emerging Federal Triangle. Noting also that the arched access to the interior courts resembled the Louvre courts, they pointed out that the planning of the complex was inspired by French design.[40]

THE INFLUENCE OF Paris on Washington is especially strong in regard to planning. Indeed, there would be no Washington plan at all were it not for the urban ideas developed in the seventeenth century and already tested in Paris. Washington's connection with Paris continued in the mid-nineteenth century as the city looked to its roots as well as to its future. Planning for the growth of sanitation and boulevards under the territorial government was based on French examples. The McMillan Commission followed the lead of previous planners for Washington in looking to Paris. Thereafter, large-scale public developments followed their lead in projects such as the Capitol Plaza and the Federal Triangle.

[40]Pierre Denoyer, "Washington," *La Revue du Monde* 7, no. 318, Apr. 4, 1936, p. 78 ; Pierre Daninos, "L'Urbanisme aux Etats-Unis," *Art et Industrie* (1935); and George Benoit-Levy in *L'Illustration,* 286, no. 4412, Sept. 24, 1927.

Fig. 13. Place Vendôme, photo mechanical print, 1890–1900. *(Courtesy Library of Congress.)*

In his article "City Improvement from the Artistic Standpoint," John Carrère noted that the city of Washington was an exception among the poorly planned cities of this country.[41] He cited the wise original plan of L'Enfant and its later renewal led by the McMillan Commission as a "splendid precedent" for establishing control over the effects of uncontrolled growth. In the plan of Washington he found the model, based on lessons learned from Paris, to establish the principal elements of circulation and communication, of hygiene, and most of all of artistic principles. His analysis underscores the point that Isabelle Gournay has made in her introductory essay for this volume, that French influence was always a means of ordering and beautifying the city as well the building and its interior.

[41]*Western Architect,* Apr. 15, 1910, pp. 40–41, 44. See also footnote 1.

Appendix

Architects and the French Connection in Washington, D.C.

ISABELLE GOURNAY

T HE FOLLOWING LISTING OF DESIGNERS AND ARCHITECTURAL OFFICES ACTIVE IN
Washington, D.C. (including members of the Commission of Fine Arts), with a
French affiliation and a checklist of their French-influenced works in Washington,
D.C., is presented in four sections: the first lists those who received the *diplôme* from the
Ecole des Beaux-Arts; the second, those who were officially admitted into the Ecole and did
coursework as second- and/or first-class students; the third, those who studied architecture
in Paris without having officially entered the Ecole; and the fourth, a selection of significant
designers who studied architecture in the United States in a program patterned after that of
the Ecole and generally under French professors; representative works in and around the
nation's capital are also mentioned.

The author would like to thank Marie-Laure Crosnier-Leconte for sharing her research
on Ecole admissions files, preserved at the Archives Nationales.

I. Recipients of the diplôme

Chester Holmes ALDRICH (Providence, R.I., 1871–1940)
Son of Sen. Nelson W. Aldrich
BArch Columbia University, 1893
Ecole des Beaux-Arts (hereafter, EBA), admitted 1895; studied in the atelier of Daumet
 and Esquié; diplôme, 1900
Carrère and Hastings

Delano and Aldrich, New York, 1903
 Embassy of Japan, 1931
 New Post Office (Ariel Rios Federal Building), Federal Triangle, 1932–34
 Addition, Carnegie Institution of Washington, 1937

William Peirce ANDERSON (Oswego, N.Y., 1870–1924)
Daniel Burnham
Graham, Burnham and Co., Chicago, 1912–17
Graham, Anderson, Probst and White, Chicago, 1917–24
BA Harvard, 1892
Degree in electrical engineering, Johns Hopkins, 1894
EBA, 1895; Guadet and Paulin; diplôme, 1899
Member, Commission of Fine Arts, 1912–16
 Union Station, 1903–08
 United States Post Office, 1911–14; north section, 1931–33
 Columbus Memorial, Capitol Plaza (in front of Union Station, with Lorado Z. Taft
 sculptor), 1912

Donn BARBER (Washington, D.C., 1871–1925)
Yale University, 1893; Columbia University
EBA, 1895; Blondel, Scellier de Gisors; diplôme, 1898
Worked for Carrère and Hastings and for Cass Gilbert
Established own practice in New York City, 1900
FAIA, 1916
Officier d'académie
Winner, Department of Justice Competition, 1911

Edward Herbert BENNETT (Cheltenham, Great Britain, 1874–1954)
Bennett, Parsons and Frost, founded 1924 (New York and Chicago)
EBA, 1895; Guadet and Paulin; diplôme, 1901; outstanding student
Chairman, Board of Architects, Federal Triangle, 1927–37
 United States Botanic Garden, 1931
 Federal Trade Commission (Apex) Building, 1938
See Joan E. Draper, *Edward H. Bennett: Architect and City Planner, 1874–1954* (Chicago, 1982).

Stanislas Louis BERNIER (Paris, 1845–1919)
EBA, 1864; Daumet
Premier Grand Prix de Rome, 1872
Professor EBA, 1905–19
President, Société Centrale des Architectes, 1911–14
 Opéra Comique, Paris, 1893–98
 Project, French Embassy, 1909

Arthur BROWN, Jr. (Oakland, Calif., 1878–1957)
EBA, 1897; Laloux; diplôme, 1901
Associé étranger, Académie des Beaux-Arts, 1926
Member, Board of Architects, Federal Triangle
 United States Customs Service, Departmental Auditorium, and the Interstate Commerce Commission, Federal Triangle, 1935
See Jeffrey Tilman, *Arthur Brown, Jr.: Progressive Classicist* (New York, 2005).

Charles BUTLER (Scarsdale, N.Y., 1870–1953)
EBA, 1892; Laloux; diplôme, 1897
Carrère and Hastings
Butler and Rodman, New York City, 1899–1922
 General Services Administration Building, 1915–17
See Charles Butler, "Office Buildings of the Department of the Interior at Washington, D.C.: Charles Butler, Architect," *Architectural Record* 44 (1918):199–213.

Jean-Paul CARLHIAN (Paris, 1919)
EBA, Paris and Marseille, ca.1940; diplôme, 1948
MCP Harvard University, 1947
Shepley Bulfinch Richardson and Abbott, Boston
 National Museum of African Art, National Museum of Asian Art, Arthur M. Sackler Gallery, and S. Dillon Ripley Center, Smithsonian Institution, 1983–87

Paul Philippe CRET (Lyon, 1876–1945)
EBA, 1897; Pascal; diplôme, 1903
Member, Commission of Fine Arts, 1940–45
Officier de la Légion d'honneur
AIA Gold Medal, 1938
 Pan American Union Building (currently Organization of American States), 1907–10
 Consulting architect, American Battle Monument Commission
 Folger Shakespeare Library, 1929–31
 Federal Reserve Building, 1935–37
 Project for French Embassy on Meridian Hill, 1929–32
 Mary E. Stewart House, 2030 24th Street, N.W., Washington, D.C., Kalorama, 1938
 National Naval Medical Center, Bethesda, Md., 1939–41

John Walter CROSS (New York, 1878–1951)
EBA, 1902; Laloux; diplôme, 1906
Member, Commission of Fine Arts, 1928–33

Thomas Cushing DANIEL (Washington, D.C., 1908–92)
EBA, 1930; Expert; diplôme, 1934

Homebuilder and developer; operated Standard Properties; active in the District of
Columbia and suburban Maryland
Architect's House, 2680 Chain Bridge Road, N.W.

William Adams DELANO (New York, 1874–1960)
EBA, 1899; Laloux; diplôme, 1902
Corresponding member, Académie des Beaux-Arts, 1931
Member, Commission of Fine Arts, 1924–28
Member, Board of Architects, Federal Triangle
Presidential appointee, National Capital Park and Planning Commission, 1929–46
Architectural consultant to Commission on the Renovation of the White House, 1949

Joseph Henry FREEDLANDER (New York, 1870–1943)
EBA, 1890; Duray, Daumet, Esquié, and Girault; diplôme, 1895
Second Honorable Mention, Competition for Building for Department of Commerce and
Labor, 1910
Jusserand Memorial, Rock Creek Park, 1936
See Chester Holmes ALDRICH

Howard GREENLEY (Ithaca, N.Y., 1874–1963)
BS Trinity College, 1894
EBA, 1897; Laloux; diplôme, 1900
Worked for Carrère and Hastings
Opened office, 1902
Edson Bradley Residence, 1907 (demolished)

John Augur HOLABIRD (Evanston, Ill., 1886–1945)
West Point graduate, 1907
EBA, 1910; Redon; diplôme, 1913
Croix de Guerre
Holabird and Root, Chicago
Jury member, Smithsonian Gallery of Art competition, 1938
Remington Rand Building, 1934
Hotel Statler (Capital Hilton), 1943
Lafayette Building (with A. R. Clas), 1940

George HOWE (Worcester, Mass., 1886–1955)
EBA, 1908; Laloux; diplôme, 1913
Consultant (1942) and supervising architect (1942–45), Public Buildings Administration,
based in Washington

Coast Guard Memorial, Arlington National Cemetery, 1928
See Robert Stern, *George Howe: Toward a Modern American Architecture* (New Haven,
 1975), pp. 198–208

John Mead HOWELLS (Boston, 1869–1959)
EBA, 1892; Godefroy Deglane, Thierry and Douillard; diplôme, 1897
Exhibited Salon du Champ de Mars, 1896, and Société Nationale des Beaux-Arts
Member, Commission of Fine Arts, 1933–37
Juror, competition, Federal Reserve Board, 1935

Frederic Vernon MURPHY (Fond du Lac, Wis., 1879–1958)
George Washington University, 1899–1900
Office of the Supervising Architect of the Treasury, 1899–1905
EBA, 1906; Bernier; 1e classe, 1908; diplôme, 1923
Worked for Carrère and Hastings, 1907–8
Received last Ecole credit, July 1909
Founder, Department of Architecture, Catholic University, 1911
Consultant, proposed Municipal Center, ca. 1932
Member, Society of Beaux-Arts Architects
Member, Commission of Fine Arts, 1945–50
Murphy and Olmstead, Washington, 1912–38
Murphy and Locraft, Washington, 1943–58
 Numerous buildings at Catholic University, including Graduate Hall (University
 Center), 1914; Martin Maloney Memorial Chemistry Building, 1917; gymnasium,
 Edward Crough Center for Architectural Studies, 1919; John C. Mullen of Denver
 Memorial Library, 1928; Ward School of Music, 1930; Curley Hall, 1939; Ryan Hall
 Dormitory, 1945; Shahan Hall, 1949; Regan Dormitory and St. Vincent de Paul
 Chapel, 1949
 Numerous Catholic parish churches, including the Shrine of the Sacred Heart, 1923
 St. Francis Hall and Rosary Portico, Franciscan monastery, 1920s
 St. Anselm's Chapel, Priory, and School, 1930
 Apostolic Legation of the Papal State, 1939

Paul NELSON (Chicago, 1895–1979)
EBA, 1923; Redon; diplôme, 1927
Architect in Paris, active in the United States and Egypt
Member, Escadrille Lafayette during World War I
Technical advisor, National Housing Agency; lived in the District of Columbia during
 World War II; helped prepare an exhibition of American planning and housing
 techniques displayed at the Paris Grand Palais in 1947

Theodore Wells PIETSCH (Chicago, 1868–1930)
MIT
EBA, 1892; Marcel Lambert; diplôme, 1897
Simonson and Pietsch, Baltimore
Office of the Supervising Architect of the Treasury, 1902–4
Founded Washington Architectural Club atelier, 1902

Henry Richardson SHEPLEY (Brookline, Mass., 1887–1962)
BA Harvard University, 1910
EBA, 1911; Laloux; diplôme, 1914
Member, Commission of Fine Arts, 1936–40

Jean-Pierre TROUCHAUD (Perpignan, France, 1908)
EBA; Expert; diplôme, 1937
 Meeker House, 3000 Chain Bridge Road, N.W., 1949
 Mulitz House, 2895 University Terrace, N.W., 1951

Nathan C. WYETH (Chicago, 1870–1963)
School of the Metropolitan Museum of Art
Traveled to Belgium and Switzerland where he practiced watercolor, 1888
Michigan Military Academy, 1889–90
EBA, 1892; Duray Pascal; diplôme, 1899
Worked for Carrère and Hastings, 1899–1900
Designer, Office of the Supervising Architect of the Treasury, 1901–3
Designer, Office of the Architect of the Capitol, 1904–5
Major, Army Construction Division, designed military hospitals in France during World
 War I
FAIA, 1914
Wyeth and Cresson, 1907
N. C. Wyeth, 1904–18
Wyeth and Sullivan, 1924–34
Municipal architect, District of Columbia, 1934–46; oversaw the design of the Municipal
 Center
 Williams House, 1907 (razed 1965)
 F. A. Keep House and C. Russell Payton House (Embassy of Kenya), 1906
 Pullman Residence (Embassy of Russia), 1909–10
 Gibson Fahnestock House (Embassy and Chancery of Haiti), 1909–10
 Sarah Wyeth House (Embassy of Chile), 1908
 First Oval Office, White House, 1909
 Key Bridge (Tidal Reservoir Inlet Bridge), 1908–12
 Granville Fortesque House (Embassy of Malawi), 1911

Consultant, Proposed Municipal Center, ca. 1932

Many public schools in the District of Columbia, including Kelly Miller Junior High
School, 1949 (demolished)

Municipal (Henry J. Daly) Building, 1941

National Guard Armory, Capitol Hill, 1942

See Nathan C. Wyeth, "Notes on the New Municipal Center," *Pencil Points* 20
(1939):578–84.

Clarence Clark ZANTZINGER (Philadelphia, 1872–1954)

Zantzinger, Borie and Medary, Philadelphia, 1917

EBA, 1896; Blondel, Scellier de Gisors, and Defrasse; diplôme, 1901

Member, Board of Architects, Federal Triangle

Presidential appointee, National Capital Planning Commission (NCPC), 1947

Justice Department Building, Federal Triangle, 1931–34

II. Officially admitted into the Ecole and did coursework as second- and/or first-class students

Welles BOSWORTH (Marietta, Ohio, 1869–1966)

MIT

EBA, 1897; Redon

Worked in Paris after World War I on restoration work sponsored by John D. Rocke-
feller, Jr.

First prize, competition for L'Enfant Monument in Arlington Cemetery, 1909

William Lawrence BOTTOMLEY (New York, 1883–1951)

EBA, 1908; Chifflot, Laloux

Bottomley, Wagner and White, New York, 1928–32

Embassy of Oman (Devore Chase House), 1930

Frederick H. BROOKE (Birdsboro, Pa., 1876–1961)

EBA, 1903–6; Laloux, Lemaresquier, Chaussemiche

District of Columbia World War Memorial, 1931 (with Nathan Wyeth and Horace
Peaslee)

Remodeling, Sulgrave Club, 1932

Local consulting architect to Edwin Luytens, British Embassy, 1927–31

John Merven CARRÈRE (Rio de Janeiro, Brazil, 1858–New York, 1911)

EBA, 1878–82; Ruprich Robert and Ginain

FAIA, 1891

Carrère and Hastings, New York, 1885
 Richard H. Townsend House (Cosmos Club), 1901
 Supplementary Report on the Extension of the United States Capitol in Relation to the Dome
 (New York, 1904)
 Cannon House Office Building and Russell Senate Office Building, 1905–8
 Administration Building, Carnegie Institution of Washington, 1908
 Washington Hotel, 1918
 Amphitheater, Arlington Cemetery, 1920

George W. CARY (Buffalo, N.Y., 1859–1945)
EBA, 1887–90; Daumet
 Wadsworth House (Sulgrave Club), 1901

Edward Pierce CASEY (Portland, Me., 1864–1940)
Son of Gen. Thomas Lincoln Casey, Army Corps of Engineers, who completed the Wash-
 ington Monument; the State, War, and Navy (Old Executive) Building; and the
 Thomas Jefferson Building, Library of Congress
Engineering, Columbia School of Mines
EBA, 1890–92; Laloux (only architecture projects)
Coordinator, decorative scheme, Thomas Jefferson Building, Library of Congress, opened
 1897
 Taft Bridge, Connecticut Avenue, 1906
 DAR Continental Memorial Hall, 1910
 Pedestal, Ulysses S. Grant Memorial, begun ca. 1902, dedicated 1922

Edouard Frère CHAMPNEY (Ecouen, France, 1874–1929)
Harvard University
EBA, 1898; Laloux
Partnership with Carl F. Gould in Seattle, 1909
Worked in the Office of the Supervising Architect and on the Museum of Natural History

William Penn CRESSON (Claymont, Del., 1873–1932)
University of Pennsylvania, 1895–97
EBA, 1896; Blondel-Scelliers de Gisors-Defrasse
Studied at Ecole des Sciences Politiques, 1902
Wyeth and Cresson, 1906–7
Married the daughter of Daniel Chester French, 1921
 Henrietta M. Halliday House (Chancery of Ireland), 1908–9

Edward Clarence DEAN (Washington, 1879–1966)
EBA, 1904–6; Umbdenstock, Paulin, Duquesne (submitted only architecture projects)

Washington, 1910–15
Worked for Delano and Aldrich and for John Russell Pope in New York City
 In the Woods (David Fairchild House), Kensington, Md., 1910

Douglas Dorell ELLINGTON (Clayton, N.C., 1886–1960)
Paris Prize, 1911
EBA, 1913; Laloux
Architect in Asheville, N.C.
 Row Houses and Center School, Greenbelt, Md., 1937

Ernest FLAGG (New York)
EBA, 1889; Blondel
Medal, Paris Exposition, 1900
 Corcoran Gallery of Art, 1893–97

Frederick G. FROST (London, 1876–1966)
EBA, 1902–3; Paulin
Bennett, Parsons and Frost
See Edward Herbert BENNETT

Wallace K. HARRISON (Worcester, Mass., 1895–1981)
Studied with Harvey Willey Corbett, Columbia University, 1916–17
EBA, 1921; Umbdenstock
Harrison and Abramovitz, New York
Member, Commission of Fine Arts, 1955–59
 Auditorium, National Academy of Sciences, 1965

Thomas HASTINGS (New York, 1860–1929)
EBA, 1880–82; André
Chevalier de la Légion d'honneur
Member, Commission of Fine Arts, 1910–17
See John Merven CARRÈRE
 Commodore John Paul Jones Monument, West Potomac Park (with sculptor Charles
 Henry Niehaus), 1912
 Butt-Millet Memorial Fountain (with sculptor Daniel Chester French), The Ellipse,
 1913

Henry HORNBOSTEL (New York, 1867–Pittsburgh, 1961)
EBA, 1894–97; Ginain
Juror, Pan American Union Building Competition, 1907

Richard Morris HUNT (Brattleboro, Vt., 1828–New York, 1895)
EBA, 1846–54; Lefuel
Worked for Thomas U. Walter on the Capitol
 Base, John A. Logan statue, 1891

Thomas Hall LOCRAFT (Washington D.C., 1903–Washington, D.C., 1959)
BS Catholic University, 1926; PhD Catholic University, 1931
Fontainebleau School of Fine Arts, summer 1927
Paris Prize, 1928
EBA, 1928–31; de Pontremoli
Member, Commission on the National Capital, AIA
 Academy of the Holy Cross, Kensington, Md., 1956
 Lorraine American Cemetery and Memorial, St. Avold, Moselle, France, dedicated
 1960

Charles Follen McKIM (Isabella Furnace, Pa., 1847–Saint James, N.Y., 1909)
EBA, 1868–70; Daumet
McKim, Mead and White, New York City, formed 1879
Member, Senate Park Commission, 1901–2
 Fort Leslie McNair (National War College Building), 1902–8

Benjamin Wistar MORRIS (Portland, Ore., 1870–1944)
Columbia University, 1894
EBA, 1895; Blondel
Member, Commission of Fine Arts, 1927–31

William E. PARSONS (Akron, Ohio, 1872–1939)
Columbia University
EBA, 1898; Laloux
See Edward Herbert BENNETT

Robert Swain PEABODY (New Bedford, Mass., 1845–Marblehead, Mass., 1917)
Harvard College
EBA, 1868–70; Daumet
Peabody and Stearns, Boston, 1870–1917
Member of the jury, District Building Competition, 1904
 Volta Bureau, Georgetown, 1894–96

John Russell POPE (New York, 1874–New York, 1937)
Columbia University
American Academy in Rome, 1894–96

EBA, 1897–1900; Deglane; diplômé honoraire, 1922
Founder of the Prix Jean Leclaire et John Russell Pope, Académie des Beaux-Arts
Chevalier de la Légion d'honneur, 1924
Member, Board of Architects, Federal Triangle
 Scottish Rite Temple, 1911–15
 John F. Wilkins Estate (Parklawn Cemetery), Rockville, Md., ca. 1917
 Irwin B. Laughlin House (Meridian International), 1920–29
 American Pharmaceutical Association Building, 1933
 Second Division Memorial (with sculptor James Earle Fraser), The Ellipse, 1936
 National Gallery of Art., 1937–41

James Otis POST (New York, 1874–1951)
EBA, 1899–1902; Deglane, 1e classe
George B. Post and Sons
 Project for George Washington University campus, 1905

Henry Hobson RICHARDSON (St. James Parish, La., 1838–1886)
EBA, 1860–62 and intermittently until 1865; André
 John Hay and Henry Adams houses, 1884–86 (demolished 1927)
 Benjamin H. Warder House, 2633 Sixteenth St., 1885–88 (considerably altered)

Arthur ROTCH (Boston, 1850–94)
EBA, 1874; Vaudremer
Rotch and Tilden, Boston
 Hale House, 1891 (razed 1941)

Paul-Ernest Eugène SANSON (Paris, 1836–1918)
EBA, 1855–61; Gilbert Questel
 Perry Belmont House (International Eastern Star Temple), 1909 (with Horace Trumbauer, associated architect)

Philip SAWYER (New London, Conn., 1868–1949)
EBA, 1892; Godefroy Redon
York and Sawyer, New York, formed 1898 (office in Washington, D.C., 1929–34, 1949–55), Louis Ayres, designer
 American Security and Trust Company, 1904

George Thomas TILDEN (1845–1919)
EBA, 1869–70; Vaudremer
See Arthur ROTCH

Evarts TRACY (New York, 1868–1929)
EBA, 1893; Raulin
Godefroy and Freynet, then Raulin
Worked in Paris from 1918 until his death in 1929
National Metropolitan Bank (with B. Stanley SIMMONS), 1909

Alexander Buell TROWBRIDGE (Detroit, 1868–New York, 1950)
BS Architecture, Cornell University
EBA, 1895; Lambert
Director and dean, College of Architecture, Cornell University, 1897–1902
Trowbridge and Ackerman (Frederick Lee), New York, 1906–21
Director, American Federation of the Arts, 1928–29
Associated architect (with Paul Cret), Folger Shakespeare Library, 1929–31

Samuel Breck Parkman TROWBRIDGE (New York, 1862–1925)
EBA, 1888; Daumet and Girault
Founder and trustee, American Academy in Rome
Founder, Society of Beaux-Arts Architects
President, Architectural League of New York, 1913
Commissioner, First National Council of Fine Arts, 1913
Chevalier de la Légion d'honneur
Trowbridge and Livingston
 American Red Cross National Headquarters, 1915–17

Whitney WARREN (New York, 1864–1943)
EBA, 1887–93; Daumet, Girault, Esquié
Warren and Wetmore, New York, 1898
Associé étranger, Institut de France, 1909
 Mayflower Hotel, 1924 (with Robert Francis Beresford, associated architect)
 Former Italian Embassy, Meridian Hill, 1923–24

III. Studied architecture in Paris without having officially entered the Ecole des Beaux-Arts and/or are not mentioned in *Edmond Delaire,* Les Architectes Elèves de L'Ecole des Beaux-Arts, 1793–1907 *(Paris, 1907)*

Percy ASH (Philadelphia, 1865–1933)
BS in architecture and civil engineering, University of Pennsylvania, 1886
American Academy in Rome, 1895–96
Godefroy and Freynet, Paris, 1896–97
Office of the Supervising Architect of the Treasury, 1900–1905

Secretary (1902) and president (1904), Washington Architectural Club
Professor of architecture, George Washington University, 1904–10
Subsequent teaching positions at University of Michigan, University of Illinois, and Penn
 State University

Ward BROWN (San Francisco, 1877–Washington, D.C., 1946)
EBA, ca. 1900; Paulin
Washington, D.C., 1906
Boal and Brown, 1910–16
 Owsky House (Residence of the Netherlands Ambassador), 1929
 Late-career restoration of homes in Georgetown and Alexandria

Theophilus Parsons CHANDLER, Jr. (Boston, 1845–1928)
EBA; Vaudremer
Founding director, University of Pennsylvania School of Architecture, 1890
 Amphitheater, Caretakers Cottage, Glen Echo Chautauqua, Md.,1891
 Edward Bazley House, Glen Echo Heights, Md., 1891
 Leiter Residence, Dupont Circle, 1894 (demolished)
 St. Thomas Episcopal Church, 1894–99

Joseph Coerten HORNBLOWER (Paterson, N.J., 1848–1908)
BA Yale University, 1869
EBA, 1875–76; Pascal
FAIA, 1893
Hornblower and Marshall, Washington, D.C., 1885–1923
 William J. Boardman House, 1893
 Duncan Phillips House (Phillips Collection), 1897
 National Geographic Society, 1902
 National Museum (Museum of Natural History), 1904
 Custom House, Baltimore, 1906–8
 Lothrop Mansion, 1909
 Army and Navy Club, 1911

Lindley JOHNSON (Germantown, Pa., 1854–Philadelphia, 1937)
BS University of Pennsylvania
EBA, 1877; Moyaux
Worked for Frank Furness
Lead architect for the Chevy Chase Land Co.

William Mitchell KENDALL (Jamaica Plain, Mass., 1856–Bar Harbor, Me., 1941)
MIT, advanced study in France and Italy
McKim, Mead and White

Member, Commission of Fine Arts, 1916–21
 Arlington Memorial Bridge, 1926–32

Charles Adams PLATT (New York, 1861–1933)
In Paris, 1882–87; Académie Julian (failed EBA entrance exam for architecture)
Member, Commission of Fine Arts, 1916–21
 Freer Gallery of Art, 1923–28
 West wing, Corcoran Gallery of Art, 1928

Jules Henri de SIBOUR (Paris, 1872–Washington, D.C., 1938)
BA Yale University, 1896
Worked for Ernest Flagg in New York City
EBA, 1898; Daumet and Esquié
Price and de Sibour, New York City and Washington, D.C., 1901–3
 Thomas T. Gaff House (Embassy of Colombia), 1904
 Folger Building, 1906
 Chevy Chase Club House, 1911
 McCormick Apartments (National Trust for Historic Preservation), 1915
 Clarence Moore House (former Canadian Embassy), 1906
 Alexander Stewart House (Embassy of Luxemburg), 1908–9
 John Hays Hammond House (Residence of the French Ambassador), Kalorama, 1910
 Clubhouse, Chevy Chase Club, 1910
 Jefferson Hotel, 1922
 Spanish Chancery, 1926
 Wilkins House (Peruvian Chancery), 1909

Robert STEAD (New York, 1856–1943)
EBA, ca. 1876–78; Perouse de Montclos
Office in Washington, D.C., 1884–1930
 Mount Vernon Seminary, ca.1925
 Elijah P. Lovejoy Elementary School

George Oakley TOTTEN, Jr. (New York, 1866–Washington, D.C., 1939)
MA Columbia University, 1892
EBA, 1893–95; Daumet, Girault, and Esquié (received McKim Traveling Fellowship from
 Columbia University)
Worked in the office of the Supervising Architect of the Treasury, 1897–98
Totten and Rogers (Laussat R.), 1899–1907
Member, Washington Society of Fine Arts and Washington Water Color Club
American delegate, International Congress of Architects, Paris, 1900
 James C. Hooe Residence, 1907
 Christian Hauge Residence (Embassy and Chancery of Cameroon), 1907

Former French Embassy, Meridian Hill, 1908
F. B. Moran Residence (Embassy of Pakistan), 1908
Edward H. Everett House (Embassy of Turkey), 1910–15
Ecuadorian Embassy, 1927

James Bosley Noel WYATT (Baltimore, Md., 1847–1926)
Harvard University, 1870; MIT
EBA; Vaudremer
Wyatt and Sperry, 1880–87
Wyatt and Nolting
 War Risk Insurance Building, Veterans Administration, 1912–20

IV. Studied architecture in the United States in a program patterned after that of the Ecole des Beaux-Arts and generally under French professors

Julian ABELE (Philadelphia, 1881–1950)
BS University of Pennsylvania, 1902
Worked for Horace Trumbauer, Philadelphia, beginning 1906
 Frank P. Mitchell House (Embassy of Argentina), 1907
 Perry Belmont House (International Eastern Star Temple), 1909 (local architect)
 Anna Thomson Dodge House (Embassy of Belgium), 1930–31

Charles L. BORIE (Philadelphia, 1871–1943)
University of Pennsylvania
Member, Commission of Fine Arts, 1936–40
See Clarence Clark ZANTZINGER

Glenn BROWN (Fauquier County, Virginia, 1854–1932)
MIT, 1875
Secretary, American Institute of Architects, 1898–1912
 Joseph Beale House (Egyptian Embassy), 1908

Edward A. CRANE (Taunton, Mass., 1867–1935)
MIT
Office of the Supervising Architect of the Treasury, 1896–1902
See John H. RANKIN

Edward Wilton DONN, Jr. (1870–1953)
MIT, 1891
Cornell

Office of the Supervising Architect of the Treasury, 1901–2
Donn and Peter, 1893–96
Wood, Donn and Deming, 1903–12
 Memorial House, George Washington Birthplace National Monument, 1932
 Consultant, proposed Municipal Center, ca. 1932

John F. HARBESON (Philadelphia, 1889–1987)
MS University of Pennsylvania, 1911
Consulting architect, American Battle Monuments Commission, 1945–80
Harbeson, Hough, Livingston, and Larson, 1945–76
 Consulting architects, Remodeling of House and Senate Chambers, U.S. Capitol,
 1951
 Remodeling of Capitol, early 1950s
 Consultant, Capitol Extension
 Rayburn House Office Building, 1965 (with Architect of the Capitol J. George Stewart)

Thomas M. KELLOGG (Washington, D.C., 1862–1935)
MIT, 1883–84
McKim, Mead and White
See John H. RANKIN

Milton B. MEDARY (Philadelphia, 1874–1929)
University of Pennsylvania, 1891
Commission of Fine Arts, 1922–27
Presidential appointee, NCPC, 1926–35
AIA Gold Medal, 1929
See Clarence Clark ZANTZINGER

Walter Gibson PETER, Sr. (Washington, D.C., 1868–1945)
MIT, 1889–90
Marsh and Peter, Washington, D.C.
 Evening Star Building, 1908
 Farmers and Mechanics Branch, Riggs Bank, Georgetown, 1921–22

Alfred Easton POOR (Baltimore, 1899–1988)
BA Harvard University, 1920; MArch University of Pennsylvania, 1924
DeWitt, Poor and Shelton, New York
 Associate architects, east front extension, U.S. Capitol, 1962
 James Madison Building, Library of Congress, 1966–80
 Restoration of Old Senate and Supreme Court Chambers, U.S. Capitol, 1976

John H. RANKIN (Lock Haven, Pa., 1868–1952)
MIT, 1887–89
Rankin and Kellogg, 1891
Rankin, Kellogg and Crane, 1903
 Administration Building, Department of Agriculture, 1904–8

B. Stanley SIMMONS (1878–1931)
MIT
 Elks Club, 1906 (razed 1979)
 National Metropolitan Bank (with Gordon, Tracy, and Swartwout), 1909
 Savoy Theater, 1913 (razed 1971)
 Jewish Community Center, 1926

Louis A. SIMON (Baltimore, Md., 1867–1958)
MIT
Opened office in Baltimore, 1894
Office of the Supervising Architect of the Treasury, 1896
Chief of Engineering and Drafting Division, Office of the Supervising Architect of the
 Treasury, 1915–41
Member, Board of Architects, Federal Triangle
FAIA, 1937
 Internal Revenue Service Building, Federal Triangle, 1928–35
 South Building, Department of Agriculture, 1930–36

Edward Durrell STONE (Fayetteville, Ark., 1902–1978)
Harvard, 1926; MIT, 1927–28
Established own firm in New York City, 1936
 National Geographic Society, 1964
 Department of Transportation, 1969
 Kennedy Center for the Performing Arts, 1971
 Georgetown University Law Center, 1971

James Knox TAYLOR (Knoxville, 1857–1929)
MIT
Senior draftsman (1897) and supervising architect (1897–1912), Office of the Supervising
 Architect of the Treasury

Contributors

William C. Allen has been the architectural historian in the Office of Architect of the Capitol since 1982. He previously served as chief architectural historian for the state of Mississippi. His authoritative *History of the United States Capitol: A Chronicle of Design, Construction, and Politics* (2001) is the most comprehensive architectural history of the Capitol.

Cynthia R. Field is an architectural historian and the chair of the Office of Architectural History and Historic Preservation, as well as associate director of the Office of Physical Plant, Smithsonian Institution. She received her doctoral degree from Columbia University. Dr. Field is the author, with Richard E. Stamm and Heather P. Ewing, of *The Castle: An Illustrated History of the Smithsonian Building* (1993).

Isabelle Gournay is associate professor of architecture at the University of Maryland, College Park. She received a professional degree in architecture from the Ecole Nationale Supérieure des Beaux-Arts and a doctorate in art history from Yale University. She is the author of *Le Nouveau Trocadéro* (1985) and the *AIA Guide to the Architecture of Atlanta* (1992), as well as numerous articles, book chapters, and encyclopedia entries published in the United States, France, Canada, Italy, and Holland.

Liana Paredes is curator of Western European Art at Hillwood Museum and Gardens. She is the author of *Sèvres Porcelain at Hillwood* (1998), *French Furniture from the Collection of Hillwood Museum and Gardens* (2003), and coauthor with Anne Odom of *A Taste for Splendor: Russian Imperial and European Treasures from the Hillwood Museum* (1998).

Thomas P. Somma was a historian of American art and the director of the Mary Washington University Galleries at Mary Washington College in Fredericksburg, Virginia. He published and lectured extensively on American sculpture and public art, and his *The Apotheosis of Democracy, 1908–1916: The Pediment for the House Wing of the United States Capitol* (1995) won the University of Delaware Press Award for best manuscript in American art.

Index

Italic page numbers refer to illustrations.